ELIZABETH FORBES

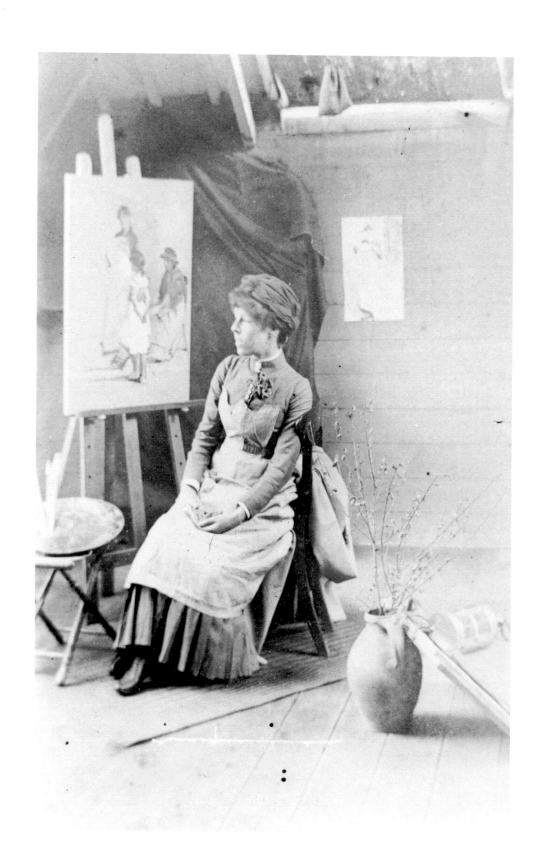

Singing from the Walls
The Life and Art of Elizabeth Forbes

JUDITH COOK & MELISSA HARDIE

with introductory essay
by Christiana Payne

Sansom & Company

in association with

PENLEE HOUSE
Gallery & Museum

1002079792

First published in 2000 by Sansom & Company Ltd, 81g Pembroke Road, Clifton, Bristol BS8 3EA, in association with Penlee House Gallery and Museum, Penzance.

© 2000 *introduction* Dr Christiana Payne *life* Judith Cook *catalogue raisonné* Dr Melissa Hardie.

ISBN 1 900178 77 X (softbound) and 1 900178 72 9 (casebound).

British Library cataloguing in Publication Data:
A catalogue record for this book is available from the British Library.

Designed and typeset by Gendall Design, Falmouth, Cornwall and printed by WBC Print, Bridgend, Mid Glamorgan.
Text set in Monotype Sabon 10/16pt.

FRONT COVER
School is Out, 1889

FRONTISPIECE
Elizabeth Forbes in her studio

Contents

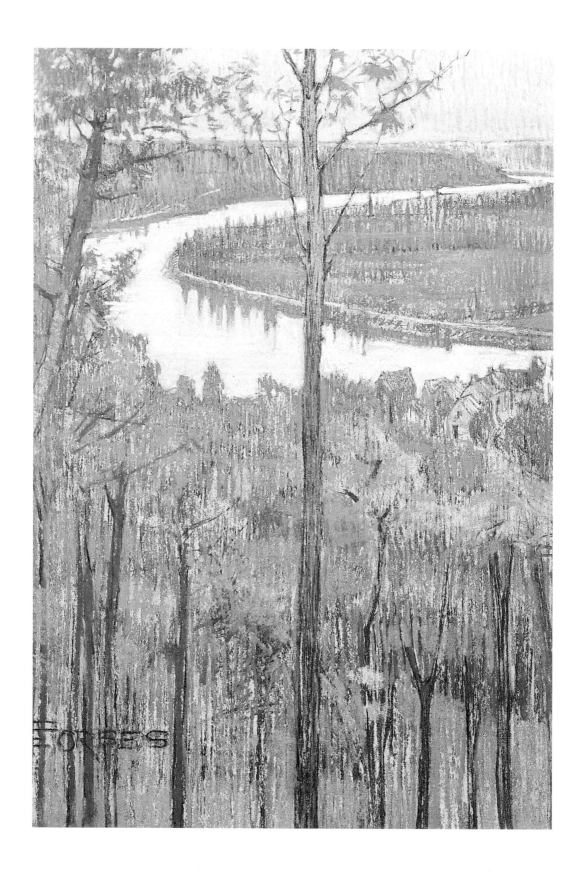

Preface

'It follows in no way that, because her limitations are different from, and in a physical sense greater than, a man's, the brutal laws which go to produce results are, in her case, different. She is marching along the same road, and though she may have other stopping places by the way and take up more modest quarters in the end, it is a journey and an arrival, an effort and a result, and the thing seen by the wayside becomes of significance to her as the painted banners under which she seeks her way...Art is a long lane with many turnings and so down each there may be a little house with a fireside and human hearts thereby.'

This deeply patronising, muddled and badly written piece of prose is the work of Ralph Peacock in his introduction to the chapter 'Modern British Women Painters' in *Women Painters of the World* published in 1905. He typifies exactly how male art critics were writing about women artists, even though some women painters individually, Elizabeth Forbes in particular, and amongst their peers of the male sex, were quite highly regarded. Five years earlier, in 1900, *The Studio*[1] had carried a notice by an unnamed critic. Headed 'Studio Talk', it described an exhibition of paintings by women artists:

The gallery of the Women's Exhibition at Earl's Court is of no little importance as a place where the latest developments in feminine conviction about aesthetic questions are adequately illustrated. It provides, perhaps, the most complete assertion of women's accomplishment in that art that has yet been made in this country and gives exceptional opportunities for estimating

PAGE 6
4.163 *La Seine près de Caumont*
chalk, paper laid onto board,
45.7 x 33cm
image courtesy of David Messum
Fine Art

the value of the effort made by what is called 'the weaker sex', to help in artistic undertakings.

Indeed many of the paintings, drawings, pastels and illustrations that went to make up the exhibition showed 'truly feminine qualities of invention and handling'. Briefly noted is 'Mrs. Stanhope Forbes' beautiful *Will o' the Wisp*, marred only by the careless and faulty lettering on its frame.'[2]

It was Elizabeth Forbes's misfortune to be a professional artist at a time when a little sketching and painting were considered ladylike activities for a young, middle-class girl. Her marriage to Stanhope Forbes, doyen of what became known as the Newlyn School, ensured that she was overshadowed by him throughout her working life. She was not the only one to suffer such a fate, another prime example being that of Gwen John with her brother, Augustus.

It was during her researches for the history of the first hundred years of the Newlyn Art Gallery, that Melissa Hardie became aware of the pivotal role which Elizabeth Forbes played in her own right. Both as a highly respected artist and as the working partner to her husband Stanhope Forbes in their School of Painting, Elizabeth was central to the cultural and social life of the community.[3] From that time Melissa Hardie began to collect reference materials relating to Elizabeth Forbes, and to keep a checklist of the works attributed to the artist, with the intention of publishing at least a monograph on the subject. With a busy personal publishing schedule and a continuing belief that not enough original source information was in hand, Hardie invited Judith Cook to work on a new biography planned for publication in 1998. In that same interim period between 1995 and 1998, Penlee House Gallery & Museum, under the directorship of the late Hazel Burston and the curatorship of Jonathan Holmes, came to the decision to present a major travelling exhibition of the work of Elizabeth Forbes in their millennium year schedule. Hence, what began as a biography with a companion catalogue-in-progress was projected to become the accompanying book for the exhibition as well. The untimely death of Hazel Burston has introduced a new curator of the exhibition in the person of Alison Lloyd, recently appointed to the directorship of Penlee House.

The art historian, Christiana Payne, was then invited to collaborate on this book, to ensure that the work is treated within the wider perspectives from which artists are judged. All four of these contributors to the book and exhibition value highly the fine work of Elizabeth Armstrong Forbes, the Canadian-born artist who was to become 'the queen of Newlyn'. It is with great respect and affection that the collaborative work done on this book is dedicated to the memory of Elizabeth Forbes and Hazel Burston, both of whom accomplished a great deal in the world of art within a similar span of years.

Judith Cook
Melissa Hardie
Alison Lloyd
Christiana Payne

Acknowledgements

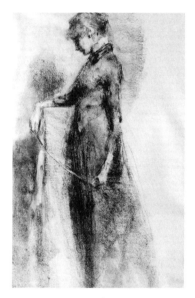

6.27 *Woman in Profile*
charcoal, 58.5 x 35cm
image courtesy of W. H. Lane & Son

This publication was launched in conjunction with a major exhibition of the same title curated by Penlee House Gallery and Museum, Penzance and shown from 8 July to 30 September 2000, touring to Djanogly Art Gallery, Nottingham from 28 October to 17 December 2000.

Penlee House Gallery and Museum would like to thank the following individuals and organisations who have given invaluable assistance in the preparation of both this book and the exhibition:

All the private collectors who have provided us with images, information and help, as well as generously lending their much-loved works to the exhibition.

Judith Cook, Melissa Hardie, Christiana Payne, John Sansom, Tessa and all at Gendall Design for the production of this book.

Graham Bazley of W.H. Lane and Son, Penzance, sponsors of the exhibition.

Staff at the Guildhall Gallery (London); Manchester City Art Gallery; National Museum of Women in the Arts (USA); Newlyn Art Gallery; Plymouth Art Gallery; Royal Cornwall Museum (Truro); Victoria and Albert Museum, Walker Art Gallery (Liverpool) and Wolverhampton Art Gallery for their assistance with loans.

Neil Walker, Tracy Isgar and Joanne Wright, Djanogly Art Gallery, Nottingham.

Belgrave Gallery (London & St Ives); Christie's (London); Richard Green Galleries; W.H. Lane & Son (Penzance); David Messum Fine Art; Phillips Auctioneers, and Sotheby's (London) for providing information and images and negotiating loans.

Monica Anthony; Joan Bray; David Evans; Mr and Mrs R.J. Gilbert; Jonathan Holmes; Mr and Mrs P.J. Joseph; Liz Knowles, and Leon Suddaby for essential help at various stages.

Bob Berry, Vince Bevan, Giles Spencer, Steve Tanner and Adam Woolfit for photography.

Jenny Agutter for opening the exhibition at Penlee House.

And finally, a thank you to our own Penlee House staff, particularly Katie Herbert, Museum Officer and also Nick Sharp, Tony Claypole, Sandra Paternotte, Ro George, Mimi Connell, Emma Henwood and Julia West – the team who made the exhibition happen.

Penlee House Gallery and Museum is operated by Penzance Town Council with partial funding from Penwith District Council.

Exhibition Sponsored by

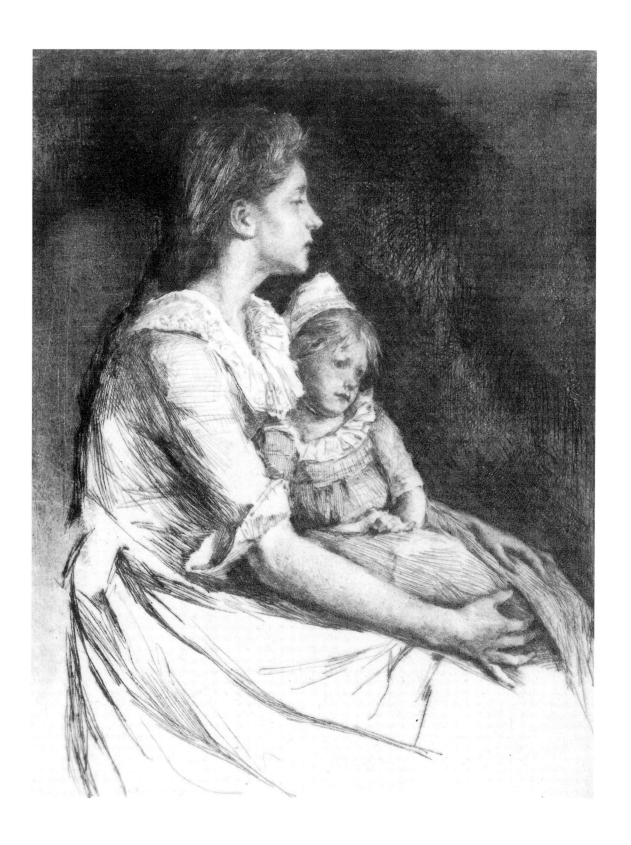

Introduction

Elizabeth Adela Forbes (née Armstrong) has suffered the fate of so many women artists, of being regarded largely as an appendage of her more famous husband, her work a pale reflection of his. A standard reference book, Christopher Wood's *Victorian Painters*, epitomises the prevailing idea of her as 'painter of rustic genre; wife of Stanhope Alexander Forbes... Her style and subjects were similar to those of her husband... she also exhibited flower pieces and a few etchings.'[1] In reality, as the illustrations to this book demonstrate, her work is wide-ranging and has an imaginative, poetic strain running throughout, even when she comes closest to the rustic naturalism of her spouse in the paintings she did in the 1880s. The contrast between them can be clearly seen if one compares *A Zandvoort Fisher Girl* (1884) with Stanhope's *Street in Brittany* (1881) (fig.1). Stanhope's painting is a masterpiece of naturalism, the light falling on each stone carefully transcribed, the figures meticulously studied as if they were still-life objects. Elizabeth's painting is less developed in its naturalism, but it has something else besides: the girl's direct stare forces us to acknowledge her as a human being, the backlighting catches her hair and transfigures her. Instead of the even coverage of all visible details, there is selectivity, with some areas broadly handled and others more precise. The colours are harmoniously arranged, the old tiles in the background picking up the pink of the floor, the blue of the apron and the green of the dish. There is a quality here that contemporaries recognised as poetry, and it was, and is, all too tempting to see Stanhope's work, in comparison, as prose.

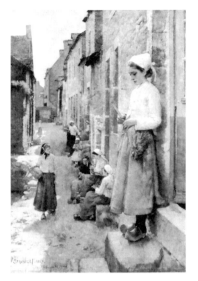

The variety of Elizabeth's work can be seen even in a single project, the illustrations to her book, *King Arthur's Wood* (published in 1904). Amongst the landscapes there are suggestive twilights, originally executed in black, grey and white chalks, broadly handled, subtly indicating space and atmosphere with just a few strokes; or, at the other extreme, she excels in achieving the decorative effect of bright colour and strong outlines in sunny landscapes that are reminiscent of stained glass. In her use of colour she evokes soft harmonies – colours toning and blending in the mellow glow of sunset – or else sharp contrasts. There is a virtuoso display of artistic skill in the plate entitled '*She rose and bent over the sleeping children*' in which large areas of the paper are left untouched in a dazzling suggestion of the effects of candlelight. In the book, as in her work as a whole, she moves easily between the world of contemporary fact and that of the imagination, manipulating her chosen media accordingly. A wide variety of artistic influences are evident, ranging from the twilights of Millet and the costume pieces of the Pre-Raphaelites through to the stylised landscape forms of Art Nouveau and the strong colours and vertical lines of Post-Impressionism.

Along with her interest in colour and in landscape, characteristic features of her work are a sophisticated treatment of light and a love of movement. The backlighting in *A Zandvoort Fisher Girl* is found again in *School is Out* (1889) and *A Game of Old Maid* (1891): she particularly appreciates light filtered through curtains and catching the edges of figures or objects, or candlelight softening and beautifying faces. Her skill in conveying movement was put to good use in her depictions of lively children, an area of art in which contemporaries acknowledged her excellence. The pastel of *The Pied Piper of Hamelin* is a superb example of this: the group of children seem drawn by an irresistible gravitational pull, caught up in one glorious sweep of movement as the piper leads them away from the bright sunlight towards the mysterious darkness of the woods.

When Miss Elizabeth Armstrong first came to Newlyn and met Stanhope Forbes in 1885, she had an artistic background that was remarkably international. Canadian-born, she was conversant with the art scene in New York, Munich, Pont-Aven and London; she was friendly with the most avant-garde artists of the day in London,

James McNeill Whistler and Walter Sickert. Indeed, it may have been partly as a result of the visit made to St. Ives in 1883-4 by Whistler, Sickert and Mortimer Menpes (who gave Elizabeth lessons in etching in Pont-Aven in 1882) that she first came to the south-west of Cornwall. In the 1880s, the question of whether she would be a Newlyn or a St. Ives artist hung in the balance. Although she was in Newlyn in 1885 and 1886, in 1887 she spent an extended period in St. Ives, where the artistic community was much more cosmopolitan than in Newlyn. Artists of all nationalities, including a substantial contingent of Americans, mixed in St. Ives, and the atmosphere seems to have been particularly encouraging for women artists. The American painter Howard Russell Butler wrote home in 1887:

> There are many artists here – lately there has arrived a young lady from Finland – she has a wonderful talent and is a most interesting person altogether, although unfortunately lame – there is also a Russian lady here – neither speak any English, but both are fluent in French. We have in our colony, in addition to the Finn and the Russian, an Austrian, a German, a Norwegian, a Swede, an Irishman, a Scot, a Canadian, four Americans and several Englishmen... [2]

The 'Canadian' was presumably Elizabeth Armstrong; the Finn, Helene Schjerfbeck, and the Swede, Anders Zorn, were later to acquire great reputations in their own countries; and the Austrian was Marianne Stokes (née Preindlsberger), whose work has affinities with Elizabeth's. By this time Elizabeth was engaged to Stanhope, and disagreement over the relative merits of St. Ives and Newlyn put a considerable strain on their courtship. In August 1887, in response to Elizabeth's expressed desire to stay in St. Ives, Stanhope made it clear that he would winter in Newlyn, declaring that 'in my opinion it is more conducive to work to be living amongst a nice pleasant set of men than with a parcel of foreigners with whom I have no sympathy.'[3] Even after this outburst, Elizabeth stayed on in St. Ives at least until January 1888, evidently happy with the company of 'a parcel of foreigners', and also, perhaps, trying to maintain her artistic independence. It is ironic that she herself probably felt more of a foreigner in Newlyn, where most of the artists were British-born, and where single women artists tended not to stay for long,

unless they married male artists.

Another 'foreigner' for whom Stanhope had little sympathy was the American-born Whistler. It is well known that Stanhope disliked Elizabeth's association with Whistler and Sickert, and sought to end it. Whistler was famous for his libel action against John Ruskin in 1879, which left him bankrupt, and for his 'Ten O'Clock Lecture', delivered in 1885. In both these very public events he championed 'art for art's sake' and spoke out against the painstaking imitation of nature and the emphasis on subject. Sickert, too, attacked *plein-air* realism, notably in an essay on Millet and Bastien-Lepage in 1892.[4] Whistler's flamboyant personality, and his outspoken pronouncements, tended to polarise opinion in the mid-1880s between his detractors and his admirers. In this period, Elizabeth seems to have been very much in the Whistler camp, while Stanhope remained a faithful adherent of the naturalism Whistler and Sickert decried. Those who admired Whistler also admired Elizabeth's work. Stanhope wrote to her in 1888 saying he had met a Miss Walker, an artist who riled him because she was an ardent Whistler fan: 'she was of course an ardent admirer of my Liza'. On another occasion he mentions a visit to an exhibition: 'About that little Whistler – honestly it is a pretty little bit of colour and voila tout – You will of course laugh and say that is everything...'[5]

One can imagine Elizabeth arguing with Stanhope that the copying of nature should only be the means to an end, to the achievement of grace, movement, harmony of colours and beauty in effects of light. Her drypoints, which were much acclaimed in the early to mid-1880s, drew inspiration from Whistler's etchings with their spare, elegant effects and their consummate manipulation of technique. Many of her paintings could be described, like Whistler's, as symphonies in colour. *A Minuet* (1892), for example, resists narrative interpretation and cannot be identified with any particular historical period: the dresses are vaguely old-fashioned, apparently chosen for their beauty and for their toning shades, of pale apricot, pink, blue and violet. The beauty of different effects of light and reflection is explored in the candle, the sheen on the polished floor, the mirror, the muslin curtains, the china in the cabinet. The musical subject matter encourages the viewer to think in Whistlerian terms of

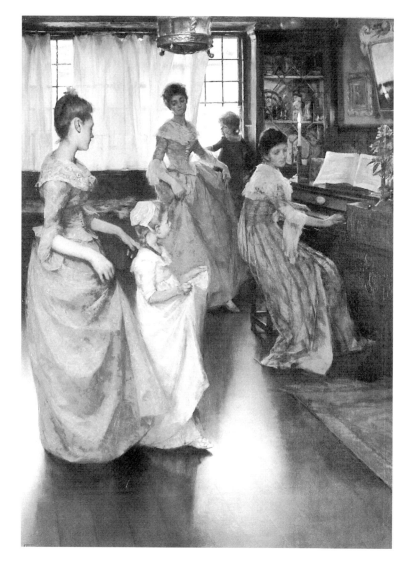

4.179 *A Minuet* 1892
oil on canvas, 88.9 x 120cm
Cornwall County Council/
Mr. A. Bolitho, on loan to
Penlee House

the parallel harmonies of music, light and colour. In her writings, too, Elizabeth shows a strong sensitivity to colour harmonies, as the passages quoted in this book will show. Elizabeth refers obliquely to Whistler in her description of her early life, written for Mrs. Lionel Birch's biography, when she says that in New York 'the fame of the brilliant exponent of "symphonies in white" and "nocturnes in blue and silver" was in the air.'[6] She could have seen Whistler's *Symphony in White No.1: the White Girl* (fig.2) in New York in 1881 and her own painting *A Fairy Story* (1896) sets girls in white dresses against flowers in a similar exploration of colour harmonies.

Although her work of the 1880s drew its subject matter largely

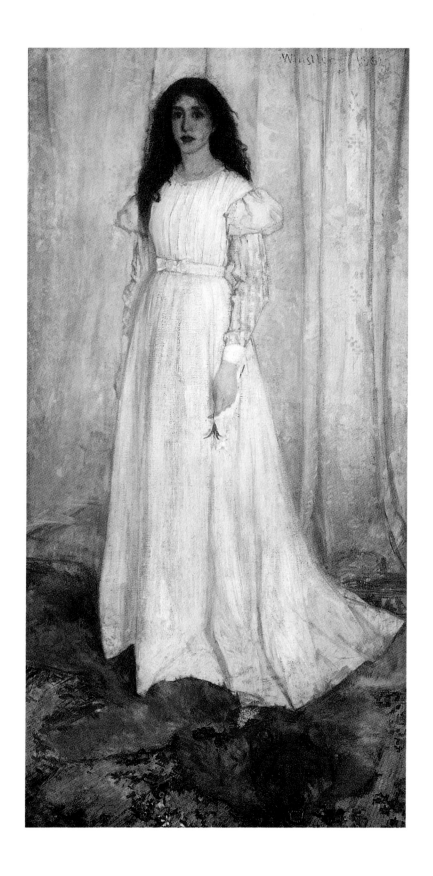

from rustic naturalism, her acknowledgement of early influences indicates that the seeds of her later, more literary paintings were sown in the late 1870s. As a student at South Kensington she pored over Frederic Leighton's illustrations to *Romola*. Then, during her 'three winters' in New York, she studied with William Merritt Chase, one of the founders of American Impressionism whose work had, nevertheless, close links with the aesthetic movement. Chase was a flamboyant character, similar to Whistler in his attitude to dress: he 'affected an elegant white suit, a glittering collection of rings, and a top hat and kept wolfhounds as pets'.[7] He was friendly with Whistler, and the two men went to Belgium and Holland together in August 1885. His studio was renowned for its elegance and its collection of antiques and bric-a-brac, demonstrating his access to a cosmopolitan culture, with objects from the old world alongside those from the new. A painting of this studio (fig.3) dates from exactly the time that Elizabeth was studying with him in New York. It shows a thoroughly 'aesthetic' interior: a woman dressed in old-fashioned costume looks at a portfolio of prints and a selection of old books, while all around her there are colourful tapestries, hangings, antique furniture and artefacts. The painting helps to propagate the idea of the artist as a man of superior sensibility, and it is not clear where the woman fits into this scheme – as a connoisseur, an art student, or perhaps an object of beauty to be savoured alongside the hangings and furniture?

PAGE 18
Fig 2 *Symphony in White, No1:*
The White Girl 1862
James McNeill Whistler
oil on canvas
National Gallery of Art, Washington,
Harris Whittemore Collection

Fig 3 *In the Studio* c1880
William Merritt Chase
oil on canvas
Brooklyn Museum of Art,
Gift of Carll H. de Silver in memory
of her husband

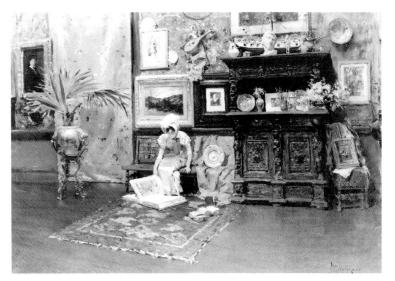

While in New York, too, Elizabeth records that she and her fellow-students heard from Paris of Jules Bastien-Lepage taking the world by storm with his *Jeanne d'Arc*. This was *Jeanne d'Arc Ecoutant les Voix* (fig.4), which was in New York by 1881. Bastien-Lepage was an important influence on the Newlyn School, and inspired a whole generation of painters with paintings of peasant life such as *Les Foins (Hay Harvest)* (1878, Musée du Louvre, Paris) and *The Potato Harvest* (1878, National Gallery of Australia, Melbourne). In this painting, however, he moved beyond his usual sphere to deal, not just with visible facts, but with visions and states of mind.[8] Many of Elizabeth's later paintings of dreamy women, often in mediaeval costume, in woodland settings are reminiscent of this famous work. She examines simple religious faith in drawings such as *Ora Pro Nobis* (1901) and *The Fisher Wife* (1906), and her painting *Jean, Jeanne and Jeannette* (1891) may be a conscious homage to Bastien-Lepage. *Will o' the Wisp* (c.1900), like *Jeanne d'Arc*, shows a woman seeing visions, but this time they are fairies rather than saints.

Elizabeth showed that she was adept at the Bastien-Lepage type of rustic naturalism in works such as *Boy with a Hoe* (1882-3) and

Fig 4 *Jeanne d'Arc ecoutant les Voix*,
1879
Jules Bastien-Lepage
oil on canvas
The Metropolitian Museum of Art,
New York

The Critics (1885-6). She exhibited prolifically in the years between 1883 and 1888: five works at the Royal Academy in 1885, eight at the Society of British Artists in 1885-6, for example (her exhibits at the latter society coincided with Whistler's time as president). Once she was married, she exhibited less and turned increasingly to literary and mediaevalising themes. It is intriguing to speculate whether this was partly an attempt to avoid bringing her work into direct competition with that of her husband, whether her movements became more restricted, or whether the turn away from rustic naturalism was a logical development of her interest in harmony and beauty. As Mrs. Stanhope Forbes, it was presumably more difficult for her to be out in the streets, painting from models in the open air: a classic photograph of Stanhope at work shows him in a Newlyn street, but Elizabeth is shown in her elegant studio (reminiscent of William Merritt Chase's) or else outside her painting hut, safely confined to her own garden.[9] When she first came to Newlyn she worked in a net loft which was 'as unlike a recognised studio as it is possible for anything to be. All kinds of ship lumber were stowed away under cobwebby rafters: it was redolent of pitch and of barked nets; and at intervals it was invaded by the red-bearded "cap'n" and a troop of fisher-lads, jersey-clad and sea-booted, who took possession without ceremony of the dark end of the loft, and proceed to "beat" or mend their nets by the rather dubious light of a ship's lantern, chanting all the time Moody and Sankey hymns or popular ditties'.[10] This is Elizabeth's own description, written for the Birch biography, and one wonders why she felt inclined to stress its picturesque imperfections: was she intending to convey the strength of her early devotion to art or, perhaps, the fate from which marriage to Stanhope Forbes had rescued her?

The difficulties faced by women artists in the late nineteenth century are well known: unable to participate fully in artistic training, especially when this involved drawing from nude models, they were also restricted in their movements. Elizabeth was able to travel widely in her youth, but she needed to be chaperoned by her mother, Frances, a shadowy figure about whom very little is known.[11] Once married, a woman's name – such an important part of artistic identity – was subsumed in that of her husband. Elizabeth

always exhibited as 'Mrs. Elizabeth Stanhope Forbes' after 1889, and her monogram changes from 'EA' (as on *School is Out*) to 'EAF' (as on *Jean, Jeanne and Jeannette*) and then, around 1893 or 94, to 'EAFORBES' (*At the Edge of the Wood* being an early example) as if her married state has gradually encroached further on her sense of identity. It is clear that Stanhope encouraged her to work, and was proud of her artistic abilities, but there is often, in the contemporary sources, a suggestion that she was capable of upstaging him. Articles written on Elizabeth in the 1890s and early 1900s are at pains to stress that she had a high reputation before her marriage, and that her art had special qualities, very different from those displayed in her husband's work. Norman Garstin, a fellow Newlyn painter, wrote in an article published in 1901 that 'Mr. Forbes is essentially of the nineteenth century: he is penetrated with the actuality of life, he sees no visions, and he dreams no dreams.' Of Elizabeth, however, he declares: 'as an artist she stands shoulder to shoulder with the very best; she has taste and fancy, without which she could not be an artist...The work which that wonderful left hand of hers finds to do, it does with a certainty that makes other work look tentative beside hers.'[12] Here, as in other sources, there is a suggestion of a somewhat prosaic male artist with a brilliant wife. Incidentally, the article also reveals the fact that Elizabeth was left-handed.

Elizabeth herself seems to have been acutely aware of the problems faced by the woman artist – and, indeed, by women in general. Her family background is mysterious. Various sources tell us that her father was William Armstrong, a Canadian civil servant, but she herself, in the account of her early life she contributed to the Birch biography, does not give his name or occupation.[13] This is the more surprising since the same book gives a very full account of Stanhope's family background. Elizabeth mentions older brothers but their names are not specified, nor is there any reference to them in any other known source. She describes an unsettled life in Canada, often with no garden and few possessions, but it is difficult to see why the life of a civil servant should necessarily involve these privations. However, it is clear that there was enough money to contemplate sending her and her mother to England for Elizabeth's education. Her uncle, Dr. Thomas Hawksley (1821-1892), with whom she and her mother stayed when

4.140 *Homewards*
oil on canvas, 30.5 x 35.6cm
image courtesy of David Messum
Fine Art

they came to London, was evidently very well off. His National School
of Handicrafts for Destitute Boys, which opened in 1886 at Chertsey,
was endowed by Hawksley at a cost of £25,000 – an enormous sum of
money for the time.[14] It seems that Elizabeth and her mother were
rootless wanderers, dependent on the generosity of a rich relative, as
so many women were when they lacked fathers, husbands or
professions. Marriage to Stanhope provided a home, not just for
Elizabeth but also for her mother, who seems to have lived with the
couple, at least in the early years of their marriage.

Thomas Hawksley had progressive ideas: he published a number
of pamphlets on charity and education, including one in 1869 which
advocated a compulsory system of education to cover the years from
6 to 14. He argued that 'the fruitful and most frequent cause of want
and misery is the deficiency of education and training' and in
particular that 'the education and training of the children of the
poor is lamentably defective'.[15] The Education Act of 1870 initiated
a more modern educational system, the fruits of which were depicted
by Elizabeth Forbes in one of her best-loved paintings, *School is Out*
(1889), which also, significantly, shows a woman pursuing a
professional career as a schoolmistress. The little girl, Noel, in *King
Arthur's Wood*, is also destined to be a village schoolmistress.
Although Elizabeth's public pronouncements tend to avoid
controversial issues, there are scattered hints that she had well-
defined views about the emancipation of women. She described
Munich, where she studied for five months in 1881 or 1882 as 'not at
all a place in which women stood any chance of developing their

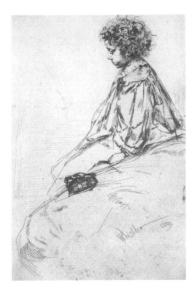

Fig 5 *Bibi Lalouette* 1859
James McNeill Whistler
etching and drypoint
National Gallery of Art, Washington,
Rosenwald Collection

artistic powers', and in 1897 she is one of the 76 women artists listed as supporters of women's suffrage.[16] In *Who's Who* she gives her recreation as 'bicycling', an occupation which more conservative social observers would have seen at the time as unladylike. (In 1898 she and Stanhope cycled together in the Pyrenees.)

The art school at Newlyn, set up by Stanhope and Elizabeth in partnership, provided an opportunity for young women to study art in an environment that was relatively free from the exploitative master-pupil relationships that existed in the urban academies. All too often female students were treated as decorative accessories and expected to adopt an attitude of hero-worship towards their male masters. Even William Merritt Chase's studio had its shortcomings in this respect: he has recently been described as 'a sultan of art, his earnest but trivial girl students his metaphorical harem'; an article published in 1895 described how 'there was an added charm bestowed upon the handsome room by the presence of a class of young women, on studious thoughts intent, sitting before their easels and playing with the mysteries of art.'[17] In the Forbes school, by contrast, Elizabeth herself provided a strong role model for the younger women: her character comes across vividly in the reminiscences of 'Fryn' cited in this book. In the next generation of Newlyn artistic marriages, it seems to have been easier for the women to follow their own careers. Two notable examples of this are Dod Procter, who was one of the students at the school, and Laura Knight, who came to Newlyn in 1907.[18] Laura Knight's early work is particularly close to Elizabeth's, with the lively children in her well-known painting, *The Beach* (1908, Laing Art Gallery, Newcastle-on-Tyne), surely indicating her knowledge of paintings such as *School is Out*.

Elizabeth's experimentation with different media – drypoint, pastel, charcoal, watercolour as well as oil – is another feature that sets her apart from most of the Newlyn artists, and underlines her links with Whistler and the aesthetic movement. It was traditional for women artists to use these media, suitable for delicate effects and for work on a small scale, rather than the oil paint that was more messy and threatening to fine clothes, but also represented the road to reputation and Establishment success, particularly at the Royal

Academy. However, the late nineteenth century was a time of widespread experiment in pastel techniques, which attracted avant-garde artists such as Edgar Degas and Odilon Redon. Chase and Whistler both worked in pastel – the latter held a one-man exhibition of pastels of Venice at the Fine Art Society in 1881 – and Whistler had experimented extensively with etching in the late 1850s and 1860s (fig.5). Elizabeth's preference for drypoint, in which the needle is used on an unprepared surface, meant that only a few impressions could be produced from each plate. In drypoint etching a copper ridge or 'burr' is forced up on either side of the needle as it pushes through the copper; Whistler described the technique:

> The tiny thread of metal ploughed out of the line by the point as
> it runs along, clings to its edge through its whole length and, in
> the printing, holds the ink in a clogged manner, and produces, in
> the proof, a soft velvety effect most painter-like and beautiful –
> and precious too, for this raised edge soon falls off the plate, from
> the continual wiping in printing – so that early proofs only have
> the velvety line and are also, because of its presence, valued ...[19]

Elizabeth's drypoints, like Whistler's, are experimental and exquisite, objects for connoisseurs. Stanhope, who did not practise etching himself, seems to have wanted to discourage her from a medium which brought her into the orbit of Whistler; but he gave a full set of her drypoints to the Victoria and Albert Museum in 1922. They were the subject of an article in *The Print Collectors Quarterly* in that year which described them as 'drypoints of such consummate delicacy and sensitiveness, yet of so much beauty, that they are in a class apart, in no way to be identified with the work of any other artist'.[20]

 Many of the characteristics of Elizabeth Forbes's work are now seen as typically 'feminine', yet they were qualities which appealed to many of the best male artists of her time.[21] An example of this is her focus on the painting of children and the illustration of fairy tales, most notably in her wonderful book, *King Arthur's Wood*, published in 1904. Yet this was the age of Edmund Dulac and Arthur Rackham, and of the gift book – sumptuously illustrated books, ostensibly for children, which drew on the latest technology, Hentschel's colourtype process, to produce volumes which had great appeal to art lovers and

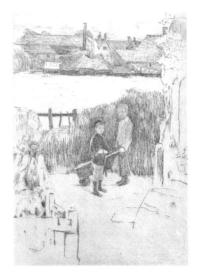

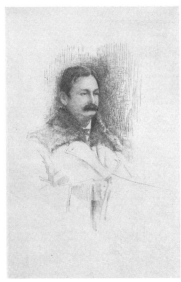

TOP
5.32 *Boys with a Barrow*
drypoint etching, 14.6 x 10.1cm
Penlee House Gallery and Museum

5.24 *Dr. Faustus*
drypoint etching, 29.8 x 19.7cm
Penlee House Gallery and Museum

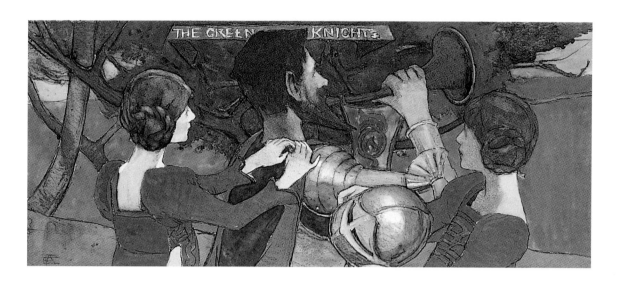

2.26 *The Green Knight*
watercolour, 17.5 x 42cm
Private Collection

collectors. Rackham's illustrations to *Rip van Winkle* date from 1905, Dulac's to *Stories from the Arabian Nights* from 1907. Both artists were sponsored by Messrs Ernest Brown and Phillips, of the Leicester Galleries, where the original watercolours for the books were exhibited – as Elizabeth's were too.[22] As for the emphasis on fantasy and on children in her work, this was an interest she shared with other artists of the time, notably her Newlyn colleague Thomas Cooper Gotch. A large number of British artists were experimenting with symbolist and Pre-Raphaelite styles in the 1890s, a tendency explored by an exhibition held at the Barbican Art Gallery in 1989 entitled *The Last Romantics*, in which several works by Elizabeth Forbes were included.[23] In this respect, as in so many others, she was in the vanguard of the art movements of her time.

In the literature on the Newlyn School, Elizabeth's work has not been fully studied, perhaps because so much of it does not fit the Newlyn stereotype (here again, the work of Gotch presents a significant parallel). In the two important exhibitions held in 1979 and 1985, none of her mediaevalising or literary work was shown. In 1979, in the exhibition *Artists of the Newlyn School 1880-1900*, she was represented by nine oils, nine etchings and two watercolours, but nothing later than 1894 was shown. In the 1985 exhibition, *Painting in Newlyn 1880-1930*, there were only six oils and no etchings, and nothing later than 1892. Yet the Stanhope Forbes section increased in size from fifteen to nineteen oils, and the scope of the exhibition,

extending to 1930, should have included the whole of Elizabeth's working life. Once again, the emphasis was strongly on her rustic naturalist pictures, with *A Minuet* (1892) the only exception to this rule. In *Stanhope Forbes and the Newlyn School*, 1993, Caroline Fox devotes a whole chapter to Elizabeth, and refers to the costume pieces in the text, though she does not illustrate any of them.[24] In the same year, 1993, Deborah Cherry published *Painting Women: Victorian Women Artists*, which includes an important discussion of Elizabeth under the heading 'Sea-changes at Newlyn', setting her work within the context of the male-dominated artists' colony at Newlyn, although this text, too, ignores the literary paintings.[25]

It is to be hoped that the present book, and the exhibition it complements, will help to give a more rounded view of Elizabeth Forbes, as an artist who is of interest in her own right, responding to the artistic movements of her day and possessed of a talent which drew much praise in her lifetime. Both as a woman and as an artist, she is an enigmatic, appealing personality, her life as poetic as her art, her story a moving and ultimately a sad one. Stanhope Forbes summed up her work in an address to the Penzance library in 1935: 'those charming and beautiful pictures which combine such lovely imaginative qualities with almost unrivalled technical skill and artistic feeling'.[26] The charm, the imagination, the beauty in her best work could be characterised as 'feminine', but to artists of her and Whistler's generation they were the qualities that distinguished the true artistic temperament from that of a mere copier of nature, that enabled art to soar above the limitations of naturalism; in Norman Garstin's words, they were 'taste and fancy, without which she could not be an artist'.

2.34 *And Then Came Riding Sir Gareth*
watercolour, 30.5 x 42.5cm
Private Collection

Christiana Payne

Notes

1 C. Wood, *Dictionary of British Art Volume IV: Victorian Painters. I. The Text,* Antique Collectors Club, 1996, Woodbridge, p.175.

2 Michael Jacobs, *The Good and Simple Life: Artist Colonies in Europe and America,* Phaidon Press, Oxford, 1985, p.159.

3 Letter to Elizabeth from Penmaenmawr, North Wales, where he was on holiday with his parents. Dated August 21, 1887. Box 9015, Stanhope Forbes archive, Tate Gallery, London.

4 Walter Sickert, 'Modern Realism in Painting', in A. Theuriet (ed.), *Jules Bastien-Lepage and his Art,* 1892, pp.133-43.

5 Box 9015, Stanhope Forbes archive, Tate Gallery, London: letters dated April 2, 1888 and December 20, 1887.

6 Mrs. Lionel Birch, *Stanhope A. Forbes, A.R.A. and Elizabeth Stanhope Forbes, A.R.W.S,* Cassell & Co, London, 1906.

7 H. Barbara Weinberg et al, *American Impressionism and Realism: the Painting of Modern Life, 1885-1915,* Metropolitan Museum of Art, New York, 1994, p.35.

8 For Bastien-Lepage, see Marie-Madelein Aubrun, *Jules Bastien-Lepage 1848-1884, Catalogue Raisonné de l'Oeuvre,* 1985.

9 The photographs of Elizabeth's studio and painting hut were published in E.B.S., 'The Paintings and Etchings of Elizabeth Stanhope Forbes', *The Studio,* Vol 4 no 24, March 15, 1895, p.187.

10 Mrs. Lionel Birch, op. cit., p.33.

11 On women artists in this period, see Pamela Gerrish Nunn, *Victorian Women Artists,* Women's Press Ltd., London, 1987; and Deborah Cherry, *Painting Women: Victorian Women Artists,* Routledge, London and New York, 1993. The only source that gives Mrs. Armstrong's first name, as far as I am aware (apart from her tombstone in Sancreed churchyard), is the census, which shows that on April 5,1891 she was living at Cliff Castle. Iris M. Green, *Artists at Home: Newlyn 1870-1900,* 1995, p.7. From the tombstone on the

grave she shares with Elizabeth, Stanhope and Stanhope's second wife, we know that Frances was born on May 27, 1816 and died on November 8, 1897. The trip to the Low Pyrenees in the spring of 1898, which was something of a watershed in the careers of both Stanhope and Elizabeth, took place a few months after her death, at a time when Elizabeth might well have felt the need to take stock of her life.

12 N.Garstin, 'The Work of Stanhope Forbes, A.R.A.', *The Studio*, July 15, 1901, vol 23 no 100, p.82, p.88.

13 In *Who Was Who*, 1915, she is described as the daughter of William Armstrong, Civil Service, Ottawa.

14 On Hawksley, see Frederic Boase, *Modern English Biography*, Frank Cass & Co Ltd, 1965, Vol V.

15 [Thomas Hawksley, M.D.], *Education and training considered as a subject for state legislation; with suggestions for making a compulsory law efficient and acceptable, by a physician*, John Churchill & Sons, 1869, London, p.26.

16 *The Queen*, October 18, 1890, p.576; D.Cherry, op. cit., p.93.

17 Sarah Burns, *Inventing the Modern Artist: Art and Culture in Gilded Age America*, Yale University Press, 1996, p.168; and, cited by the same author, Clarence Cook, 'Studio – Suggestions for Decorations', *Quarterly Illustrator* 4 (1895), p.235-6.

18 For Dod Procter and Laura Knight, see Laing Art Gallery, Newcastle-upon-Tyne, *Dod Procter R.A. 1892-1972*, 1990, and C.Fox, *Dame Laura Knight*, Oxford 1988.

19 Katharine A. Lochnan, *The Etchings of James McNeill Whistler*, Yale University Press, 1984, p.101.

20 Arthur K. Sabin, 'The Dry-Points of Elizabeth Adela Forbes, formerly E.A.Armstrong (1859-1912)', *Print Collectors Quarterly*, February 1922, vol 9 pt 1, p.76. In this article, Mortimer Menpes was cited as the artist who taught Elizabeth to etch in Pont-Aven, and who still held many of her early plates.

21 For example, Caroline Fox writes: 'her very feminine sensitivity and lightness of touch contrasts with her husband's more solid approach'. C.Fox, *Stanhope Forbes and the Newlyn School*, David and Charles, Newton Abbot, 1993, p.43.

22 D.Hudson, *Arthur Rackham: his Life and Work*, William Heinemann Ltd, London, 1960, p.57; C. White, *Edmund Dulac*, Studio Vista, London, 1976, p.23.

23 John Christian et al, *The Last Romantics: the Romantic Tradition in British Art, Burne-Jones to Stanley Spencer*, Lund Humphries in association with the Barbican Art Gallery, 1989.

24 C.Fox, op. cit.

25 D.Cherry, op. cit., pp.183-6.

26 Address given to Penzance Library by Stanhope Forbes, January 26, 1935.

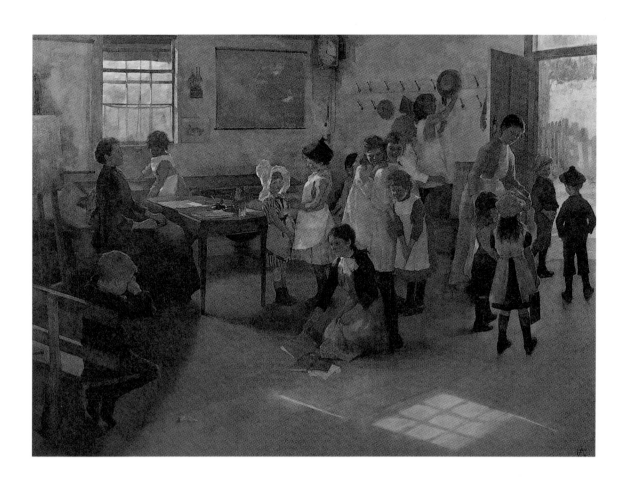

Early Days

We owe almost all that we know of Elizabeth's early life to the autobiographical sketch she contributed to Mrs. Lionel Birch's book on Elizabeth and Stanhope Forbes[1]. Elizabeth's writing is in a chatty and anecdotal style which often gives the impression that everything is for the best of all possible worlds. Rarely are we allowed to glimpse the real person underneath, to see her lonely childhood and the very real difficulties she experienced in following her career.

She begins her childhood reminiscences by saying that she finds it puzzling that anyone should find her life of much interest. 'As I look back through the years, for the most part very happy ones, I feel that the only noteworthy milestones are the memories of kindly faces and sympathetic, outstretched hands. Along the road I have travelled, I know that I owe to them all that has fallen to my share of success and joy. For my own personal pleasure I shall love for a little while to look back, and revive old interests and friendships in memory. But if, in setting down the things which seem to have influenced me most in my artistic development, I prove tiresome to you and still more to your public – well, you have brought it on yourself, and so I must plead for forgiveness.'

She was born Elizabeth Adela Armstrong in the province of Ontario on December 29, 1859[2]. Her father, William Armstrong, was a Canadian civil servant. She was the only daughter and much the youngest in the family, arriving after her brothers had virtually grown up:

I was a lonely little child. My big brothers, whom I adored, went off early about their business in the world, and I was left to find

PAGE 30
4.224 *School Is Out* 1889
oil on canvas, 105.4 x 118.7cm
Penlee House Gallery and Museum

my own interests and pleasures. When I was thrown with other children, I suffered agonies of shyness, and always tried to creep away and curl up in a corner, if possible with a book. For which, of course, I was laughed at, and thought myself disliked. But I can never remember the time when I did not get a passionate pleasure out of what seemed to me beautiful, and little memories, such as of a spray of honeysuckle, and the pencilled-cast shadow of it against the old grey wooden house where I was born, seem clear and strong to me still. But I had not always a garden...

The reason for this lack of a garden was that William Armstrong's career appears to have demanded constant travelling with the consequent upheaval and loss of a settled home. This, she said, brought about 'an almost Spartan simplicity of surroundings. We lived in our trunks: there was no time to accumulate pretty things, and few books came in my way which could afford much food for my imagination.' The effect of this 'mind-hunger' was to make her cherish any random scraps of poetry she could find, the attraction being the rhythm of the words rather than their content.

I suppose the painter instinct must have awakened soon, for I can recall still how the very names of the great men, whose work I should not have understood had I seen it, used to make my pulses beat. I used to sit doubled up for hours, staring into vacancy, like a fakir, while fancies and sensations bubbled inside me, till the mocking voice of some older member of the household brought me back to the existing world and I would spring up covered in confusion.

In retrospect, the artist's eye literally colours these early memories:

I think the clearest impression which I have left of those early Canadian days is of the glory of the marvellous mantle of snow, which each succeeding winter throws impartially over the fair country and the rawness and unloveliness of the new towns: so much that is ugly is hidden away; so many angles softened; so purely dazzling when the sun is high with the delicate tracery of every leafless twig drawn in clearest cobalt shadow on its marble immobility, flushing to rose-leaf colour under the sunsets, and loveliest of all – beneath the twinkling frosty stars. I used to

PAGE 32
5.3 Portrait of the Artist
drypoint etching, 10.1 x 7.6cm
Penlee House Gallery and Museum

4.185 *Museum Interior*
oil on panel, 13.7 x 8cm
Private Collection

scrape the frost flowers off a window-pane and stand watching, lost in the wonder of it all, till I was carried off to bed.

She adored her father who, she thought later, must have understood her better than she realised for, 'after the manner of all sensitive children, I was dumb about all my dreams and fancies; but I was his Benjamin, the child of his old age, still a baby when his sons were growing up and passing out into the world.' One of her greatest pleasures was to be allowed to meet him at the end of the afternoon and walk with him round the wooded hill on which stand, admirably placed, the government buildings of Ottawa and, most particularly, to visit the 'great Chaudière Fall, the boiling cauldron of the French voyageurs, bubbling and churning its white froth forever.'

William Armstrong was determined that his little daughter should be encouraged to study and develop her talents and, to this end, employed a French emigré, an old abbé with some Beaux Arts training, to give her drawing lessons. She does not say how old she was when her father decided that she should go to school in England but it seems likely that she was in her early teens. Her mother was to accompany her as chaperone and they were to live with an uncle, Dr. Thomas Hawksley, in his large house on the Chelsea Embankment, next door to Rossetti.

Her father travelled to Quebec with his wife and daughter and saw them safely aboard their ship. 'We called goodbye to him from the vessel's side as he was rowed ashore, a tall man, standing erect, with thick curly grey hair and very blue clear eyes. It was my last sight of my father, for two months afterwards a black sealed letter came to us in England. He had been stricken down suddenly, in full health, by a mortal stroke.'

Devastated as they were by William Armstrong's death, there was little to be gained by returning permanently to Canada, not least because he had particularly wanted his daughter to study painting and drawing in London. Elizabeth's life in her uncle's tall, old-fashioned riverside house remained a solitary one though richer, she writes, 'in artistic influences'. Eager to carry out her husband's wishes, Mrs. Armstrong entered her daughter as a student at the South Kensington Art Schools at what Elizabeth later considered to have been too young an age:

It was almost a pity I was set so soon to follow the school routine; most of my companions were beyond me in age and development. But the Museum was a treasure house of inexhaustible delight and although my artistic taste has passed through many phases since those days, I find that many things which drew me most strongly then are potent to move me still – the beautiful fragment attributed to Buonarotti, the Madonna of the downcast lids that seem to quiver, so soft and living and warm is the marble face; and the terracotta copies of the calm prelates who sleep with folded hands on their tombs in the room of the Italian Renaissance.

Life in Chelsea also opened up to her the world of literature. She read her first novel, George Eliot's *Romola*, an ancient copy of which she found in the corner of the attic of the Chelsea house, tied up with other books and old copies of the *Cornhill Magazine* in dusty bundles. Not only was she gripped by *Romola* but enchanted by its illustrations that were by the popular Victorian artist, Frederic Leighton.

'I shall never forget the hours spent prone on the wooden floor under that baking roof! But my heart was aflame with the realisation of Romola, the "strong white lily", beautiful false Tito, and poor

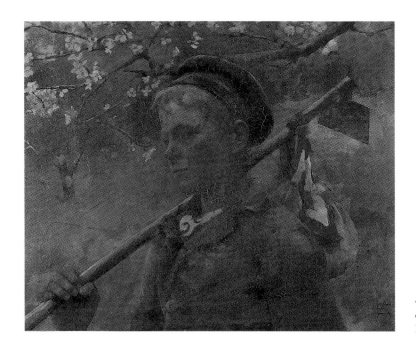

4.36 *Boy with a Hoe*
oil on canvas, 48.3 x 58.4cm
Private Collection

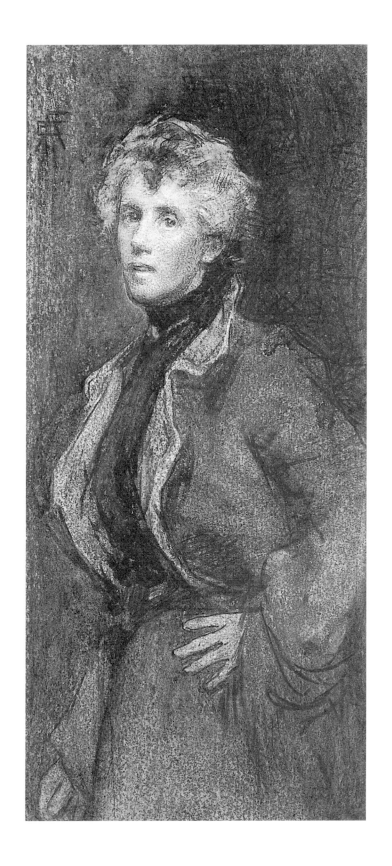

little Tessa; and the murmur of old Florence was far louder in my ears than the noises in the Chelsea streets.' Further investigation yielded more treasures, an almost complete set of the works of Ruskin 'in which I waded neck-deep', before she was 'whirled breathless through all the great Carlyle series'.

Years later she recalled stopping outside a stationer's shop which she passed each day on her way to the Art School where, among many engravings and photographs of celebrities who had patronised it, was one of Carlyle, 'the Clothes Philosopher'. Fresh from the pages of his *French Revolution*, she stared hard at his portrait, then remarked to her mother, in a tone of intense longing, 'Oh, mother, I'd give anything to see Carlyle!' As she spoke she looked up and saw, close behind her 'the shaggy head, and the same deep-set melancholy eyes, which were looking down into mine with such a queer, kind, droll expression as though they would say, "you little atom of humanity, what do you want with Thomas Carlyle?" I do not know if he would have spoken. I only know that I turned crimson to the ears and fled down the street, leaving my mother bewildered.'

She continued studying, encouraged now by Dr. Hawksley who was comfortably off and a generous benefactor to many. 'I was never happier than when I could escape in the summer evenings to the flat leaded roof of our house among the chimney pots, to watch the sunset colours fade from the sky and the river.' She was particularly intrigued by Rossetti's house. 'But the poet-painter lived in it no longer. He lay dying elsewhere at this time, I think. What was behind the closed shutters I never knew; but the old paved courtyard was fascinating to look down upon. The house was said to have been built for Nell Gwynne and the monogram of Royal Charles is in wrought-iron over the gate.'[3]

After several years in Chelsea – she does not say how many – family matters made it necessary for her mother to return to Canada and Elizabeth accompanied her. 'I went with her, and for almost the first time in my life, found a chance to participate in the gaieties natural to a young girl.'

PAGE 36
6.21 *Elizabeth Stanhope Forbes, A.R.W.S 'By Herself'*
charcoal, 35 x 16cm
Private Collection

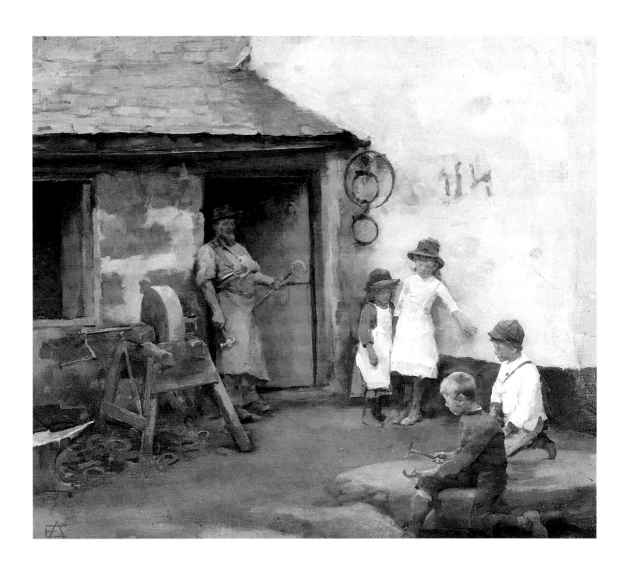

Apprenticeship

The return to North America not only opened out Elizabeth's social life, but also set her firmly on the path to becoming a serious artist. In retrospect she saw the summer of her return as an idyll: 'To say I enjoyed all the pleasure of long summer days among the islands of the great river would be to put it mildly. Devotion to a life of art seemed very far away, and had it not been that an invitation to spend a few weeks in the United States took my mother and me to New York, my life might have drifted into quite different channels.'

For it was in New York that her friends introduced her to the Art Students' League, a group of youthful enthusiasts taught by artists who had studied in Europe but who were not much older than their pupils. Here, for the first time, Elizabeth learned of the new enthusiasm for painting *en plein air*. It is hard to imagine now what a revolution this actually was. For centuries artists had either made sketches or small watercolours of landscapes and then returned to their studios to develop them into larger works in oil, or had painted such scenes from memory. Now painters were setting up their easels along the small fishing harbours or in the village streets of northern France and painting exactly what they saw in front of them.

Elizabeth found the atmosphere of the League congenial, 'the comradeship so warm, that I ever look back to the three winters spent in the American city as among the dearest part of my memories.' Spurred on by the enthusiasm of the young painter-teachers and 'brimming over with enthusiasm', she applied herself, at the early age of about 18 years, with a will.

'The long discussions on "Art" with a big "A" would sound

PAGE 38
4.93 *The Forge* c.1885-6
oil on panel, 25.4 x 30.5cm
image courtesy of David Messum
Fine Art

quaintly pathetic now, if one could hear them reproduced on a phonograph,' she was to recollect years later.

> We used to keep them going on winter evenings in the classroom till the cast of the *Running Faun* glimmered ghostly in the twilight, and the irate caretaker came to turn us out! A good deal of good-natured chaff and criticism used to fall to the share of the 'English girl', as they chose to consider me. Here, where the fame of the brilliant exponent of 'symphonies in white' and 'nocturnes in blue and silver' was in the air, a raw disciple, fed on *Modern Painters*, had short shrift. And not so very long before, William Hunt had come back, preaching the gospel of the Romanticists: half of us were on our knees before Jean Francois Millet; and then from Paris came the news that Bastien-Lepage had taken the world by storm with his *Jeanne d'Arc*. It was a glorious time and we had plenty to argue about, until at last a handful of us turned restless and left our happy Alma Mater behind to try our luck in that Europe which was calling to us so loudly.[1]

It says a good deal for Elizabeth's mother that she was prepared to devote herself over the next few years to supporting her daughter's ambition to become an artist. This required not only constant financial support but the considerable amount of travelling and disruption needed to chaperone her daughter, since it would have been unthinkable for a young and 'decent' woman to live alone among male art students in the 1870s and 1880s.

Elizabeth had been greatly influenced in New York by the artist William Chase who had extolled the virtues of Munich as a place to study rather than Paris to which she had been naturally drawn. He was, she said, the most inspiring and enthusiastic teacher it had ever been her good fortune to meet. She was also influenced by other art students who had earlier studied in Bavaria. Chase made every effort to persuade her, therefore, to go to Germany and so it was that at the end of her three years' study in New York, accompanied by her mother, she set off enthusiastically for Munich.

It was not to prove a good decision. 'Unwisely,' she wrote, 'I chose Munich as my Mecca in preference to Paris.' She was to find herself doubly isolated. First, the attitude of the Bavarian art establishment

to American students had changed radically since Chase had studied in Munich. In those early days, American students had been considered 'alien and exotic', had been treated with courtesy and hospitality and welcomed into the close artistic world. It was not surprising that they then returned to the States full of energy and new ideas. But now the novelty had worn off and Americans were treated at best with indifference, at worst with hostility.

'Of the Americans,' Elizabeth wrote, 'only Frank Currier remained, a good deal of a recluse, in his little village of Schleissheim.' She recalled a delightful visit to him, where he worked in a room stacked with canvasses and littered with drawings, his style 'for the most part instinct with a nervous and passionate appreciation of the glory of the sunsets over low-lying fields, and the noble woodland studies, where the interlacing of boughs of wind-blown trees were drawn with a tense and masterly energy.'

His masterly use of charcoal in his landscape work was to have a lasting influence on Elizabeth, teaching her what a wide range 'from velvety blackness to the pearliest of greys, from firm and strenuous line to faint tones like breath on paper – lie within the possibilities of that most docile of mediums.'

Elizabeth's second disadvantage was that as well as being an unwelcome American student in a new German artistic climate, she was further isolated by being a woman. She was totally unprepared for the prejudice she was to encounter continually during her stay in Munich. 'In the recognised art training of the Munich schools, I found my sex to be a perpetual disadvantage.' She found it impossible to be taken seriously. It might be considered an accomplishment for a young and marriageable woman to be able to produce some pretty little sketches, but that a woman should seriously consider becoming a professional artist was almost unthinkable. In spite of this she was determined to persevere and it says much for her tenacity that she stuck it out for five unhappy months, working as hard as she could, until driven away, discouraged and deeply depressed. To cap it all, she had found neither the teaching in Munich nor the work being produced particularly inspiring.

What should she do next? She felt guilty that her devoted mother had sacrificed her own social life in Canada to accompany her to

5.20 *Mother and Child*
drypoint etching, 15.2 x 9.1cm
Private Collection

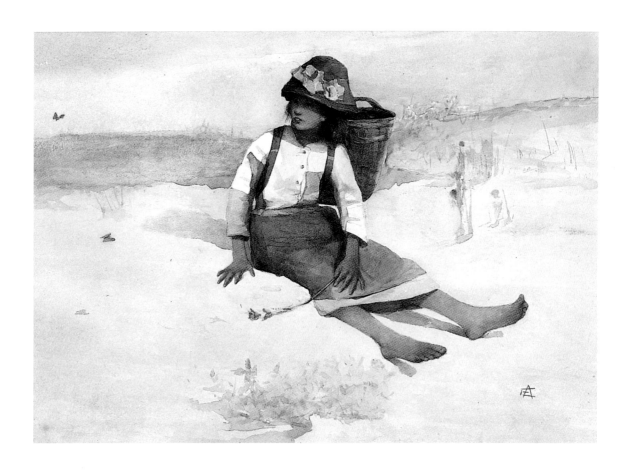

4.99 *Girl with a Basket*
watercolour, 26.5 x 39cm
Private Collection

Europe, but she also felt driven to salvage as much as possible from
what had so far proved an expensive and depressing experiment.
From time to time during her sojourn in Munich, she had received
enthusiastic letters from old Art League friends from which she had
learned of the growing importance of the tiny town of Pont-Aven in
the Finisterre area of Brittany, which had become a centre for the
enthusiasts of the *plein air* school of painting. After what appears to
have been a good deal of discussion, she finally persuaded her
long-suffering mother to let her try her luck in France; so the two
women then packed their bags and set off for Pont-Aven.

Elizabeth describes Brittany in 1882 as an 'outlying and primitive
land'. It certainly was then and indeed, to some extent, still retains
its own very definite and separate identity from the rest of France.
When Elizabeth lived in Pont-Aven, Brittany was not only cut off
from the rest of the country by poor communication and bad roads
but also by its history. For centuries it had been a separate entity, a

country within a country, with its own language, closely akin to Welsh and even more to the old Cornish tongue, a place of strange stone circles and massive rows of menhirs, where the inhabitants were deeply suspicious of rule from Paris. The women still wore exotic peasant dress and strange, often bizarre, lace 'coifs' on their heads proclaiming which part of Brittany they came from.

To the Bretons, the history of a century earlier was still raw. In 1789 the Bretons had backed the French Revolution with some enthusiasm but when the new government ordered that there should be only one language throughout France, the Bretons turned against it to a man. The use of their own language, to them an integral part of their life, had been promised to them in perpetuity from mediaeval times when Brittany's Duchess Anne had become Queen of France.

The result of the government's attempt to bring Brittany into line with the rest of the country was total hostility, resulting in 1793 in what was to become known as the 'Chouan Uprising' (The Chouannerie, the Breton resistance, took their name from the Breton word for the owl, the night-hunter). The British government of the day, seeing an opportunity to attack the French Revolutionary government, encouraged a band of some 5,000 French emigrés, who had been camped out in England, to land in Brittany and join the Chouans. The insane British choice was to land the rebel emigrés at the extreme tip of the Quiberon peninsula, a spit of land some eleven kilometres long

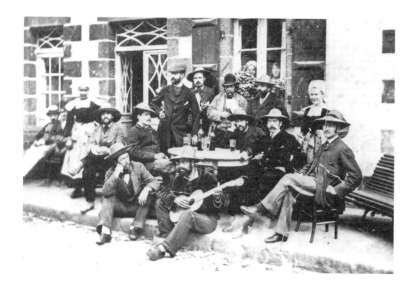

Artists and locals, Pension Gloanec, Pont-Aven, c.1880

and less than half a kilometre across at its widest part.

The result was inevitable. General Hoche, who had based a substantial force at the old fort of Penthièvre, half way up the peninsula, lay low and allowed the landing to take place and the returning emigrés to be met by the Chouans. The rebels literally walked into the arms of Hoche's troops and were slaughtered in their thousands. Some 6,200 were taken prisoner and many were shot 'pour encourager les autres' in the towns and villages of Brittany. There was no back-up from the British in the way of arms or assistance; indeed most of the ships which brought the emigrés to Brittany were beating it back home. Not surprisingly the aftermath of the 'Dèsastre de Quiberon' as it was known in Brittany, had resulted in continuing hostility towards both Paris and England, who the Bretons felt had betrayed them. They had retreated into themselves, deriving a hard living from the thin soil and the treacherous coastal waters, a far cry from today's small holiday resorts and yacht marinas.

Tourists had hitherto been few, but it appears that the arrival of strangely-dressed young men, clutching easels and spending generously in the pensions and bars of Pont-Aven, was soon greeted at the very least with tolerance. Today the town suffers from the fate that has also overtaken St. Ives in Cornwall. When the artists first discovered it, Pont-Aven was a busy fishing port, a few kilometres from the coast, with narrow quays, quaint cottages and a series of picturesque water mills beside a swiftly-flowing river. Now the water mills have become bistros and restaurants, the quaint cottages gîtes and second-homes, joined by a sprawl of new housing and hotels. The streets are lined with artists' ateliers and shops selling Breton souvenirs and by lunchtime in the holiday season it is almost impossible to get into the town by road.

It is all a far cry from Pont-Aven as it was when Elizabeth and her weary mother finally arrived and booked into the single hotel, the Hotel des Voyageurs. This still exists, much enlarged, its name changed to the Hotel Ajonc d'Or – the Hotel of the Golden Gorse. After the cold atmosphere of Munich, however, Elizabeth was totally charmed by the society that greeted her in that 'outlying and primitive' land. Old sepia photographs in the town's art gallery today

show serried ranks of painters all of whom are classified as 'American'. It seems that 'American' was used as an adjective to describe virtually all the English-speaking students.

Elizabeth described the crowd that gathered around the long table d'hote of an evening at the hotel as both notable and cosmopolitan and 'from many lands'. Some of the men, she notes, had already made their mark either at the Paris Salon or the English Royal Academy. 'Others, comparatively unknown, have since "arrived".' Among these would be the young Paul Gauguin but it does not seem that the visits of Gauguin and Elizabeth overlapped.

She describes the young artists as a lively picturesquely clad Bohemian group. The old photographs certainly confirm this, showing most of them dressed as if for a production of Puccini's *La Bohème*, wearing smocks, floppy bow ties and either black berets or huge straw hats. They might themselves, thought Elizabeth, have provided a rich subject for an artist, have been worthily set on canvas 'by a Zorn or a Kroyer', as they lingered long at the table, excitedly exchanging their experiences of the day's work and the latest artistic theory to come from Paris. Such conversations, held under flickering oil lamps, went on far into the early hours of the morning.

Here, at last, Elizabeth was given every encouragement. The young men were only too delighted to have the company of a congenial young woman, albeit that she was accompanied by her long-suffering mother. It was in Pont-Aven that she made her first tentative efforts towards producing work for exhibition. Emboldened by what she felt was a growing improvement in her technique, she sent several small watercolours to the Royal Institute in London where she met with unexpected success. 'To my intense surprise, I had the satisfaction of learning that they had found purchasers on the opening day.' She had finally taken the first steps on the road to becoming accepted as a professional artist.

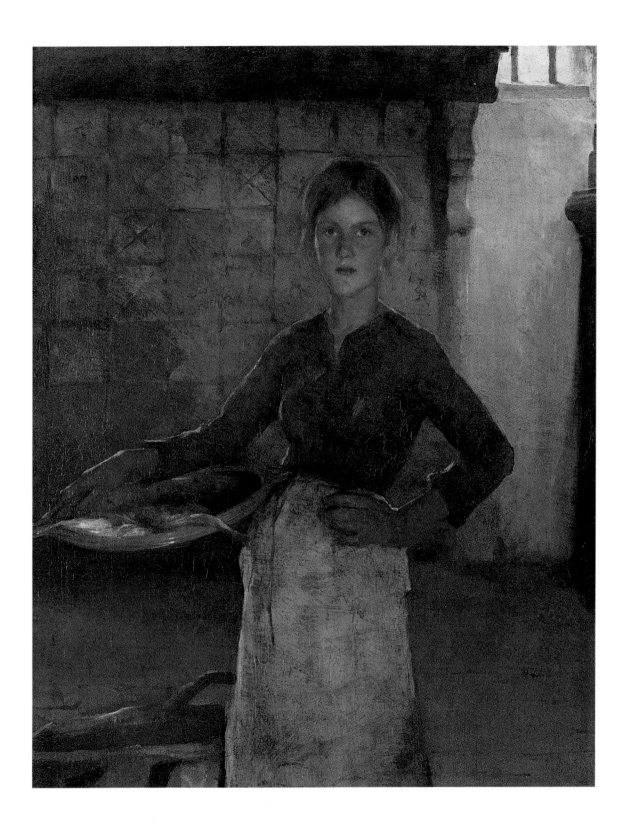

Widening Horizons

Elizabeth fell in love with Brittany. Its remoteness, magnificent coastline and, above all, the extraordinary light obviously appealed to her as an artist. Also, she had always been attracted to fairy stories and legends (as indeed were many of her artistic contemporaries) and Brittany with its strong Celtic influence and strange tales fired her imagination. Tristan had sailed to Brittany from Cornwall to meet the other Iseult; any fisherman foolish enough to find himself alone in the Baie des Trepasses at midnight might well be coerced into acting as ferryman to the souls of dead mariners waiting on a black ship, while L'Ankou, death or the devil depending on your viewpoint, waited for the unwary around every corner.

The sale of her pictures at the Royal Institute cheered Elizabeth immensely. 'This gave me courage and I went on to more ambitious efforts, which all, I think, ended in failure or erasure; but the time thus apparently wasted had its compensations.'

She was learning both what she was capable of and also where there were still weaknesses in her technique. 'The first spasmodic flutterings of a newly fledged sparrow are not much more ineffectual than are generally the first efforts of the beginner in art in the direction of original work. The poor fledgling of the atelier finds himself for the first time face to face with all the problems of choice and arrangement of subject complicated with all the material difficulties of changing effects, recalcitrant models and of the technique of the material in which he works.' Had her situation been different she might well, she noted, have succumbed to 'hopeless depression' but the support, assistance and praise she received from

PAGE 46
4.284 *Zandvoort Fisher Girl* 1884
oil on canvas, 67.3 x 53.3cm
Newlyn Art Gallery collection at
Penlee House

her artistic colleagues provided both stimulus and encouragement.

Elizabeth and her mother continued living at the Hotel des Voyageurs but many of the artists were to take over a nearby pension that they used as their headquarters. The pension has long since become a shop but there is now a plaque on the wall to mark the fact that L'ècole de Pont-Aven was founded there in 1888 by Edouard Vuillard, Emile Bernard and Madeleine Bernard.

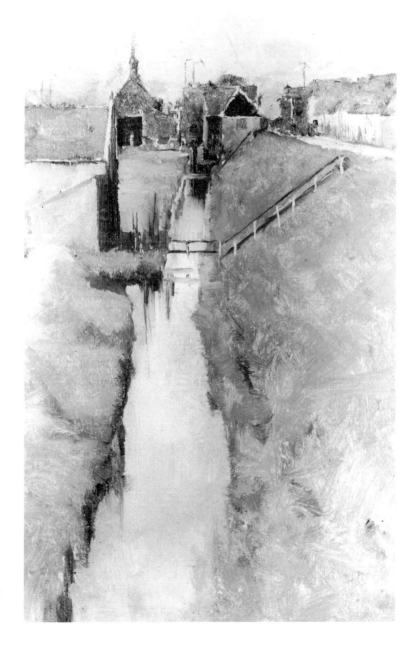

4.268 *Volendam, Holland from the Zuidende* c1895
oil, 26.8 x 19.4cm
Tate Gallery, London, image courtesy of the Belgrave Gallery, London and St. Ives

'I cannot describe the charm of the impression this old Breton land – "la vieille Armorica" – makes on me,' Elizabeth noted. But she was finding herself overwhelmed by the technical problems of reproducing it. She considered that she simply lacked the power to give expression to what moved her so intensely, and so turned her attention to another source. In Pont-Aven she was surrounded by tempting human subjects, fishermen mending their nets, elderly women, their faces framed in white lace, and the children, especially the children.

The young lady who was to be seen on the quays or in the town with her sketchbook or easel had immediately attracted the attention of the local children and Elizabeth decided that they would provide her with plenty of material. Asking them to model, however, was one thing; getting them to sit still, turn up when asked and to remain in one place without wandering off was something else. They were, she said, willing but provoking and continually tried her patience.

Two small girls paid what she described as a 'naïve but most unwelcome tribute to my skill'. She had sat them together, both picturesquely dressed and wearing small versions of the local Breton coifs and had spent most of a morning painstakingly making sketches of them. Called away briefly, she returned to find, to her horror, that one of the faces had been almost obliterated.

Enraged, she asked the girls who was responsible. There was a long silence, followed by tears, then one of the girls nudged her companion and said: 'C'est Marie Jeanne que l'a fait!'

Why, asked Elizabeth trying to control her temper, had Marie Jeanne done such a thing? The little girl broke down and sobbed while her friend continued relentlessly: 'C'est parce-que'elle se trouvait si jolie sur son portrait, qu'elle a voulu se donner un baiser...et regardez donc, Ma'amselle, tout le charbon noir s'est resté sur sa bouche!' Marie Jeanne had thought her portrait so pretty that she had felt impelled to kiss it, the evidence being the charcoal now liberally smudged around her mouth.

Then there was 'a most paintable urchin', a small 'mousse' or cabin boy, blown into Pont-Aven with his shipmates as a result of a winter storm. He knocked on the door of the room where she was working and pleaded with her to let him in. Once in, he perched beside her stove and she found it impossible to dislodge him. His

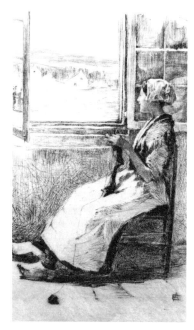

5.25 *The Girl at the Window*, 1884
drypoint etching, 15.2 x 11.4cm
Private Collection

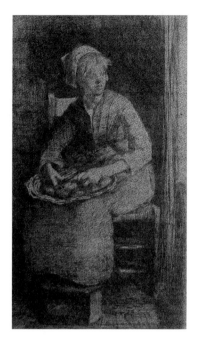

5.26 *Peeling Onions*
drypoint etching, 15 x 8.9cm
Penlee House Gallery and Museum

PAGE 51
4.117 *Girl Peeling Onions*
oil on canvas, 38 x 28cm
Private Collection

hands were blue with cold and he was obviously hungry. Elizabeth therefore went to the hotel kitchen and brought him back food that he wolfed down, after which he agreed to pose for her. But then, when night came, he refused to leave, pleading with her to let him sleep on the floor by the stove.

Reluctantly she agreed, only to discover by the next morning he had acquired a much larger and less attractive companion. Between the two of them they made her studio unendurable for three days, lounging around and smoking vile-smelling cigarettes. They also cooked 'weird messes' on her stove. At last, she was forced to appeal to the proprietress of the Hotel des Voyageurs, Madame Julia, to get rid of them for her.

She ascended the steep stairs, an embodiment of the awful majesty of law and order, and with a mousse grasped firmly in each powerful fist, sternly cast them forth into the night and the storm. I was pitiful over the little one with the wistful eyes, but Madame Julia was inexorable. They were 'vauriens' and it was not to be permitted and the next day my studio was vigorously cleaned with soap and water.

It was while she was working in Pont-Aven that Elizabeth first heard of a young painter by the name of Stanhope Forbes who was working in nearby Quimperlé. 'Some of my American friends occasionally visited Quimperlé, and returned with the report that Stanhope Forbes was, in the jargon of the atelier, "very strong"; but it was not until my return to England that his '*Fish Sale*' and his Breton pictures of the preceding year aroused my interest...' Although he was the man who was to take over her life, it is ironic that he certainly did not arouse sufficient interest when she was in Pont-Aven to provoke her into visiting Quimperlé to meet him and see his work.

Stanhope Alexander Forbes was born in Dublin in 1857. His father, William, was at that time the manager of the Midland and Western Railway of Ireland. William Forbes had a tremendous enthusiasm for the novels of Dickens and Thackeray and, most of all, for the works of Carlyle, an enthusiasm he encouraged his young son to share. He was also a collector and teller of folk tales, a genial and

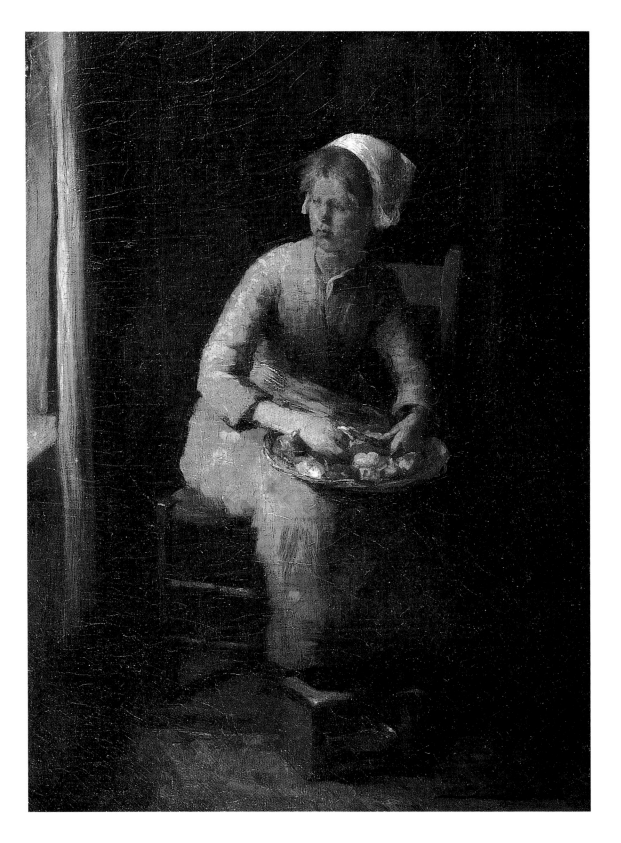

6.22 *Stanhope A. Forbes, A.R.A.,*
drawn by Elizabeth Stanhope Forbes
charcoal, 33 x 15.2cm
image courtesy of W. H. Lane and Son

sociable man, known both for his generosity and sense of humour.

But it was his French mother who was to be the dominant force in Stanhope's life; indeed, from his letters it is clear she remained his emotional crutch, with all that implies, until her death. Although she had two sons, Juliette Forbes, née de Guise, adored him: nothing was too good for 'Stannie'. She was sure he suffered from a delicate constitution, which she put down to his having fallen into the sea when he was six, and cosseted him accordingly. The relationship was such that over the years he wrote to her on an almost daily basis, sometimes twice in a day. Hundreds of letters covered every aspect of his life in minute detail, in Paris, Brittany and Newlyn. There was little he did not tell her, from descriptions of every sketch he made and what he had eaten for lunch to complaints about how he felt when he had a cold, had a bilious attack or was troubled by his liver. Both he and his mother considered they were prone to liver problems.

Juliette also wrote back to her son worrying about whether or not his diet was sufficiently sustaining, expressing her anxiety if an expected letter from France or Cornwall was even a day late. She was also a frequent visitor, descending on him wherever he was whenever she felt the urge. Mrs. Lionel Birch delicately put it that he exhibited 'a degree of intimacy and dependence unusual in a young man in his twenties'. Now, more bluntly, we would call him a 'real mother's boy'.

Because of his supposed delicacy, Stanhope and his brother were first taught at home by a governess who would take the boys on lengthy holidays to her family in Galway where her father was a vicar. A French holiday in the Ardennes when he was eleven prompted the boy to start sketching, a pastime which Juliette encouraged from the start. Shortly afterwards William Forbes was transferred to London and young Stanhope was sent to Dulwich College, but he had scarcely settled in before his father was off again, this time to run the Great Luxembourg Railway whose headquarters were based in Brussels. Juliette, still concerned for her son's health, decided that he should not go to school like his brother but have his own tutor until he was ready to embark on training for his career.

She was immensely ambitious for him, encouraging him to study

first at the Lambeth School of Art and then the Royal Academy School, before going on to Paris in 1880. She worried about him continually while he was in Paris. Students in the Paris ateliers were expected to work very hard and for long hours. Equally, their friends and fellow students expected them to take part in the lively society of the bars and cafés, enjoying the talk, the drink and the girls, experiences recollected by George du Maurier and made famous in his novel, *Trilby*. But if Stanhope Alexander Forbes, while studying at the studio of Leon Bonnat in Montmartre, was tempted by a lifestyle of Bohemian dissipation, there is no record of it.

It was an old friend, Henry La Thangue, a student at the Ecole des Beaux Arts who suggested to him that since he was interested in the *plein air* school of painting he might visit Brittany. So it was that, in 1881, Stanhope took his friend's advice, going first to Cancale where he stayed at the Hotel de l'Europe. It was in Cancale that he painted the picture that was to launch him as a popular artist, his *Street in Brittany*. Stanhope always said that he had learned more from painting in Brittany than he ever did in Paris.

From Cancale he moved to Quimperlé which he described in glowing terms: 'A beautiful rapid-flowing river, a thickly wooded valley and in it a quaint old town with the whitest of houses and queerest of roofs. Very steep streets crowded on market days, almost empty on other days. All the men dressed in regular Breton costumes and, of course, the women in the most wonderful coifs and collars.' He continued to ask Juliette's advice on his every move, while she organised the practical details of his work, such as the buying of materials, the framing of pictures and the contacting and entertaining of dealers.

It would be three years before Elizabeth and Stanhope were to meet. In the summer of 1883, she and her mother received a summons from London. Dr. Thomas Hawksley, the uncle with whom they had lived all those years ago in Chelsea, was anxious that Elizabeth should begin to establish herself on the London art scene. She describes her uncle as a man of remarkable 'and most winning' personality, possessed of indomitable energy and will-power, strong enough to triumph over both disability and ill-health. He was a philanthropist who expended a great deal of effort on his special

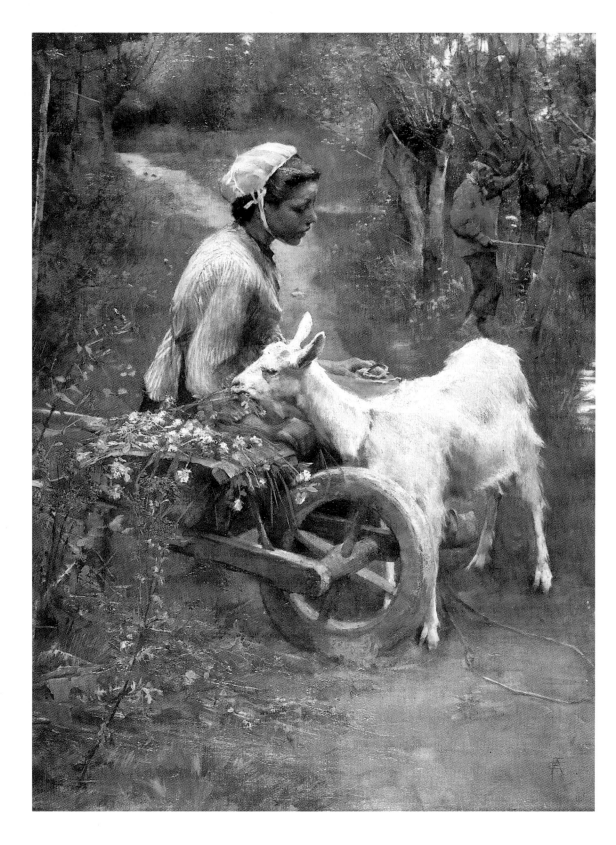

interest, the National School of Handicrafts for Destitute Boys which he founded in Chertsey, a school designed to train young lads as craftsmen who would otherwise never have had the opportunity.

He had always followed Elizabeth's career with interest and was prepared to support her in London, but once back in Chelsea she found it almost impossible to settle down to city life after the freedom she had enjoyed in Brittany. She felt hemmed in by the streets and buildings. Although living with her uncle and mother in Chelsea, it appears that, from the end of 1883, Elizabeth also maintained either a flat or a studio in Victoria. Her contact address from 1884 in one early catalogue of her work was at 18 Lupus Street, St. George's Square, London, SW1, and later, after her removal to Cornwall, she could be addressed in care of her uncle at his Victoria Street offices. In the summer of 1884 she persuaded her uncle to let her go to Holland, after learning that some of her old friends from the New York Arts League were working out there, among them her teacher, William Chase. He was working at Zandvoort, near Haarlem, with a compatriot, Robert Blum.

Delighted once again to be with congenial and sympathetic artists, she went to work with a will in what she described as 'a novel setting'. She made drawings and paintings of nearby almshouses and their inhabitants and of the fish market and the men and women who worked in and around it.

She received every encouragement from Chase and Blum, the former 'ready as ever' to help her with advice and criticism. She did some truly splendid work, not least her painting *Zandvoort Fisher Girl*. The young woman, dressed in blue, stands with a hand on one hip, a tray of fish propped on the other, in front of a tiled wall looking gravely out at the onlooker.

Enthused and energized by her summer in Holland, Elizabeth returned to London and immediately set about learning the technique of drypoint etching, under the tuition of Walter Sickert and James Whistler. She began a series of etchings based on her drawings of the almshouses and her pictures of the Zandvoort fisher folk. She loved the new medium and proved so successful in it that a number were exhibited at the Royal Academy, leading to her being invited to join the Royal Society of Painter-Etchers.

PAGE 54
4.153 *Jean, Jeanne et Jeanette* 1891
oil on canvas, 55.6 x 44.4cm
© Manchester City Art Galleries

5.28 *In the Almshouses, Zandvoort*
drypoint etching, 27.9 x 12.7cm
Private Collection
image courtesy of Penlee House
Gallery & Museum

PAGE 57
5.25 *The Girl at the Window*
drypoint etching, 15.2 x 11.4cm
Private Collection
image courtesy of Penlee House
Gallery & Museum

A critic writing in *The Studio* ten years later praised her 1884 etching, *A Dutch Girl:*

No detail to complete the effect is lacking, yet nothing obtrudes itself. The figure has no air of a model being posed, but is instinct with movement: the line of wool that connects the stocking with the ball on the floor seems still for just a second only ere it moves again. The drawing of this particular line seems to be in itself a proof of real power. To find one to measure it against you must turn to Whistler's 'Venice' etchings, where a telegraph wire, apparently as unimportant as this thread, plays a very vital part in the scheme of the design. The pleasure derived from refined work with repressed emotion is always keen, and when, as in this etching, one's first enjoyment is amply reinforced by more minute study, you feel tempted to praise it unreservedly, for the cumulative effect is not so often met with that it can be disregarded.

'This was,' Elizabeth told Mrs. Lionel Birch, 'a branch of art of which I was intensely fond, and one of the few modes of expression which I could pursue more easily in London than elsewhere. Afterwards, when I had settled in Cornwall, the difficulty of having my plates printed, more especially of having the trial proofs pulled while actually at work, proved too discouraging, and gradually, to my regret, I found myself compelled to lay aside my etching tools, and I ceased to contribute work to the society to which I had felt it such an honour to belong.'[1] However, as we shall see later, here she was, at least in part, being 'economical with the truth'.

Newlyn

Fired by painting *en plein air* in Brittany, British artists began exploring to see if they could discover a small town which might make an artistic centre similar to Pont-Aven but in their own country. Artists were already painting in St. Ives, although its great period would be considerably later. In the late 1870s the artist Thomas Cooper Gotch, Caroline Yates, who would become Mrs. Gotch, and Walter Langley and his wife visited Newlyn on several occasions. It was Langley who has the honour of being the first artist to settle there, in 1882. He was soon joined by a friend, Edwin Harris.

According to Caroline Fox's introduction to the catalogue for the Newlyn Gallery's exhibition 'Artists of the Newlyn School' in 1979: 'It was probably one of these two artists, both of whom came from Birmingham, who wrote an anonymous letter to the *Magazine of Art* in 1898, in answer to an enquiry concerning those who composed the Newlyn School. The anonymous writer states firmly "It was Birmingham that first discovered Newlyn" and supplies a list of artists who worked there for several consecutive years "as near as possible in the order in which they came in groups".'

To some extent Newlyn in 1882 was as cut off from the mainstream life of the rest of the country as had been Pont-Aven from that of France. There had been earlier visitors, some famous, including in 1792 James Boswell, who loved the pilchards and mackerel but hated the clotted cream.[1] He also thought the 'squalid' cottages and fishermen's stores on St. Michael's Mount should be cleared away to make it look more picturesque! By the 1870s the extension of the Great Western Railway into Cornwall had opened

PAGE 58
4.10 *The Apple Pickers* 1883
oil on canvas, 86.4 x 66.1cm
Private Collection

5.38 *The Carpenter's Shop*
drypoint etching, 20.3 x 26.4cm
Victoria & Albert Museum, London

the county up to brave summer visitors, but Newlyn remained much as it had been during the preceding centuries.

Physically, Newlyn has changed far more than has Pont-Aven. When Langley arrived in 1882 the only harbour was the tiny Old Harbour built in 1435 but the scale of the fishing was such that new 'piers', north and south, were added in 1884 and 1894. Today there is a further, vast, new fish quay and a large new fish market, and the tiny anchorage at the lower end of the town has been filled in and grassed over. The most marked change, however, is the distribution of the town itself. In the days when the Newlyn School first discovered Newlyn, there was no road around the harbour and the town was divided into two distinct parts, Newlyn Town itself on the cliff overlooking the Old Harbour, and Street-an-Nowan, a huddle of cottages at the mouth of the Coombe River. Access between them by foot or by cart was only practicable at low tide. When the tide was up access between the two was only possible by using a roundabout route which involved climbing the very steep road up Paul Hill. Until the 'new' harbour road joined them together, the two ends remained somewhat suspicious of one another, and deeply so of Penzance, a mile down the road.

As in Pont-Aven, the people of Newlyn were fiercely loyal to their county and very suspicious of 'upcountry' folk and their rulers in London. The great Chartist reformer, William Lovett, was a Newlyn man from a radical family. Back in the days of the Napoleonic Wars his mother had led the group of women who greeted a press-gang, which had arrived to 'impress' or kidnap fishermen into the navy. The women hit the press-gang over the head with large fish and successfully drove them off. The port was one of the busiest in the country with huge numbers of boats, their main catches being mackerel, pilchards and herrings.

In a letter home in April, 1884, Stanhope Forbes wrote: 'Never has there been such fishing known, and were it not that fish are so cheap the people would be rolling in money. Boats are bringing in as many as 12,000 mackerel and the great difficulty is to find means of packing these large quantities. The salesman's bell is heard each minute, and the beach is always crowded with buyers.'

Newlyners were also, like their Breton counterparts, very devout

although they had long since left Roman Catholicism and, indeed, the Anglican church behind them in favour of Wesleyan Methodism. The Cornish Sunday was a tradition which lasted well into the twentieth century, a day when the only activity should be to attend chapel. The incoming artists were given short shrift. Their landladies refused to allow them to paint in their houses on Sundays and artists setting up their easels in the streets or on the quays found themselves attacked and, on one occasion, their canvasses slashed. Stanhope Forbes expressed his frustration in a letter to his mother on June 1, 1884.

As ever more artists arrived seeking lodgings, good ones became hard to find and he was fortunate to have found a room in one of the best houses, Bellevue, run by a Mrs. Madden and which, as its name

5.37 *The Bakehouse*
drypoint etching, 26.4 x 20.3cm
Victoria & Albert Museum, London

suggests, had splendid views across the bay. 'The rooms are very good, especially the sitting room which is large and looks towards the sea.' Mrs. Madden was a kind and attentive landlady, but she, too, had strong religious views as to what was proper on a Sunday. 'She is a strict Sabbatarian, who considers even letter writing to be a breach of the Lord's Commandment.' So she did not allow him to paint on a Sunday. 'I am told she would turn me out bag and baggage if I were to paint or otherwise break the day. Apart from this, she is a nice old dame, and the first week's bill was moderate – £1.4s, ten shillings for the room and fourteen shillings for goods [board].'

It was in 1896, when the town was full of artists, that both the toughness and the religious devotion of the Newlyn fishermen came together in what became known as the Great Newlyn Fishing Battle.[2] Wesleyans were forbidden to fish on Sundays but during the spring of 1896 fish were scarce everywhere. By April and early May fishing fleets from Yarmouth and Lowestoft arrived off Newlyn to see what they could catch in Mount's Bay and the East Coast men had no inhibitions about fishing on Sunday. They proceeded to do so, in full view of the Newlyn fishermen standing, hands-in-pockets and in their Sunday suits, on the quay. On the evening of Sunday, May 17, when the Lowestoft men came down to the harbour to make ready for sea, the Newlyn men tried to dissuade them, first with words then, when that failed, with physical force. In spite of what can only be described as 'a punch-up', the Lowestoft men went out and fished. When they returned they were met by a hostile mob who promptly threw the entire catch back into the sea.

Two days later, reinforcements arrived from Lowestoft to be greeted by an even larger local crowd who again threw all the landed fish into the harbour. By the afternoon a handful of policemen were desperately trying to keep the two warring factions apart, while the local magistrates telegraphed London asking for 'gun boats and troops'.

By Friday 300 soldiers of the Second Berkshire Regiment had arrived under the command of a Major Hassard. They marched into town from Penzance railway station to the boos and jeers of the population, with six local magistrates striding bravely at their head. The soldiers took possession of the south quay as a gunboat, *The*

4.188 *A Newlyn Maid*
oil on canvas, 27.9 x 22.9cm
Newlyn Art Gallery collection at
Penlee House

Ferret, arrived off shore. Fighting then really got underway in earnest for while some Newlyners continued to fight the Lowestoft men, in most cases they now joined forces and attacked the troops. According to local legend, the entire fishing fleets of Porthleven and St. Ives (usually suspicious of Newlyn men) then sailed into the harbour with flags flying 'to fight off the English army', as a further contingent of fishermen marched in from Penzance. The soldiers fired volleys over the incoming boats, huge battles were fought up and down the quays, and the government had to send in three more Royal Navy vessels (with armed seamen aboard) as it was becoming seriously alarmed at the ability of a group of fishermen to tie up 300 soldiers and four ships for days on end. The riot finally petered out through sheer exhaustion and £800 damages were paid to the

Lowestoft men for the loss of their catches. It is an event still recalled with amusement in Lowestoft as well as Newlyn.

Although the town was full of artists, none of them, apparently, felt strongly enough moved to record the event on canvas. The battle does, however, give some idea of the kind of society on which the upcountry, middle-class artists imposed themselves ('colonised' was a term used in art circles) and why Newlyn seemed so strange and exotic. The work of the Newlyn School has, forever, set its population like flies in amber in a romantic ambience of picturesque harbours, seascapes and beaches, lamplit rooms and vine-covered cottages, whereas life was hard and dangerous and the population had to struggle to make ends meet.

Having said that, the town derived many advantages from becoming an artistic centre. Its people, while remaining suspicious of the 'London' artists, were not averse to adding to their incomes by renting out cottages for them to live in, even less to letting old stores and sheds for use as studios. The narrow, souk-like streets were a natural gift to painters, while the whole was bathed in the wonderful light which has continued to attract painters to the far west. The rough seafaring men, their faces tanned by the weather, made fine models as did their women and children (adult models sixpence an

5.39 *The Cornish Pasty*
drypoint etching, 20.3 x 26.7cm
Victoria & Albert Museum, London

hour, children four pence). Here, though, were no exotic peasant dresses and lace coifs. The working dress of the women who cleaned and salted the fish and worked on the nets was a long dark skirt over which went a hessian or canvas apron, a thick shawl to keep out the cold with a kerchief on the head.

The new tourist trade with the coming of the railway was to alter even this, and later the artists would grumble that fashion had reached the fisherfolk, especially the girls who had begun to change their hairstyles from the great swept-back knots and plaits. Crimped fringes 'ruined' many a pretty face, while a girl's Sunday best might now even include a bustle or crinolette. 'All very well in a stylish London beauty but appalling with these surroundings of sea, boats, and fish,' complained Stanhope.

Stanhope Forbes had been among the wave of artists who had arrived in Newlyn in 1884 following the excited reports of the early pioneers. He described it to his mother as a 'sort of English Concarneau and is the haunt of a great many painters'. He cited Thomas Gotch and Walter Langley, though he knew them only by reputation, but noted that Ralph Todd, with whom he had shared lodgings at the Hotel Metayer in Quimperlé, was also working in Newlyn as was Leghe Suthers, with whom he had travelled home from Brittany. In fact neither of the latter two was actually in Newlyn when he arrived and Gotch did not settle there until two years later.

'But,' Forbes wrote, 'they are flocking here each day.' On September 4, *The Cornishman* noted that there were no fewer than twenty-seven artists then residing in Newlyn. But, as Caroline Fox points out, few artists at that time settled permanently in the town. They treated Newlyn as others, and indeed many of them, had treated the Breton towns of Pont-Aven, Quimperlé and Cancale, coming and going as the mood took them. Stanhope Forbes was unusual in that he spent most of his time there.

Two artists who did not stay the course were Frank Bodilly and Frank Bourdillon. Bodilly spent only two years as a painter, before leaving to study law, although in 1886 he had considerable success at the Royal Academy with two paintings, *A Quiet Hour* and *A Street in Newlyn*. He married the sister of Caroline Yates, Gotch's wife. His reference in *Artists of the Newlyn School*[3] ends, gnomically, 'he

5.36 *Net Beating*
drypoint etching, 19 x 12cm
Victoria & Albert Museum, London

PAGE 67
4.241 *Portrait of Stanhope with 'Cello*
oil on board, 23.5 x 14.6cm
Private Collection

is said to have gone to India and to have become a judge, but later to have been involved in a scandal and to have ended up a Trappist monk...' Bourdillon, who joined Stanhope at Bellevue in 1886, also found religion.[4]

Bourdillon was in the vanguard of artists who criticised the stranglehold of the Royal Academy and finally changed from painting what he saw around him to imaginary scenes from the days of Queen Elizabeth I. In 1892 he found God, became a missionary, and ended his days as a curate in Ramsgate.

Meanwhile, as male artists continued the trek westwards, Elizabeth Armstrong's reputation was growing in London. She worked hard at her drypoint etching under the tuition of Whistler and Sickert who had become her good friends, and was exhibiting paintings and etchings at both the Grosvenor Gallery and the Royal Institute. But she continued, she writes, to chafe 'like a prisoner behind bars' in London, both in the dark days of winter and in the breathless summer heat. As artists went to and fro between London and Newlyn, news of the English *plein air* school grew and finally her uncle agreed that she should at least visit Cornwall to discover what it was like 'and so it came about that the end of the year [1885] found my mother and me en route for Newlyn.'

Her brief account of her early life ends with some significant words: 'And now, dear friend, I think you know the rest; so I will leave you to pick up the threads and to weave such a web as may seem most fitting to you out of the united fortunes of Elizabeth Armstrong and of Stanhope Forbes, which began soon afterwards.'[5] Elizabeth always referred to her husband as Stanhope or 'Stannie', while he called her 'Lizzie'.

The artistic society in which she found herself was a curious one. As in Pont-Aven, it was a totally separate entity from its hosts. Few of the painters fitted the conventional picture of the creative genius starving in an attic for the sake of his art. Many had private means. It was an intensely male environment, indeed defined by Stanhope Forbes himself as 'the brotherhood of the palette'. It was a society knitted together by what is now termed 'male bonding', partly brought about by the fact that the young men were exiled from their families and friends in London or Birmingham and had little or

4.244 *Portrait of Stanhope with Umbrella*
oil on board, 30.5 x 26.7cm
Private Collection

nothing in common with the local inhabitants. In no time at all they had set up both a cricket team and an amateur dramatic society and were entertaining each other to lavish dinner parties, further distancing themselves from the people among whom they lived. There were few women involved, even as wives. The talented Caroline Yates, one of the first artists to come to Newlyn and who had trained at the Slade in London and worked in Paris, hardly painted at all after her marriage to Gotch.

They sit there in their group photographs, frozen in time. One group of eleven artists taken in 1884 shows them in a weird assortment of headgear, bowlers, fishermen's caps, a woolly tammy with a huge pompom and the deerstalker made famous by drawings of Sherlock Holmes, staring sternly out at the photographer. In another, a larger group is in summer gear, wearing straw boaters and

knee breeches, the few women tightly corsetted into light frilly dresses. Single (male) artists are shown painting in the street wearing the inevitable artist's smock and floppy hat.

The *Biographical Dictionary of Women Artists* notes that the strong masculine bias of the Newlyn School shows in its subject matter. Men are painted in strong poses, working on their boats, forging anchors, fishing at sea, while women are shown sitting and mending nets, knitting jerseys, or posed prettily against cottage backgrounds. The artists complained that the prettiest girls were often too shy to pose in public. Yet, in real life, Newlyn women had to be tough, strong and independent as their men were at sea for so much of the time.

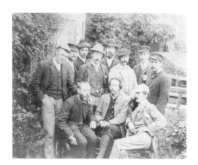

Group of Newlyn artists, c.1884
From Newlyn Artists Album
Cornwall County Council, on loan to
Penlee House

While Elizabeth, writing years later, had coyly implied that her own personal and independent story ended with her meeting with Stanhope Forbes and the weaving together of their two lives, it is certainly not how she saw it when she arrived in Newlyn in 1885. She was singularly unimpressed by Newlyn's male artistic community and disliked its atmosphere.

Indeed, she felt so strongly about it that after a first brief sojourn in Newlyn she and her mother moved to St. Ives which she found far more cosmopolitan in its artistic outlook and where, as a woman artist, she was made to feel welcome. She might well have settled in St. Ives for good had she not, in the November of 1885, met Stanhope. (In her biographical sketch for Mrs. Birch's book, she reports this as being 'early in 1886' but Stanhope's letters are a more reliable source in this instance.)

The two finally made their acquaintance at the house of Edwin Harris, an artist Elizabeth had known in Pont-Aven. Stanhope duly wrote at once to his mother: 'On Friday night I went round to the Harrises and was introduced to the young lady artist Miss Armstrong. She cannot be said to be pretty but is a nice intelligent and ladylike girl. I had a very long and interesting talk with the Canadian girl about Pont-Aven and all my old friends there, for she, Miss Armstrong, was staying at Julia's while I was at Metayers.' The die was cast.

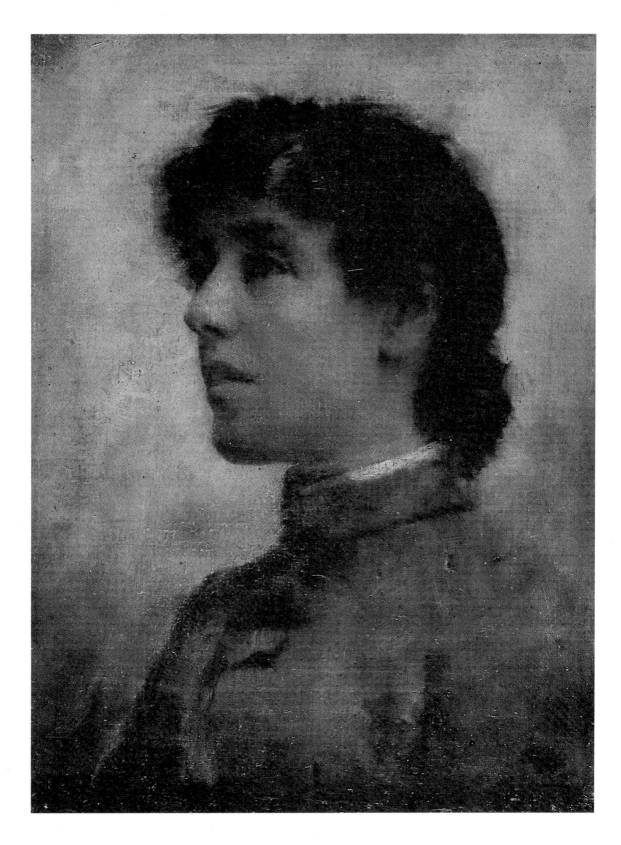

A Cornish Romance

Very shortly after his arrival in Newlyn, Stanhope began work on the painting that was to put both him and the Newlyn School on the artistic map, *Fish Sale on a Cornish Beach*. He had watched how, when the fishing boats arrived with their catch, the people would flock to the foreshore (now part of the harbour) both to welcome them home and to buy. He was obviously deeply inspired, writing to his mother that he could not imagine anything more beautiful than the beach at low water. 'If I can only paint figures against such a shining mirror.' He ordered the canvas for the painting in the June of 1884 although he told Juliette that he had already designed and thought out the work, 'but to carry it out will be a long and difficult job'.

He gave the picture the working title, 'The Arrival of the Boats with the Fish and the People Crowding Round on the Wet Sand', and he made several small studies for the painting. Writing in *The Cornish Magazine*[1] in 1895 he noted:

> From the first I was fascinated by those wet sands, with their groups of figures reflected on the shiny surfaces, which the auctioneer's bell would gather around him for the barter of his wares...It was there I elected to paint my first Newlyn picture, and out on that exposed beach for many a month, struggled with a large canvas. Yes, those were the days of unflinching realism, of the cult of Bastien-Lepage. It was part of our artistic creed to paint our pictures directly from nature, and not merely to rely upon sketches and studies which we could afterwards amplify in the comfort of a studio.

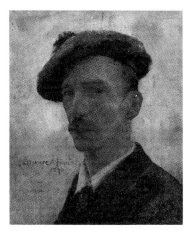

PAGE 70
Stanhope Alexander Forbes
Portrait of Elizabeth Adela Forbes
oil on canvas, 35 x 27cm
Newlyn Art Gallery collection at
Penlee House

ABOVE
Stanhope Alexander Forbes
Self Portrait
oil on canvas, 35 x 27cm
Newlyn Art Gallery collection at
Penlee House

Stanhope Alexander Forbes
Fish Sale on a Cornish Beach 1885
oil on canvas
(Plymouth City Museum and Art
Gallery)

His first, somewhat grandiose, notion of a painting five foot by nine foot, had to be scaled down because of the sheer practicalities involved as he wrestled with a large canvas on a cold and 'sloppy' beach, on several occasions in the teeth of a biting onshore east wind. 'Painting out of doors is no joke,' he wrote to Juliette in September 1884, 'and this picture will be a long, weary job.' On one occasion he says he 'sallied forth to have another go at the large picture. I got blown about and rained upon and my model fainted.'

There was also the problem of an audience: 'To plant one's easel down in full view of all, and to work away in the midst of a large congregation needs a good deal of courage; but it takes even more to boldly ask some perfect stranger to pose for one under such trying conditions. But our principles demanded it...'

The three main figures in *Fish Sale*, the girl leaning against the small boat, the fisherman with a sack over his shoulder and fish in his hand, and the older woman sitting on a wooden stool, are obviously posed, but they are posed against a background of a shore dotted with busy figures, fishing vessels either anchored or still coming into port, the whole set against the mirror of sea and sky and reflected in the shining sands. In this work, more than in anything else he ever painted, he truly captured Cornwall's remarkable light.

The picture was greeted with acclaim at the 1885 Royal Academy Spring Show. A critic writing in the *Magazine of Art* picked out *Fish Sale* and Whistler's *Portrait of Pablo Saraste* as 'the best and most noteworthy of the year', although he thought the Whistler the better of the two. He noted the strong influence of French technique in Stanhope's work. It was this very French influence that obviously biassed the Trustees of the Chantrey Bequest who had considered purchasing *Fish Sale* for the nation, since they rejected it on the grounds that it was 'too positively the outcome of a foreign school'.[2]

His obsession with the shining sands did not, however, prevent Stanhope from enjoying a busy social life. Norman Garstin, writing in *The Studio*[3] in 1901, describes how the young men 'found the friendship and the camaraderie of the ateliers in Paris and Antwerp, a sympathy with each other's intentions, a mild climate suitable for out-of-door work, these were the determining causes that led the

young artists to setting up their easels hard by the Cornish sea...'

Stanhope, whose flood of letters to mother only paused in October 1884 when she actually visited him, told how he now knew all the pretty girls in the place, as well as the children, how Walter Langley was in 'high glee', as he had sold a painting for 400 guineas, that the artist William Fletcher had arrived and was to share his lodgings, that 'a new man, Detmold', had also taken up residence at Bellevue, and that he saw a great deal of Frank Bodilly 'who is great on fishing'. He was also now involved in a round of dinner parties and musical evenings, jolly little parties for more visiting artists, and

4.216 *First Primroses of Spring*
oil on panel, 30.5 x 22.9cm
image courtesy of W. H. Lane & Son

on one occasion 'a feast' to celebrate Langley's temporary departure from Newlyn. The latter had ended at two in the morning when the artists had formed a line and marched throughout the village, headed by Langley, to see him off from Penzance railway station.

By the time he and Elizabeth finally met, *Fish Sale on a Cornish Beach* had made Stanhope something of a celebrity in local artistic circles. Nevertheless, it is clear that, from the first, he took her seriously. Indeed, as early as 1883, she had a picture of her own, *Summer*, accepted by the Academy and she was, by this time, exhibiting regularly at the Royal Institute.

In spite of his somewhat unflattering first description of her looks he was soon deeply smitten. He was twenty-eight years old, and so far as can be ascertained, had experienced no previous emotional involvement with a woman. His obvious attraction to Elizabeth was noted not only by his friends but by the locals. One day, shortly after they met, he was crossing Newlyn Bridge with her when he saw one of his models, 'Uncle' Sam Plummer, leaning against its parapet. Thinking he might be useful as a model for Elizabeth, he went over and introduced her to him, whereupon Plummer 'roared out in a voice like a foghorn, loud enough to be heard in Penzance: "So that's Miss Armstrong – they do say you and she are going to be wed!"' An embarrassed Stanhope brushed this aside. Later, when their engagement was announced, Plummer was to tell everyone: 'I said 'ee was going' to wed 'er, didn' I? An' so 'ee be!'

Elizabeth remained in Cornwall into the summer of 1886 and Stanhope continued his courtship, writing to his mother that she was 'one of the most energetic and industrious girls I have ever seen and that is better than a dowry of two or three hundred a year.' She was, he pointed out, a real professional and had sold her pictures at the Grosvenor and British Artists' galleries and her etchings at the Royal Academy.

Some time in June he must have proposed, for he then wrote to his mother asking for a cheque for fifteen pounds to enable him to buy Lizzie an engagement ring. He was obviously keen to marry her, discussing whether the wedding could take place in Newlyn, as he felt the 'opulence' of the Forbes family home in London could be an 'awful ordeal' for Elizabeth...In July he wrote to Juliette: 'That you

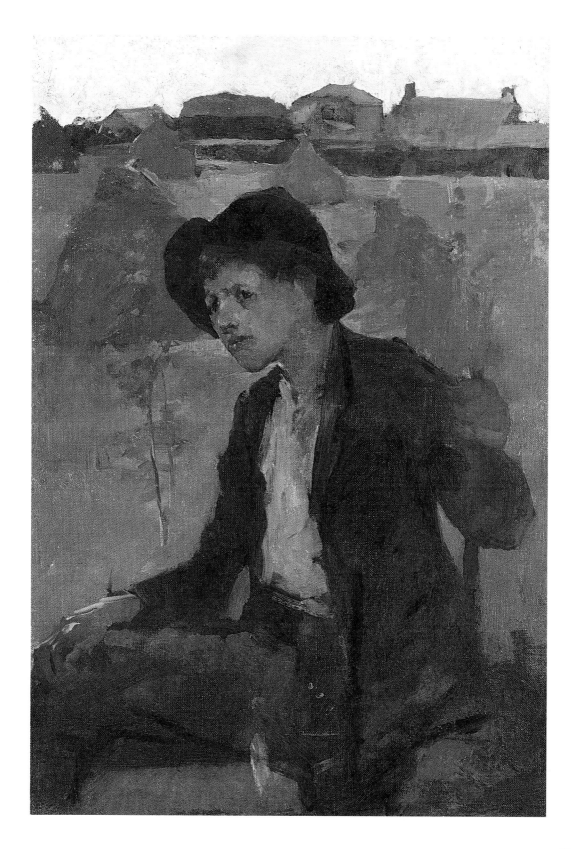

should know and love the girl I hope to make my wife, is now my constant thought.' He did his best to persuade his mother to come to Cornwall for a holiday and meet Elizabeth, suggesting that she too should stay in St. Ives, where Elizabeth had her lodgings, as he felt Newlyn might be unsuitable with its oceans of mud, whereas St. Ives already boasted several good hotels and had fine beaches.

It is hardly surprising that Juliette did not share her son's enthusiasm and her opposition was at least one of the reasons why the couple were to have such a long engagement. She wrote to him telling him briskly that he should return to London where he would meet 'lots of nice girls'. It is unlikely that any girl would ever have been considered by his doting mother to be good enough for Stanhope Forbes but a young and independent woman painter was considered highly unsuitable. Stanhope's need to stress the fact that Elizabeth's talent and application were better than a dowry, suggests that at least one of Juliette's criticisms was that Elizabeth's family were not wealthy.

In September 1886 Stanhope's Aunt Annie came down to St. Ives to inspect the fiancée and she duly reported back in a letter to her daughter, Alice:

> We had such a pleasant day in Newlyn and I like Mrs. Armstrong (Elizabeth's mother) very much. We paid a visit to all the studios...I fear love-making and painting don't go together. Stannie has not done much of the latter and oh! to say he is silly over Miss Armstrong is to say nothing; he is too foolish and does not care who sees him. If I were Miss Armstrong I should box his ears. I liked Miss Armstrong very much but if anything she is less religious than her intended husband which is to me dreadful...It is most amusing the friendship that exists between these artists and they are in and out of each other's rooms and houses at all times of the day.

But for whatever reason – Juliette's opposition, Stanhope's lack of independent finance, even, possibly, Elizabeth's doubts – there was to be no speedy wedding and during the three years between Stanhope's proposal and their marriage, Elizabeth continued to work, dividing her time between London and St. Ives, while regularly visiting her

fiancé in Newlyn. In 1887 Forbes was working on his next large-scale work, *Their Ever Shifting Home*, for the next year's Academy. It shows a band of gypsies walking down a Newlyn country lane, led by a young woman carrying a child, followed by a group of men leading a horse-drawn caravan. He started the painting when his family were visiting St. Ives during the summer of 1886. It was to take him a long time. In February 1887 he wrote to his mother telling her he had almost finished the roofs of the houses, had 'keyed up' the sky, and repainted the trees, but had hardly touched the ground as he needed to return to Paul Hill to get the wheel ruts right.

He had made a detailed oil sketch of the figures in the painting for it had proved both difficult and expensive to persuade the gypsies to remain in Newlyn to pose for him. They had promised to return but from the appearance of the woman it is likely that this would have proved difficult because she is obviously already pregnant with a second child. Another problem was that he found himself surrounded by an audience of up to a hundred all the time he was trying to paint the gypsies.

Baulked of an immediate wedding, Stanhope might have hoped that at the very least Elizabeth would stay in Cornwall most of the time, but she remained as independent as ever, returning to London for extensive periods to work, especially on her etchings, and it is over these that a serious and deep-seated difference arose between them which was to become apparent during their prolonged correspondence.[4]

Over the next three years Stanhope wrote to Elizabeth during her long absences almost as often as to his mother. There is no trace of the letters she wrote to him during this period – nor indeed at any other time – which lends weight to the stories of those who worked at Higher Faugan at the time of her death: namely that her personal correspondence was burned along with a number of sketches and unfinished works.

It is obvious from Stanhope's letters to Lizzie that she was nothing like such an eager correspondent. Since the letters are only dated 'Sunday afternoon', 'Wednesday morning', etc., it is not possible to put exact dates on them but letter after letter begin with such phrases as 'why don't you write?', 'I walked all the way into

4.184 *Mother and Child*
watercolour and charcoal,
43.2 x 40.6cm
image courtesy of West Cornwall Art Archive

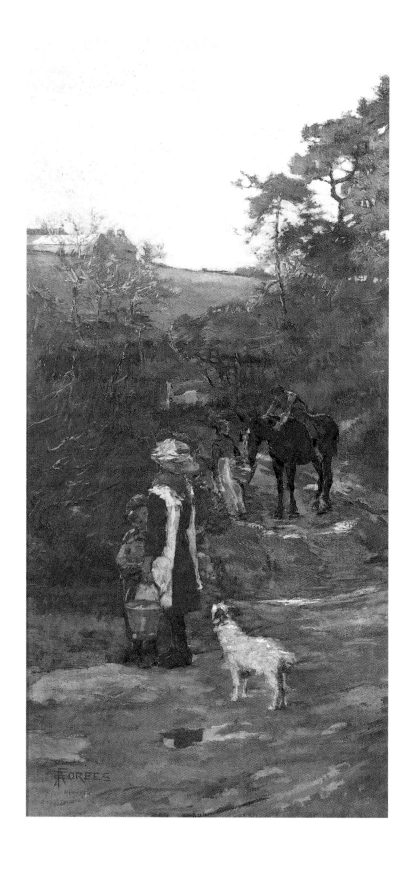

Penzance today and there was no letter', and 'You bad girl not to write on Friday so that there's no letter this Monday'. He addresses her throughout as 'Dearest Lizzie' or 'Liz', referring to himself all the time, somewhat archly, as 'Your Boy'.

An exception to the non-dating rule is a letter sent on December 7, 1886 in which he notes that 'it will be six months tomorrow since we became engaged to each other' and asks 'does she miss her cross Boy very much?' Is she, he enquires, still continuing to see the artist Walter Sickert? 'You know I most particularly desire you not to see him again...the feeling doesn't get any less, so it is better you should know it.'

Elizabeth's taking advice and help from both Whistler and Sickert caused very real differences between the couple, although Stanhope admitted how fine her etchings were and how much she had learned, going so far as to tell his mother that the critic, Napier Hemy, had said they were as good as any currently being exhibited. Again and again he makes clear that he loathes and detests 'the Whistler gang' and is deeply upset by her continuing working relationship with them. He did not approve of the work of either Whistler or Sickert, but this was not the main cause of his concern. His dislike of their respective styles and success paled into insignificance beside what he perceived as their reputations.

Walter Sickert was one of the outstanding artists of his generation, but he had always lived what might be described as a 'rackety' life. He had started out as a touring actor but later gave it up to become a student at the Slade School of Art in London. On leaving, he went to Paris to study with Degas, before returning to London permanently. Influenced by the French artists who took the streets, cafés, theatres and brothels as subject matter, he often used the London theatres and music-halls as subjects for his paintings, achieving notoriety for his scenes of low-life bars and prostitutes. He was even (much later) a candidate for the role of Jack the Ripper, a theory put forward in a book by Stephen Knight published in 1974, *Jack the Ripper – The Final Solution*. The argument is unconvincing and it is most unlikely that such a story was circulating at the time Sickert knew Elizabeth.

As to American-born James Whistler, he had a flamboyant

PAGE 78
4.221 *Road to the Farm*
oil on canvas, 61 x 30.5cm
image courtesy of David Messum Fine Art

personality, was often in debt, and was a close friend both of Rossetti and Oscar Wilde. He believed that 'art should be independent of all claptrap, should stand alone, and appeal to the artistic sense of eye and ear, without confounding this with emotions entirely foreign to it, such as devotion, pity, love, patriotism and the like. All these have no concern with it' – not a philosophy likely to endear him to the highly conventional Stanhope.

In 1879 Whistler had sued John Ruskin for libel. Reviewing one of Whistler's paintings, Ruskin, in a notable phrase, had said that the artist was 'flinging a pot of paint in the public's face'. Whistler won the case but was awarded only a farthing's damages and also had to pay his own costs which brought him bankruptcy and much unwelcome publicity. Whistler had many involvements with women but at the time he was friendly with Elizabeth it is highly unlikely he would have had any designs on her as he was deeply in love with a young widow, Beatrix Godwin. They married in 1888 and the match was an extremely happy one, brought to an end only by Beatrix's early death some eight years later.

We do not know how Elizabeth replied to Stanhope but it is clear that he was not convinced. In another letter he writes: 'I have had a long talk today with Thomas Gotch about Whistler and I really can hardly bear to think that you are likely to meet him tomorrow.' A few days later he wrote again saying that he hoped sincerely she had 'seen the last of him for some time, however amusing he might be'.

Elizabeth must have made some response, for he wrote again admitting that he was deeply prejudiced against Sickert, although he had never met him, and detested the school to which he belonged. 'I cannot find words strong enough to show my contempt for them. I feel sure a time will come when you see it too, but my prayers do not go up to those who were instrumental in drawing you into that clique.'

The 'life-styles' of Sickert and Whistler were no better and no worse than most of their contemporaries. But they shocked poor Stanhope because, although he had trained and worked as a painter, in almost every other way he remained a deeply conventional product of his age. He had always been sheltered from financial anxiety and hardship, indeed even from the practicalities of trying to promote and sell his own work; Juliette had seen to that. As a result he had

never really had to rough it with fellow artists, share their struggles and anxieties or work at anything else in order to make ends meet. He was unusually fortunate in that he had always been underpinned by his family's substantial means.

In spite of his dire misgivings, Elizabeth continued working on her etchings, for which she had a very real talent, almost up until the time of her marriage. Afterwards there were hardly any. The excuse she made to Mrs. Lionel Birch – that it was too difficult to continue with the medium from her base in Cornwall – was only part of the story. The more important reason was Stanhope's adamant opposition to her continuing her working relationship with Whistler and Sickert. Once they were married he moved easily into the role of a late-Victorian husband and on the surface she was to complement him as a dutiful wife, although things may not always have been as they seemed. However, Stanhope's disapproval resulted in that particular artistic door closing on her forever.

5.14 *Boy with a Stick*
drypoint etching, 10.1 x 7cm
Penlee House Gallery and Museum

The correspondence continues and it is obvious that for a long time there were severe problems with Juliette. Although it seems that Elizabeth spent the Christmas of 1886 with the Forbes family, Juliette was far from reconciled. A letter written in the new year of 1887 says: 'No news from mother. Ah, Liz! It is wonderful what a test of her love has stood and it has been tried for years. Poor thing, her last letter was a very sad one. I do so hope the day will come when she will thoroughly understand you. There is nothing she craves more than the affection of a daughter. But you will both, I know, have to go through much together before then, it cannot be otherwise with your nature, but I am confident of the result in the end.' He continues that one day he hopes she will be able to talk to one 'who in every way is so like a person – and I say this without any foolish vanity but out of a deep sense of gratitude – that you love as much as your own Boy Stan.'

Elizabeth seems to have been confiding something of her problems with Juliette to her uncle and writing to Stanhope giving him her uncle's views on the situation. Stanhope reminds her that her uncle 'knows nothing of matrimony' although he supposes she has been comforted by having long talks with him.

Not all Stanhope's letters refer to their personal problems. There

are descriptions of the amateur theatricals embarked on by the artists, describing the costumes each had made, or had made by local seamstresses, and in great detail. Some had little drawings attached, along with notes as to what roles they had played. He also described what he had written for himself to say at concert parties: at one of these he had played the head and legs of an animal of some kind and 'Garstin played the arms'.

He tells her about the progress of his work, writes at length about both praise and criticism of it (the latter making him very despondent), asks, briefly, how she is getting on? He then swings between telling her he can manage well enough without her and pleading with her to return to Cornwall soon.

Did she ever have any doubts during that long engagement? If she did, then there is no record of it. She continued working hard. After a brief stay at Cliff Castle, Newlyn, where her mother continued to live until her death in 1897, she returned to St. Ives and borrowed a studio from the artist, Percy Craft, writing to Stanhope that she had made up her mind to do several things while there. She made no bones as to her preference. 'I certainly like the place better than Newlyn.'

Stanhope exhibited *Their Ever Shifting Home* in the Royal Academy exhibition of 1887 but if he was hoping for the success of *Fish Sale on a Cornish Beach* he was to be disappointed. It was not well received and, as he wrote to Elizabeth, 'had very few complimentary remarks and it seemed to me to astonish nobody. It looked very bad for me.'

Elizabeth's fascination with painting children, begun in Pont-Aven, continued and she was to make the subject matter very much her own. It is the theme of one of her best known paintings, *School is Out*, painted in 1888. The scene is the little village primary school in Paul. One teacher is still at her desk, another is showing the little ones out. Small girls, some in tammies, one in an enormous frilled white bonnet, cluster in a group in front of the teacher's desk. A little boy, possibly made to stay in, sits on a bench and weeps. It is a delightful painting. Of Elizabeth's work, Tom Cross, former head of Falmouth College of Art, rightly says: 'She painted with a delicacy and clarity that few of the Newlyn painters, including Stanhope

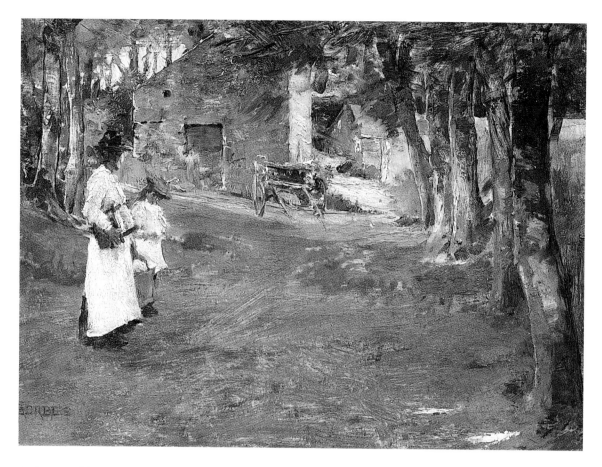

4.60 **On a Country Road**
oil on panel, 25.4 x 35.6cm
Image courtesy of David Messum Fine
Art

Forbes, could rival, and although much of her work is small in scale and less dramatic in subject, her skill is no less evident.'

At the same time, Stanhope was working on his next major works, *The Village Philharmonic* and *The Health of the Bride*. The latter shows a village wedding, the bride and groom seated stiffly at the wedding breakfast table, she in white, crowned with flowers, he in a new serge suit. A sailor relative raises a toast to the happy couple, an elderly man, presumably the groom's father, takes two small grandchildren on his knee, and an old woman wears an old-fashioned white cotton bonnet while the younger guests are obviously dressed in their would-be fashionable best. Through the window there is a glimpse of the sea and the masts of ships. To paint his picture Stanhope used a local inn and some of his friends, as well as his regular models, as sitters.

The picture was a huge success at the Royal Academy and was bought by Sir Henry Tate for the then large sum of £600. Later it

would be part of the collection which Sir Henry left to the nation as the foundation of the Tate Gallery. The picture's sale enabled Elizabeth and Stanhope to marry. Presumably his mother's opposition had made him feel he had to be able to support his wife without application to his family for financial assistance. In a letter to Sir Henry Tate in July 1889 he apologised for being somewhat preoccupied, not least because of his impending marriage. 'It was inevitable after painting the picture.' He was now thirty-two and Elizabeth thirty.

Frank Bourdillon, in a letter to a friend dated August 7, wrote that preparations for the wedding had been going on for some time but that the actual day was kept secret for they were both now so well known they were alarmed at the idea of crowds of bystanders turning up 'to gawp at the wedding'. Bourdillon's duty was 'to take charge of nice old Mrs. Armstrong'. At 2 p.m. on August 6, the couple were married at St. Peter's Church in Newlyn. 'Forbes had only his brother down for best man...while Miss Armstrong was assisted by a Miss Locking (a lady artist).'

Elizabeth did not marry in a traditional wedding dress with 'wreath and veil' as the locals would have put it, but in a walking dress of white cashmere, with satin facings and 'a fancy hat trimmed with lilies of the valley'. The bridesmaid also wore white cashmere and 'a fancy hat trimmed likewise with sage green and crushed strawberry'. As Elizabeth's brother was unable to come over from Canada for the event, most unusually she was given away by her mother.

After the ceremony the wedding party repaired to the house hired by Mrs. Armstrong, 'on the parade at the corner of the road, turning up to Regent Square and St. Mary's Church'. There they had a 'cake and other delicacies' until 'Forbes and his wife went off to Plymouth by the 6.35 p.m. in first class style and a heavy shower of rice. As we were nearly all artists and their connections (all our own crowd and the married men from St. Ives) the company (I hope you will admit it) could not fail to be entertaining. And when the shouting was all over, Tayler and I stayed to dinner at the Morrab Road until it began to get rather late and I had to climb to the top of my mountain.'[5]

There is no mention in Bourdillon's account of Juliette Forbes attending the ceremony, nor is there a clue in the surviving

correspondence as to why, if that was indeed the case, she chose not to attend her son's wedding. Stanhope's father, William, had died in December 1888, a full eight months before the wedding date, but it is plausible that Juliette, aside from her oft-repeated disapproval of the match, was keeping to the customary year of mourning as a ready excuse.

6.12 *Girl with Hands Behind Her Back*
charcoal, 43.2 x 26.7cm
Private Collection
(see photograph on page 2)

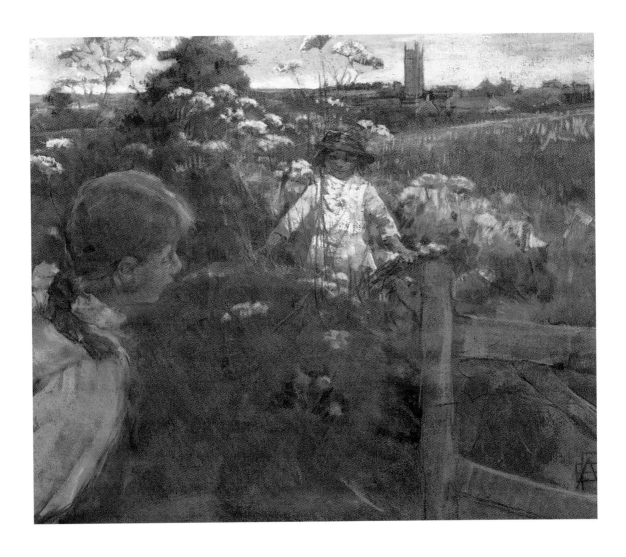

Settling Down

After honeymooning on Dartmoor, Stanhope and Elizabeth returned to Newlyn and, for the next four years, lived at Cliff Castle in Newlyn with its splendid view over the Bay, referred to in their correspondence as 'The Castle'. Elizabeth's mother, Frances Armstrong was a permanent lodger there, both before the marriage, and after they departed to a home of their own. While their relationship may have followed fairly conventional nineteenth-century lines, Elizabeth, unlike her friend Caroline Gotch, did not gradually stop painting to devote herself to domesticity nor was there any suggestion that Stanhope expected that she would. For those with only moderate means, servants were cheap and there were plenty of local young women prepared to do housework. Elizabeth would work constantly and exhibit widely throughout the twenty-three years of her marriage in a range of media – oils, watercolour and pastel – while also continuing with her drawings and illustrations.

The young couple threw themselves into the busy social life of the Newlyn artists and indeed were renowned for their hospitality. Many evenings were spent at reciprocal dinner parties. A handful of tiny menu cards survive among the Stanhope Forbes papers, a typical one reading:

Huîtres à la Tuke

Sole Sauce Harvey

Epaule de Montoc

Poulet Boilea avec pommes de terres anciènne, chouxfleur

Champagne Veuve Cliquot

Claret Chateau Heff

Oeufs farci Wessington[1]

PAGE 86
4.138 *Hide and Seek*
pastel, paper on linen, 38.1 x 48.3cm
image courtesy of Richard Green,
London

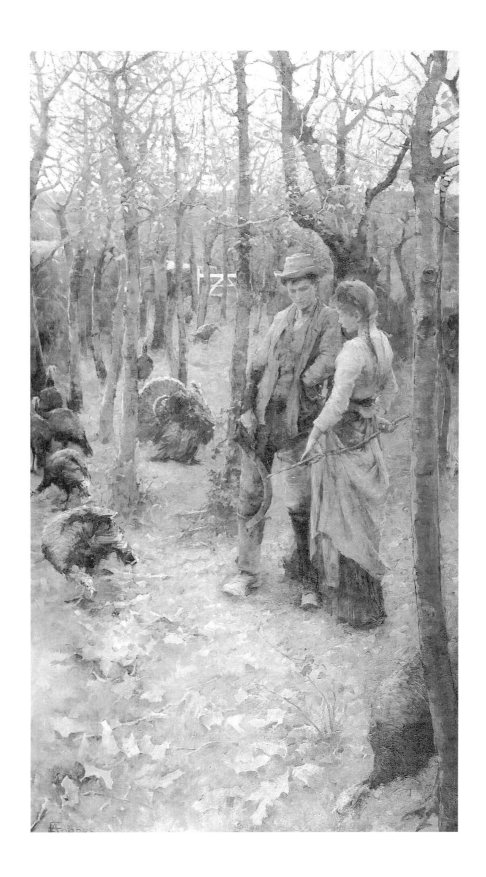

It was at about the time of their marriage that Newlyn began to sprout what were described as 'glass houses', prompting one unnamed artist to comment later in the *Magazine of Art*, 1898, that he had preferred the town before the speculative builder had stepped in and 'erected glass studios and all manner of other buildings'; after which, he continues, a host of swells would come down for holidays calling themselves artists.

According to Caroline Fox,[2] the speculative builder was the amateur painter Arthur Bateman who saw a need for studios built with lots of glass to enable the artists to make the most of the Cornish light while also being protected from the weather. The first he built was for Stanhope Forbes, the next for Bramley, followed, wrote Bourdillon in a letter to his sister, by 'a combined studio or glasshouse' for Garstin and himself. He described Bramley's studio as 'a lovely glasshouse...four sides and a roof of glass, a sort of magnified conservatory not lumbered up with plants and water pots.' Later he was to say that his own 'glasshouse' was so pleasant and comfortable that it was not conducive to work. In 1889 Bourdillon had turned to fantasised historical scenes, his best known painting of the period being *On Bideford Sands*, which shows two men in Elizabethan costume apparently stopping a duel between two others.

The most important local artistic event until the opening of the Passmore Edwards Gallery in 1895, was the Private View held every year in the studios around The Meadow. Every March the artists would collect together all their work and hold what Stanhope, in a paper he gave in the Passmore Edwards Gallery in 1939, quoted an old Newlyn man, Simon the Tanner, as describing as 'that there private view!'

In yet another letter to his sister, dated April 1889, Bourdillon described how they were organised: 'From 1.30 - 2.30 we had invitees from the village, i.e. our landladies, models, etc. From 2.30 to 5.30 all the top knots and bigwigs and from 5.30 to dusk the doors were opened to everybody who wanted to come in. There was a rush and dust and heat! Fearful to endure. How the ladies bore it, I can't think, for I know I was tired enough. We must have had a thousand people there all together.' Later Stanhope was to say that he still felt nostalgic for the old days of the Meadow Private Views, when the

PAGE 88
4.18 *At the Edge of the Wood,* 1894
oil on canvas, 134.6 x 81.8cm
Wolverhampton Art Gallery

PAGE 91
4.162 *Landscape Near Paul, Cornwall*
watercolour gouache, 43.2 x 30.5cm
image courtesy of David Messum
Fine Art

Meadow itself would be crowded with people making a picnic of it, looking through the studios, chatting on the grass and drinking tea and eating the cake provided for them in the open air.

But an even more important artistic event was the sending off of paintings to the Royal Academy. Months of frantic activity were followed by weeks of desperate anxiety while the hopeful painters waited to hear whether or not their works had been accepted. For those who were fortunate, their next concern was the position of their pictures on the Academy walls. Status was everything. Eventually the Great Western Railway Company added an extra van to its famous *Flying Dutchman* train in order to carry the artists' submissions to the Academy.[3]

Then there were the amateur dramatics described so graphically by Stanhope in his letters to Elizabeth before their marriage. These never lost their appeal and by 1890 had outgrown the Newlyn schoolroom and were being performed in the large St. John's Hall in Penzance. The 1890 show proved so popular that it was taken over to Falmouth and put on there. Henry Tuke described it as a vast success, noting that Caroline Gotch had charmed everyone. He does not mention whether Elizabeth took a role.

In 1891 Elizabeth and Stanhope returned to Brittany and spent the summer there. Stanhope wanted to introduce Elizabeth to Cancale, which so inspired him in his early days. She loved it, writing about it with enthusiasm:

> Cancale has certain features in common with our own Newlyn. Further out, in a wider sweep of the Bay, lies the great Mont St. Michel – the larger prototype of our own St. Michael's Mount; the slate roofs of Cancale lie in shadow under the cliff, just as nestles the kindred village on the English coast. Whosoever loves the Cornish soil must perforce feel drawn towards that Breton land of which, if one believes the old legends, it once formed part.
>
> There is so much in common, too, between the racial characteristics of the two peoples. Beneath the more apparent light-heartedness and bonhomie of the folk on the southern side of La Manche, one feels more, especially in the men, that deeper strain, that simple faith and capacity for religious emotion which,

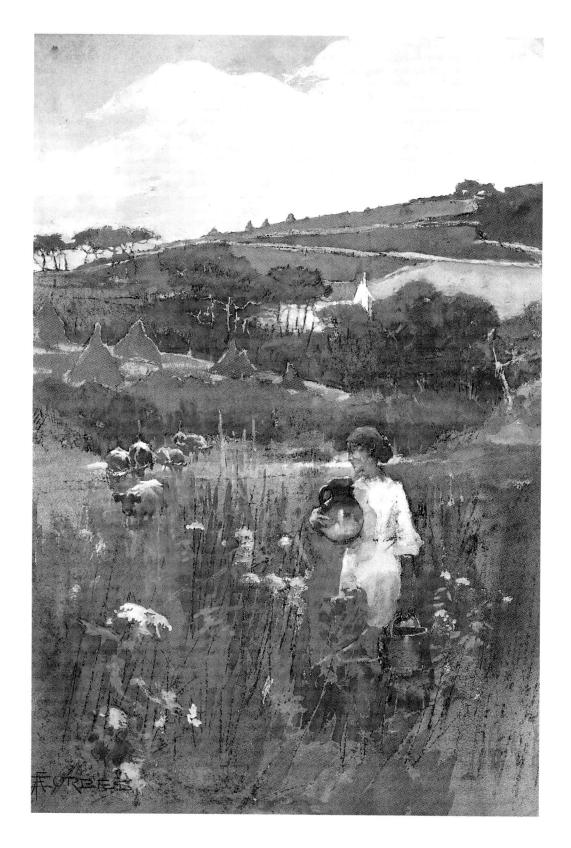

in Cornwall, had given Mr. Forbes his theme for his Salvation Army. Here it naturally finds expression in the old beliefs and ceremonies of Mother Church. Touchingly impressive is the celebration of the Fête Dieu, when one wakes to find that the whole seafront and the steep village street have been draped by busy hands with all the clean white linen that the housewives can muster, garlanded with ropes of greenery and made gay with flowers and flags. At the appointed moment is heard the distant sound of the solemn chant, and the long procession is seen approaching; the priests in their vestments, the scarlet-clad acolytes, the 'Filles de Marie' in their blue and white, and then the long train of brown and bearded sailors, bare-footed, and with heads uncovered, many carrying as votive offerings, little carefully-fashioned models of their boats – all making the pilgrimage thus to the little favourite shrine four kilometers away, where Our Lady makes perpetual intercession for all who go forth to the deep sea.

In the conformation of the Bay, there is one essential difference from ours at Newlyn. Far, far out, at the Bas de l'eau, the ocean recedes, laying bare miles of gleaming sand. Then Cancale wakes to an especial and most picturesque activity. Down to the beach troop crowds of strong-limbed, white-coiffed women, skirts kilted high, and shrimping nets on shoulder; old men, boys and girls, happy, gossiping, gaily gesturing. 'Venez donc, Madame, et vous verrez comme il faut beau le-bas!' called out one of my models, her eyes sparkling with pleasure. 'C'est pour moi un vrai fête d'y aller!' Of the patient, plodding peasant of the fields one feels the pathos of his dull senses, the glory of dawn and of sunset signify to him nothing but the beginning and end of toil; but the strong salt sea-wind seems to have given these dwellers on the coast something of its own exhilaration. In inarticulate consciousness they are certainly alive to the wonder of that harmony of turquoise and silver which lies far out in the ocean bend at the Bas de l'eau. There is spread out a whole world of freshness and fair colour and mystery, strange creatures flap and wriggle helplessly on the firm, shining sand; the white-capped girls scoop up the

transparent shrimps in their nets and gather up the preciously
guarded rough brown shells from the parcs aux huîtres.

All of this shows that when she set her mind to it, Elizabeth could
also paint glowing pictures in words.

The year 1891 was a good one for Elizabeth for she was awarded
a medal at the Paris International Exhibition for her painting *One,
Two, Three and Away* and had also been admitted as a member of
the Grosvenor Gallery Pastel Society. Indeed between 1890 and 1892
Elizabeth never stopped working. She painted three major works in
oils, *Mignon, A Game of Old Maid* and *A Minuet*. Her interest in

4.94 *A Game of Old Maid* 1891
oil on canvas, 101.6 x 63.5cm
image courtesy of Natura Designs

93

children continued in numerous drawings, pastels and watercolours, resulting some years later, first in 1900 when she was given an exhibition at the Fine Art Society, which she called 'Children and Child Lore' and again in 1904 in an exhibition at the Leicester Galleries called 'Model Children and Other People'.

In *Mignon*, the lute-player sits surrounded by stacked-up theatrical properties and both *A Game of Old Maid* and *A Minuet* show her understanding of, and sympathy with, children. In both paintings a smaller child or children look on while their older friends or siblings practise an adult ritual – in the case of the first card-playing, in the second the dance.

The reviews of *A Minuet* when seen at the 1892 Royal Academy Exhibition were moderately favourable. The *Ladies Pictorial* of June 18, commented: 'Painted in rich but quiet tones, this picture, with its graceful figures and subdued colour, is possessed of many charms. Yet, truthful and successful as it is, one cannot help feeling that Mrs. Forbes' true province lies in the painting of open-air pictures (in which her remarkable faculty for landscape as well as figure has full play) rather than in subjects like *A Minuet*.' The critic of the *New York Evening Post* damns with faint praise: 'Decidedly the best showing by Americans is made by Mrs. Stanhope Forbes – a Canadian – in her true, if somewhat perfunctory rendering of *A Minuet* in a dimly lighted room.'

Contemporary collectors of information about the Newlyn School not only rarely dated cuttings and reviews, but sometimes failed to note from which publication they were taken. Two such reviews of *A Minuet* are examples. The first is grudging, noting that 'the colour is good and [there is] some spirit of design, but a sad absence of finish and grace of line, surface, modelling and research...' The second is well worth quoting not only because of what it says about Elizabeth but for its attitude to women painters. (Elizabeth, it is well to note, now appears as 'Mrs. Stanhope Forbes'.)

The only other fact to be remembered before going to the Academy is that there are no pictures of distinction this year; nothing which rises much above the average. Bearing these two things in mind, it will be found that women make a very fair

(4.193) **On a Fine Day,** 1901 (study)
oil on canvas
image courtesy of the Belgrave
Gallery, London and St. Ives

showing. A large number of exhibitors are women; you will be surprised to see so many, if you glance through the list of names in the catalogue. This proves at least that comparatively few are now willing to limit themselves to the small galleries and special shows. That their work is accepted, I regret proves little, for the Academy standard might be higher. Several have their pictures 'on the line', and in centres of honour. Foremost this year is Mrs. Stanhope Forbes, with her *Minuet*; she is one of the most accomplished of the Newlyn School, and at times, in colour and effects of light, surpasses her husband.

In 1892 Stanhope achieved his ambition to be elected an Associate of the Royal Academy. He was also the youngest. His election received the general approval of the art world, the *Piccadilly Magazine* stating that 'on the whole' the appointment is satisfactory.

The report notes that he is considered a leader of the Newlyn School and has been thought its most representative member since the purchase of *The Health of the Bride* in 1877 [sic]... 'Mr. Forbes is closely connected with the Forbes of the London, Chatham and Dover Line; he is of private means – which counts for much at elections – and is married to that delightful, especially with pastels, Miss Elizabeth Armstrong, a lady of English birth [sic] who owes most of her training to New York', it continues, inaccurately. The report ends with a sneering reference to Stanhope's admiration for Bastien-Lepage. The anonymous critic of *Life*, alternatively, writes that 'no young artist of late has risen more rapidly in eminence; and he is withal so modest and unpretentious and so chary of self-advertisement, that one is the more pleased to hail a rising star....possibly his bent in Art has been unconsciously directed by his mother, a charming and accomplished lady of French birth, who is justly proud of her son's good work.'

It is interesting to see how far afield was the interest in the Academy exhibitions in 1890s. Even the *Daily Free Press* of Aberdeen ran the story of Stanhope's election, topped by a drawing of him gazing soulfully into the middle distance, taken 'from a photograph by R. W. Robinson of Redhill, Surrey'.

In the late summer of 1892, Elizabeth became pregnant. From Stanhope's letters to his mother she seems to have had a healthy pregnancy, continuing to paint and take long walks right up to the baby's arrival. The birth was a little later than expected and a nurse was already staying in the house when the event took place. Alec Forbes was born on May 26, 1893 and, after first sending her a telegram, Stanhope at once sat down and wrote to mother.[4]

'Lizzie', he wrote, 'was quite well yesterday and went out for two walks, enjoyed her dinner and played (cards) a little with me. She went to bed about twelve. Soon I heard something going on and presently the old lady (the nurse) came down to tell me she was beginning to feel bad, so I went off at once for the doctor.

'I brought him back about 2 a.m. and the little chap was born about 5.45 a.m...a dear little man. He came into the world in a most capital manner. Everything went off most successfully – on the whole my dear girl had a very good time. I went up to see her and she was looking first

rate, with the wee chappie lying in her arms, as proud as punch.'

Whatever Juliette might once have thought of Elizabeth she responded to the news of the arrival of another male Forbes in rapturous terms. 'I was so pleased and excited at the news that I can't say much except my heartiest and warmest congratulations to you both. Of course, though I expected it every moment, when the telegram arrived I felt nervous and was gladly relieved to see that both Elizabeth and the baby are doing well.' She hoped to have more news soon of the appearance of 'the little one'. Uncle William, she wrote, sent his congratulations too. 'God bless you, my dear, and may your little one be a comfort to both of you and bring you every happiness through life. I hope to hear daily of the progress of both.'

Congratulations flooded in to Elizabeth and Stanhope from family, friends and acquaintances all over the country, many expressing the hope that he might be 'an artist like his father'...Norman Garstin wrote that he was not surprised the baby had been born late 'since you've never been on time for anything, I'm sure your baby could not be punctual!' Dochie Garstin added a note to the effect that she had lost her bet with Elizabeth that it would be a girl.

'WJW', presumably William Wainwright, wrote:

Hail little Stanhope Forbes,
Born to perpetuate more daubs,
And to follow in the track of Pa and Mother
May you wax and never wane,
May you never have a pain,
And paint as well as our Dad some day or other![5]

Even the manager of the Harrow branch of the National Bank Ltd. sent Mr. and Mrs. Forbes his formal congratulations.

All was well and little Alec continued to flourish. Shortly after his birth, the Forbes family left the Cliff and moved up above Newlyn to the village of Paul where they rented a fine old house, which had been built in the seventeenth century by William Godolphin, called Trewarveneth, the translation of which is 'the house on the hill'.

4.256 *Toddler with Rattle*
oil on canvas
Private Collection
image courtesy of West Cornwall Art Archive

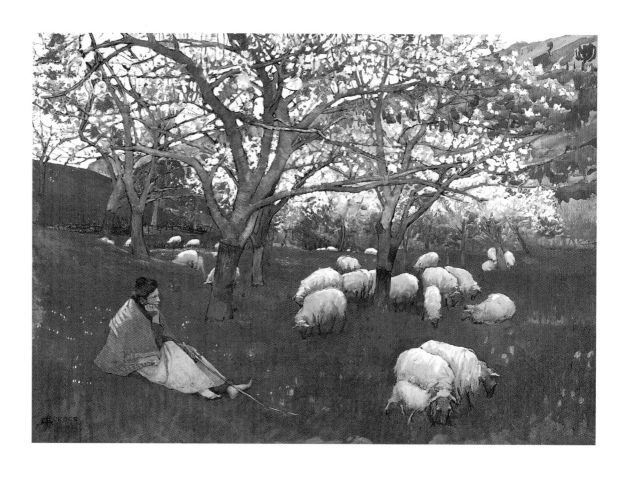

Painting in the Pyrenees

CHAPTER SEVEN

Elizabeth and Stanhope adored Alec. There is no clue as to whether or not they were unable to have any other children or if a conscious decision was made, given Elizabeth's determination to continue with her professional career, to limit their family after Alec. For whatever reason, he would remain their only child. A portrait painted by Elizabeth when he was four shows a sturdy child standing behind a chair. His fair hair is long and shining. Like most boys, certainly middle-class boys, born for centuries before the 1914-1918 War, he still wears a dress. In this case it has a large sailor collar tied in front in a huge bow. He also wears knee-length white socks and ankle-strap shoes.

This is a practice never mentioned today when there is so much discussion of gender issues and male/female influences on very young children: that, no doubt, Sir Francis Drake, the Duke of Wellington and many other such wore frocks until they had reached what is now school age... In this context, it is interesting to note a letter from Stanhope to his mother, dated July 18, 1886, when he first met the Gotch family. Although they were to become his good friends, to begin with he was far from approving. Gotch he likened to 'an unmade bed' and found Caroline Gotch far too lively, but he reserved his greatest disapproval for the way she dressed her little daughter, Phyllis, in 'boys' clothes', no less, to give her greater freedom. 'This absurd way of dressing their sweet little girl is all too characteristic of them. Mrs. Maddern is VERY shocked. "O, Mr. Forbes, I do call it wrong!" ' The portrait of Alec, which must have met with Stanhope's complete approval, is of idealised childhood; he stands in a golden glow in front of a large copper bowl.

PAGE 98
4.231 *Shepherdess of the Pyrenees* 1899
pencil, watercolour and bodycolour,
40.6 x 55.2cm
image courtesy of Christie's Images

ABOVE
4.261 *Two Dutch Girls*
watercolour
Private Collection

The next few years would see the gradual breaking up of the original 'Newlyn School' of artists as time, marriage and a desire to try pastures new took their toll on the merry band of young bachelor artists who had descended on Newlyn in the early 1880s with their strange ways, concerts, cricket matches and bohemian parties. Also, because of the weather, enthusiasm for wholly *plein air* painting was diminishing. While Bramley and the Gotches would remain, many of the others moved away up the country, some returning from time to time, others not at all.

Elizabeth, practical as ever, partially solved the matter of painting outdoors without being either rained off or blown away, by having a moveable studio especially built for her. Obviously it could not be moved very far afield but it did allow her to paint both real life and imaginary subjects set in autumn and winter landscapes. An edition of *The Studio* published in 1894 shows a photograph of Elizabeth at work in her studio, the writer 'E.B.S.', admiring her perseverance and noting that the studio had been 'the cradle of many of her later pictures'.

E.B.S. continued: 'It need not be said that, true to the conditions of the *plein air* scheme, Mrs. Forbes attaches great importance to the actual painting of the picture out of doors, and clings loyally to the programme of the naturalists which, accepted as gospel but a few years ago, is now finding many backsliders, who would fain resort to the easier plan of working up large pictures in the studio, from studies made upon the spot.'

Her adoration for her small son and the need to oversee the household (albeit with domestic help) does not in any way appear to have affected her output or its quality, nor her other pursuits.

The year after Alec's birth she had exhibited a painting *Jean, Jeanne and Jeanette* at the London Guildhall Loan Exhibition. It seems most likely it was actually painted in 1892 in Cancale and is of a young girl sitting by a wheelbarrow from which a goat is eating. In the background is a young boy.

She also painted *At the Edge of a Wood*. The same edition of *The Studio* as quoted earlier, notes that it was painted 'a stone's throw from her studio, within the boundary of her domicile, yet he would be a bold man who apart from the costume of the figures, was able to fix it even as peculiarly "English"...You may dislike

genre subjects, or the *plein air* treatment, but you cannot honestly say this is other than a singularly good example of a school which, since the days of Bastien-Lepage, has received favour everywhere, and also provoked the specially insistent obloquy of a few critics who chance to dispute its aims.'

It was also about that time that Elizabeth became caught up by a then popular genre which, in spite of all her technical skill, now appears very dated. She was not alone, even among the Newlyn artists, in becoming entranced by the fashion for pseudo-mediaevalism, a mediaevalism which owed more to Tennyson and *Idylls of the King* than to any real historical basis. The result is a series of pictures showing models in what can only be described as fancy dress.

In *On a Fine Day*, five girls in jewel-coloured 'mediaeval' gowns are posed in front of a golden pastoral landscape; in *The Leaf* a young woman, similarly attired, stares pensively into a pool in a wood. There is no doubt that these paintings proved immensely popular. In 1916, four years after her death, a Thomas Brasher wrote to Stanhope about the 'lovely picture' he had bought some years earlier. 'I do not know the subject of it,' he writes, 'and I am writing to see if you can kindly tell me. The subject apparently is Shakespearean. In a wood a lady is sitting down looking at a minstrel who is playing a lute. In the middle distance are two hounds wandering in the wood and in the background an open landscape is seen. I'm afraid this is a very poor description of a picture which is a constant source of pleasure to me.' The picture was almost certainly *Take, Oh Take, those Lips Away*. 'It is a truly lovely picture,' continues Mr. Brasher, 'and the pleasure it gives me cannot be counted in pounds, shillings and pence. It hangs in a place of honour in my small collection.' Of more lasting appeal is *A Game of Old Maid* also painted about this time.

During Alec's early years it would seem that as a rule Elizabeth stayed in Cornwall to be with him when Stanhope had to go to London. An undated letter in 1897 from Stan to Lizzie giving details of his expected time of arrival in Penzance the following Saturday, castigates her as in their pre-marriage days for not writing to him often enough, then continues: 'You haven't told me what my sweet

4.283 *Young Girl (nude)*
oil on panel, 49 x 30cm
Trehayes Collection

boy thought of his Daddy's letter and I am wondering if he enjoyed it. I think it was on Friday or Saturday that I posted it. Very sorry to hear he isn't quite so well, I think it must be in sympathy with his Daddy.' (Stanhope had a cold.) There is a charming drawing in the margin of a male figure wearing a bowler hat and overcoat rushing arms outstretched towards a smiling female figure holding in its arms an excited toddler.

'Daddy's letter', also undated, gives an indication of how Stan thought of, and spoke to, his small son:

> My own dear Boy – Many thanks for the nice little card which Daddy was welly pleased to get. Daddy is looking forward to seeing his Little Man next week. He misses him welly much and is thinking of the time we shall have together when we all come up in the spring. We shall go to the zoo and see the lion, the tiger, the monkeys, the kangaroo, elephant and giraffe and we shall have tea with bonne-mama and Mummy will join us in her wonderful new hat and we shall all come home together in a cab – love and many kisses, your own Daddy.

This too, is decorated with lively sketches of all the animals mentioned, a tea party with Elizabeth wearing a huge hat and, finally, figures dimly seen sitting in the back of a hansom cab.

In 1898 Stanhope and Elizabeth took a painting holiday without Alec in the Low Pyrenees, an expedition which Elizabeth wrote about at length and which was published in *The Studio* some years later under the title 'On the Slopes of a Southern Hill'.[1] It shows that she had lost none of her undoubted energy nor her love of exploring, for she and Stanhope hired solid-tyred bicycles and set off on a cycle tour looking for a picturesque base in which to settle for a month or two.

'Perhaps,' she begins, 'it was because we came on our village just at the magical minute when the last red gold of the sun was dying from the hills; perhaps it was the troop of handsome barefooted girls who bewitched us. They were crossing an old Roman bridge, erect and dark against the pale sky, their sickles at their waists, bundles of fresh-cut grass on their heads. "Adios!", they called back to the strangers in a chorus of civil and kindly welcome.' The first sight of the bridge and its occupants later inspired Stanhope to paint it,

under the title *The Old Bridge*, though the only figures portrayed are a young girl with some goats, a peasant behind a haywain and another sitting by the roadside.

As they arrived the bell was ringing for the angelus in the church 'with a string of pearly-white houses at its feet, with its broad setting of purple mountain above, and purple reflection in the river below'. Stanhope and Elizabeth, who were staying at a small seaside resort, had already spent several weeks exploring the foothills of the Low Pyrenees 'that borderland which, with all the evidence of douanes and milestones to the contrary, is neither France nor Spain, at least in either sentiment or tongue, but belonging to a people apart, who intermarry without reference to the frontier, and keep intact the old language and racial characteristics, which have been theirs so long that no record exists of their beginning.' (The Basque language is virtually the only one for which no root has ever been discovered.)

Although it was only late February, the sun was 'uncompromisingly brilliant', the roads dusty, wayside figures

4.273 *Will o' the Wisp*
oil on canvas sealed to panel, triptych,
68.6 x 111.8cm
National Gallery of Women in the
Arts, Washington D.C.

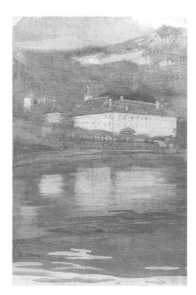

4.49 *Chateau At Lac D'Annecy*
watercolour and bodycolour on linen
laid on card, 35 x 24cm
image courtesy of Christie's Images

'commonplace'. 'The endless groves of pollard oaks thrusting crooked arms, like beggars, up to the hard blue sky, offended with their shadeless monotony.' They were in fact on their way back to the coast when they found their haven because 'in spite of the physical exhilaration of exercise in strong, pure air, on perfect roads, a certain sense of discouragement was beginning to make itself felt, when, as we ran down a long slope, the valley opened up before us.' The sight of the village enchanted them. 'All this arrested our wheels and we exclaimed with conviction Eureka! This shall be our village and our abiding place!' The village was called Ascain.

It was too late to find lodgings that night but they returned with their baggage the next morning to find it had not lost its charm when seen in broad daylight. Madame at the village inn was polite but deprecatory. Her rooms, she told them, were small and few, and monopolised mostly by commercial travellers. Were there, they asked, any furnished cottages or apartments to let? Madame thought a while then suggested a small villa on the road to La Rhune.

The scenery was glorious but the artists were tired and weary by the time they had struggled up the path and found it. However, 'a touch of comfort and home in its aspect attracted us, perhaps a legacy from a former English owner'. The view was so beautiful that they decided then and there that this would be their base for the rest of their holiday. Negotiations were quickly concluded and they took possession. A pony chaise was hired along with a baggage wagon, a bullock-cart, 'piled high with supplies and materials for our campaign'. It took hours for the latter to arrive from the coast.

Along with the villa went Marie, a bonne à tout faire, recommended by Madame L'Epicière as: 'Laborieuse, d'une economie parfaite, et avec ça, toujours gaie et de bonne humeur.' And, notes Elizabeth, she lived up to her reputation. She arrived with her belongings carried on her 'small classical head'; in her hand a green parrot in a cage, a cherished souvenir of her sailor husband. The parrot soon made its present felt, 'an accomplished but discreet fowl, not addicted to screaming but fluent in three languages, Basque, Spanish and French, to which he quickly added a little English.' Marie, she writes, while a true-born Basque, had perfect manners. How comforting it was, notes Elizabeth, when they

returned from painting all day in the chill of the evening, to see Marie in her bright peasant clothes moving among the wavering lights and shadows in the big kitchen, the fragrance of burning logs mixing with that of a juicy chicken or a joint of tender lamb.

During her stay in Ascain Elizabeth embarked on a series of drawings and pastels of the village and its surroundings, including the villa. An early charcoal drawing of a view of the village from a field on its outskirts with a young girl leading a cow on a halter, is particularly fine.

They immediately sought out their neighbours for permission to draw and paint on their land and also to enquire if they would be prepared to model. There was no shortage of subject matter. They found the way of life both picturesque and intriguing, not least the use of oxen for transporting heavy goods. 'Nothing is more reminiscent of a bygone age than these creatures...their patient heads held low, their backs covered with sheepskins hung with scarlet tassels.' The rural population was equally picturesque; young men described by Elizabeth as looking like Greek gods, old men erect and sinewy in 'wonderful faded clothes. One with the face of Dante lifts his beret in dignified salute as he drives his flock of sheep past our gate. Rustic Henry Irvings urge their lumbering bullock-wagons down the difficult mountain tracks. They direct their beasts with large gestures and wavings of their ox-goads, as though performing an incantation and call to them with deep-chested resonant voices.'

Not since their early days in Newlyn had the artists found such a wealth of unsophisticated and willing models who, it seemed, fell naturally into the most picturesque poses in their faded clothes and rope-soled shoes. The women, especially, 'carry their small heads nobly poised on their round throats and robust shoulders.' They had been told they would find the mountain Basques too superstitious to sit for them but this rarely proved to be the case. The couple were welcomed from the first and as for the peasants 'their delight knew no bounds when they were able to recognise some familiar objects in my sketches.' Once they had grasped the idea that they were wanted as models they assented with an enthusiasm 'only partially due to pecuniary reward'.

So enthusiastic did the villagers become that when a particular sitter was required at short notice, a member of his or her family was

4.86 *Fetching Water*
gouache over black chalk, 45.7 x 33cm
image courtesy of Phillips
International Auctioneers and Valuers

detailed off to take over whatever work that one was doing. Soon the acquaintance was made of that group of young girls who had so enchanted them on their first sight of Ascain, when they had seen them crossing the old bridge. 'They were all sisters or cousins, lively as green lizards on a sunny wall, and apparently as poor.' One, 'a hazel-eyed gamine of fifteen', attached herself particularly to Elizabeth. 'She was an ideal model, a brown-limbed, lithe young animal, to whom blazing sun, drizzling rain, or biting March wind appeared to be equally unimportant.' Elizabeth was amused at her model's complete disregard for all ideas of comfort, while her food

appeared to consist only of dry bread occasionally accompanied by the leaves of wild sorrel. When pressed to accept food from the Forbes's kitchen she would either refuse altogether or put it aside to take home and share with her family.

During the first two weeks in the village it was fine enough to enable them both to paint outdoors but this was followed by ten days of unsettled weather when black rain-laden clouds 'came rolling up from the sea with hysterical bursts of sunshine between that lasted just enough to lure us out to our doom, a thorough soaking. After a few days we gave it up – turned our poor painted presentments of the jocund spring dejectedly to the wall and sought refuge, shivering, in interiors.'

Yet here, too, there was much to inspire her. The local farmhouses were heavily timbered with projecting upper stories, the family living 'sandwiched' between the two sources of their wealth, the cattle and the produce of the fields. The grenier was packed with hay, while the ground floor was home to cows, pigs and sheep. In one little old cottage Elizabeth discovered a 'Rembrandt old woman', lurking in the velvety gloom moulding fresh butter into pats. 'When the Angelus de Midi rang, she dragged out a few old sticks from a corner, and, crouching inside the big fireplace, made up a crackling blaze. Then she stirred up a weird concoction in a pot and poured it out steaming for her grandson who came in wet and bare-footed from the fields. She was sublime, that old woman, in her invincible philosophy and capacity for seeing the joke of a situation. The crazy old cottage walls shook with her jolly laughter when her small neighbour of superior education explained that the English stranger wanted to paint her. Such a superlatively funny thing had never happened to her before.

Through her interpreter she indicated that while the stranger was welcome to the house, such as it was, she would not be put in any picture, not she – 'her time was over for that sort of thing. But it was a wonderful joke all the same, and she cackled and bubbled away with merriment all by herself for an hour after.' She also seemed impervious to the weather, even when the water dripped through the roof or the rain blew in through the unglazed windows. She continued washing her plates, conscious of no hardship and then,

4.230 *Sheltering From The Sun*
watercolour and bodycolour on linen
laid on board, 33 x 21.5cm
image courtesy of Christie's Images

with kindly courtesy, tried to press on Elizabeth an old mackintosh and an umbrella to ward off the driving rain.

With the end of the storms and rain came yet another dramatic change in climate. The sun shone and the grass was knee-deep in meadows white with daisies and blue with gentians. Leaves appeared on the trees within days and water poured down and tumbled in cascades into the Rhune river which ran through the valley; for weeks they basked in endless sunshine.

But all holidays have to come to an end. Having watched the mountain above them in all its moods, even one morning finding it covered with snow, Elizabeth and Stanhope decided that before going home they should attempt to reach its summit. By this time they had been joined by other (unspecified) artist friends and the whole party, complete with guides, Marie, some of her friends and a mule 'for the weaker ones', made the attempt on the summit, laden with picnic baskets.

They climbed steadily first through meadows full of 'hoop-petticoat narcissus', then up paths 'hardly visible and growing ever steeper', until they reached the summit of a crag only to find other peaks high above them. Below they could see the level blue stretch of the Bay of Biscay 'that grew ever wider as we climbed, and the white line of breakers that curves away to Biarritz at the north, while to the left of us was the wide mouth of the Bidassoa, with Fontarabie and the Cap du Figuer.' It was a hot and tired company that finally flung itself down on the grass of the summit clamouring for cool drinks and, she notes, cigarettes. 'But with the sweet wind blowing in our faces, straight across from the jagged crests of the Pic d'Midi and his mates, when we peered over the edge, and looked down, down, into the serene blue depths below, where the rivers showed like skeins of silk, and where two huge...eagles were majestically circling, we owned that our climb had earned an abundant reward.'

After the picnic hampers had been emptied and the party was replete, Marie and her companions provided an impromptu entertainment. To the accompaniment of an old Spanish lovesong, and snapping their fingers to make the time, with the sharp click of castanets, the girls whirled and pirouetted against the sky in the

fandango and 'as a final tour de force, Marie, who was a notable dancer even in that land of graceful women, gave us a pas seul full of complicated execution, an empty bottle balanced on her head!'

A drawing by Elizabeth catches the moment exactly. Marie, a white apron over her full skirt, is turning in the dance, her body half-twisted, her head bearing its bottle, facing the audience while her shadow makes a fantastic shape beneath her feet.

It was the end of May and Elizabeth and Stanhope had been away for nearly three months. It was also now becoming unpleasantly hot. Saying good-bye to the neighbours who had made them so welcome 'cost us more of a pang than we would have thought possible'. They had been generous of themselves and their village and 'their patriarchal life had unrolled itself before us, with the dignity of its ever-recurring tasks, its simple pleasures'.

The bullock-wagon was once again loaded up with their possessions, a pony-chaise hired for the trip back to the coast. 'We packed away our palettes with a sigh for how little we had been able to record...' What her account of that holiday, written for *The Studio* much later, shows is just how well and evocatively Elizabeth could write when she chose to do so and was not being consciously arty.

They returned to Newlyn and to Alec, who must have missed them greatly, full of plans for the future. These included building a house of their own and the setting up of a School of Painting. If they were to remain permanently in Cornwall then Stanhope felt that they should utilise both the place and their expertise by offering tuition. His decision was to have far-reaching consequences, not least that of attracting a whole new wave of painters to west Cornwall.

The Newlyn School of Painting

CHAPTER EIGHT

Three years before the Forbes's trip to the Low Pyrenees, Newlyn had acquired its own art gallery. It was commissioned by John Passmore Edwards, an enterprising entrepreneur and public benefactor. Passmore Edwards was born in Cornwall, became a successful journalist and then proprietor of a stable of newspapers and journals. He was a firm believer in the value of education and the acquisition of knowledge, and of the twenty or so public institutions he funded in Cornwall, seven were libraries, while others were technical schools which included a library. But he also had a particular interest in the visual arts and in 1893 had underwritten the costs of the South London Art Gallery, Camberwell and, in 1900, was to fund the Whitechapel Gallery. [1]

The gallery envisaged by Passmore Edwards was to be for a known school of artists: the 'Newlyn School'. The local response to his idea was by no means one of unbounded enthusiasm, except by the artists themselves. This is a dismal trait of the locale which has lasted to this day, as evidenced by the opposition of many local worthies to the building of the St. Ives Tate Gallery, and also to an extension in 1998 of the Newlyn Art Gallery itself. The Tate Gallery, St. Ives, which opened in 1993, was argued over interminably until tourists began arriving in droves to visit it, bringing their money with them.

When most of the fears and suspicions regarding the Newlyn project had been allayed, building began in April, 1895. Passmore Edwards laid the foundation stone with a special trowel 'of artistic design made of beaten metal', in fact a mix of the county's two most famous minerals, tin and copper. Stanhope was at once

PAGE 110
4.79 *A Fairy Story* 1896
oil on canvas, 121 x 91.4cm
Private Collection

BELOW
4.15 *The Art Critics*
mixed media, 30 x 29.5cm
Private Collection

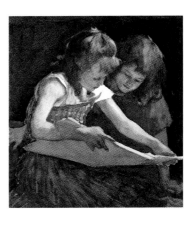

4.62 *Crossing the Stream*
crayon, watercolour and bodycolour,
61 x 45.7cm
image courtesy of Christie's Images

acknowledged as the leading member of the group that would run the gallery when it was completed.[2] For the rest of his long life he would be Newlyn's most prominent figure, often referred to by the nickname given to him by his students – 'The Professor', after the opening of the Forbes's private School of Painting.

By today's standards the project went ahead quickly, despite the initial hiccup in that April, when everything had to stop while Passmore Edwards was prosecuted by Madron Urban District Council for starting to erect an art gallery without giving notice in writing to the correct offices of his intention, thus breaching local bye-laws. The matter was quickly resolved, however, and the gallery was finished by the autumn.

The inaugural exhibition was opened on October 22, 1895 by Leonard H. Courtney, M.P., 'supported by the Right Hon. Lord St. Levan and T.B. Bolitho', to be followed by a public luncheon at the Queen's Hotel, Penzance (tickets 4/-) at which the principal speaker was Sir Arthur (then Mr.) Quiller-Couch (the famed 'Q').

Introducing Q, John Cornish spoke of how the 'Newlyn School' had helped spread the fame of the county outside its borders (even if some people thought it was an actual art college), pointing out that it had done for the art world what Quiller-Couch had for the literary. Quiller-Couch, he said 'is the man who erected Troy Town upon Dead Man's Rock'. In a thoughtful, if amusing, reply, Quiller-Couch noted that Mr. Forbes and the Newlyn School had undoubtedly left their mark on the century's artistic history but that 'Mr. Forbes and his art friends would be the first to smile at him if he were to pretend to complacently say Newlyn had said the last word about art. If that were the case, the building would indeed be a monument but a sepulchral monument.'[3]

The day was rounded off by a *conversazione* held in the gallery itself that evening 'at which several Ladies and Gentlemen have kindly consented to assist'. This would include music and dramatic sketches, the latter presumably performed by those artists with a continued enthusiasm for amateur dramatics.

Both Elizabeth and Stanhope exhibited in the Inaugural Exhibition, where twenty-three pictures were sold immediately, including three by Elizabeth. She also bought a painting by Frank

Bramley for ten guineas. It was not until the second exhibition, of drawings and sketches in December, 1895, that Stanhope sold his first sketch at Newlyn, although by this time he had no problems finding buyers for his work. He had continued, as he would for the rest of his working life, painting popular scenes of rural life and work; but, nothing ever again matched up to *Fish Sale on a Cornish Beach*. It is noteworthy, in studying sales records of the Newlyn Art Gallery exhibitions, that during her lifetime Elizabeth's paintings and sketches were always popular, and her works amongst the best sellers in every exhibition she entered.

Elizabeth and Stanhope continued exhibiting in Newlyn and elsewhere, including the Royal Academy, throughout the 1890s. By the end of the decade Elizabeth was accompanying Stanhope to London for various exhibitions leaving Alec in the care of his nurse. He was to be privately educated until he was old enough to go to the boarding school his parents had chosen for him, Bedales. An undated letter to his paternal grandmother in London,[4] heavily printed in capital letters and with uncertain spelling, thanks her for the present of a book and continues 'we have a pup. It is so fat we are afraid it won't be able to move.' His parents are out of town, he informs her,

4.158 *King Arthur and Guinivere*
watercolour, 12 x 14.6cm
image courtesy of Belgrave Gallery,
London and St. Ives

at 'Daddy's private view...my chums Frank and Tots are coming down and we shall have some paper chases.'

By the beginning of 1899, Stanhope was publicly expressing his dismay at the number of artists who were leaving Cornwall permanently but this seems to have made him all the more determined to stay in Newlyn. In large part, the reason was that they now loved the area so much, but another factor must have been the status he had acquired both locally and nationally. He had become so closely associated with the Newlyn School that his name was virtually synonymous with it.

The setting-up of the project took most of 1899, but finally in October the Newlyn School of Painting was officially inaugurated 'for the student who wishes to learn seriously to study painting and drawing according to recent developments'. The Forbeses were still living in Trewarveneth at that time and the school itself was based around studios on the Meadow.

At his inaugural lecture on the School's first day, Stanhope told the students: 'All we can do for you is to set you on the path, to show you how to avoid the errors, the false starts that we ourselves made in our time, to help you to grasp those broad first principles which underlie any work of art. Learn to draw, learn to grip your subject as a whole in its big lines and masses, learn to *see* and good luck to you!'[5]

Neither he nor Elizabeth would want the students slavishly to copy their methods, indeed far from forcing their technique on them, they wanted them to experiment, to use their brains, to 'observe and weigh in the balance the work of painters of the widest diversity of style, to keep your intelligence alert, to so train your hand that it may swiftly and subtly respond to the trained eye.'

Five months later, at the end of the first session, he expanded on the philosophy they had devised. It had been a joint decision, he told them, that most of the first term would be devoted to drawing in pencil and charcoal, even if this 'did not seem so amusing as splashing about in a paint box, but the qualities that go to make up a charcoal drawing are well-nigh indispensable and are moreover the foundation upon which the best work rests.'

When looking at students' work they had felt over and over again that all too often the work was over elaborate and sometimes

PAGE 114
(4.193) *On a Fine Day* 1901 (study)
oil on canvas, 39.5 x 28.5cm
Private Collection

BELOW
4.133 *The Hayfield*
watercolour, black chalk,
30.5 x 43.2cm image courtesy of
Phillips International Auctioneers
and Valuers

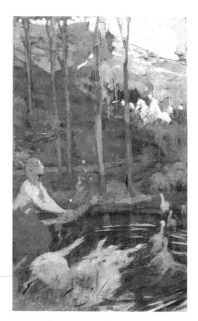

4.124 *The Goose Girl and the Prince*
oil on canvas, 40.6 x 27.9cm
image courtesy of David Messum
Fine Art

PAGE 117
4.201 *Path to the Village*
oil on canvas, 74 x 48.5cm
Private Collection

wondered how often they had used the expression 'make it simpler' on their rounds of inspection. 'The power of emphasizing the big facts, of grasping the masses and realising the thing before you in a large spirit – this is indeed one of the greatest of all qualities, and it is this which, above all, puts the stamp on the work of the master.'

Another strict principle was that of 'fidelity to nature. Truth is a very subtle thing indeed, not easy to seize upon or ready to be caught...search nature thoroughly and get at the heart of things. Never mind if you rub out your drawing a dozen times, or if you take ten minutes mixing a tone, so long as you get it right; but don't be satisfied until you get it exact...By all means experiment and try everything if you have time. But there are things that are not open to argument and which I cannot pass.'

He also listed other basic principles which had to be adhered to – slovenliness was unacceptable:

The ill-stretched canvas, the carelessly set palette with its half-dried bits of old paint, the dirty, badly-washed brushes – all these must go, and in their places let us see proper workmanlike tools, so that at least you start fair. Carelessness is not an artistic virtue...ten minutes spent occasionally in cleaning up, in putting the brushes in order, and resetting the palette, will sometimes do more than an hour's work on a picture which may be getting in a muddle through the fault of the paint-box rather than its owner!

As to which medium they wanted to use or what use they made of influences, that was up to them, so long as they had nothing to do with 'tricks, dodges and devices'. They should study the Masters. 'True outline is the shorthand of the accomplished draughtsman: look at the outlines in Holbein – tense as a bent bow, and true as an arrow shot from the string. He held and felt the solid form as the modeller grips his lump of clay.'

The early years of the School was an extremely busy time for both Elizabeth and Stanhope for as well as teaching in their school, albeit with assistance from other artists, they continued their prolific output, Stanhope's paintings including *The Lighthouse, The Smithy, Rescue at Dawn* and *Forging the Anchor*. Elizabeth, side by side with her mediaeval themes, such as *Ora Pro Nobis* and *A Knight,*

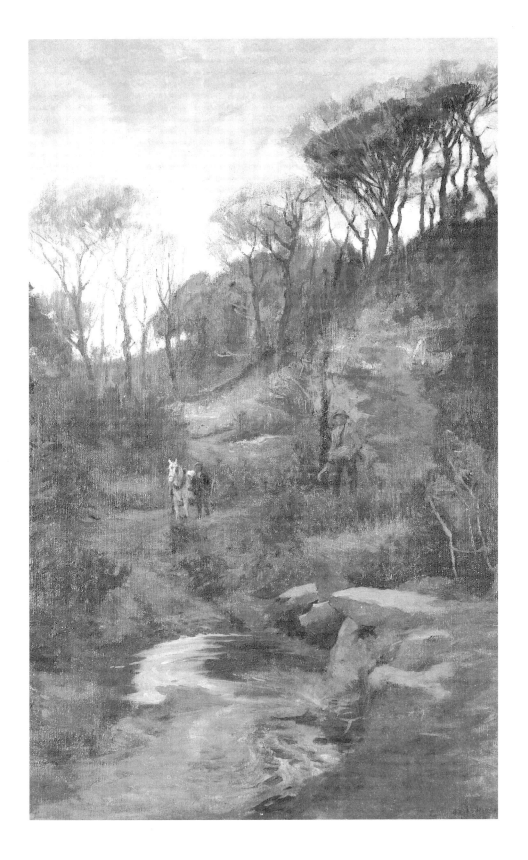

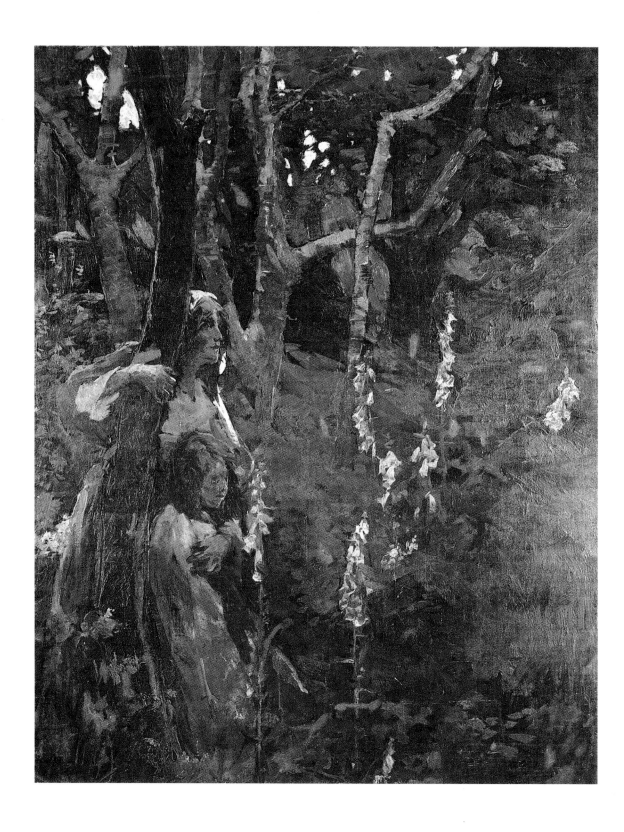

continued with her fine studies of childhood such as *The Fairy Story* and *Firefly*.

An account of student life at the School of Painting and the vital part Elizabeth played in it, appeared in *Girls' Realm* in 1904[6]. It is worth quoting fully as it shows what a caring, as well as a devoted, teacher Elizabeth was, and her 'hands-on' attitude to her students' well-being.

The writer, Gladys Beattie Crozier, had been given permission to attend classes for a week and take photographs for the magazine at the 'Stanhope Forbes Art School' [sic].

The day began early and all students had to be in the Meadow Studio by 9.15 a.m. A student, Betty, informed the writer on their way to the Meadow that they always had fresh models on Mondays and it was always interesting to find out how 'Mrs. Stanhope Forbes would pose them'. The model on that occasion proved to be a 'pretty Newlyn maiden, clad in a striped cotton skirt of rustic pattern, a faded green blouse left open at the throat, a bright blue sun-bonnet and carrying a rake.' A photograph shows Elizabeth arranging her on the model's throne. Possibly it was for the benefit of the photographer that Elizabeth is wearing a rather fine, tightly-corseted gown and a hat the size of a meat plate, heaped up with flora and fauna, but further photographs show some students wearing much

PAGE 118
4.76 *The Enchanted Wood*
oil on panel, 64 x 51cm
Private Collection

BELOW
4.130 *Harvest Moon*
oil on canvas, 50 x 68.5cm
Private Collection

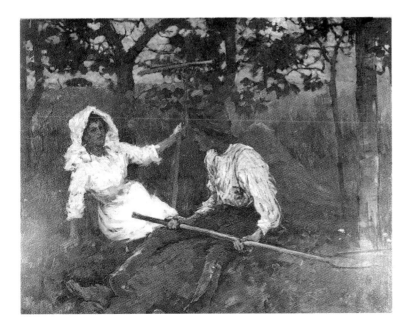

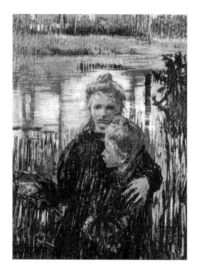

4.233 *Sisters*
pastel, 43.1 x 30.5cm
image courtesy of Christie's Images

the same kind of headgear, not only when sketching outdoors but also, and inappropriately, in the studios.

After the model had been posed, with chalk marks to ensure she could take up exactly the same position again, the students got down to work while Elizabeth circulated, watching what they were doing and giving advice. During breaks model, teacher and students would stroll together in the garden, chattering loudly as a relief from the silence in which they worked.

The largest working area consisted of a long, wide room divided into two sections, each with its own model and group of students who would remain there for a week, during which time they worked from two models, each of which posed alternate days from 9.30 a.m. to 12.30 p.m. every morning and from 2 p.m. to 5 p.m. in the afternoons on Mondays, Wednesdays and Fridays. In this way each student could complete two separate studies in any one week.

Another studio, further down the Meadow, was reserved for those wanting to draw from the Life. 'Life' in Newlyn did not, the writer hastily reassured her readership, mean the nude. In 1904 it seems that Mr. Forbes felt his models should be partially draped. These were professionals, hired from London and elsewhere and Mrs. Crozier much admired 'a handsome, copper-coloured Italian boy pulling at a rope, and forming an excellent study of the muscles of the human frame.'

An interesting light is thrown on the hiring of models during this period by correspondence in the Tate Gallery's Stanhope Forbes Archive. There are a number of letters from Italians either from their home country or living in England. Some, having heard that the School uses Italian models, offer themselves for hire and these are all too often followed up by further letters requesting a response then, finally and in desperation, asking for their photographs back. Letters from Antonio Fuseo and Carmino Tedesche fall into this category. Others, such as that from the mother of Orajio Cervi, dated January 5, 1904, are straightforward complaints. Signora Cervi writes that she feels her son was overcharged for board and lodgings out of his wages of two pounds a week and that if he were to return, she wanted the Forbeses to agree to pay his train fare to Penzance and then either to find him good but cheaper lodgings – pointing out that

these could be obtained in most places for ten shillings a week – or if that was not possible then the School would pay something towards it. 'I do not like to press this,' she wrote, 'but he has been offered other work.'

Two pounds a week appears to be on the low side, for both Gaetano Antonelli and Raphael Gallo wrote that their fee was 7s.6d. an hour, though there is no record of either receiving a response to their offers.

One of the studios on the Meadow site was used for still life where 'on alternative pedestals around the room were studies arranged by Mr. Stanhope Forbes himself', and also for casting. Another was given over to 'beautiful reproductions of works of the Renaissance period by the 15th century Italian sculptors'. Mrs. Stanhope Forbes was quoted as thinking these latter sculptures as more useful for young students to draw from, as a stepping-stone to working from live models. Otherwise, coldly classical heads were the usual form for a beginner.

The final 'studio' was an outdoor walled garden, where the most advanced students worked in the afternoons in fine weather from a special model. 'The changing light and shadows renders work under these conditions too difficult for inexperienced workers used only to the steady light of the ordinary studio.' A photograph shows Stanhope making a point about one model to a group of female students. However, the main work in hand at that time, according to Mrs. Crozier, involved 'a crimson-robed enchantress lying hidden in a wood', the model 'garbed in one of Mrs. Stanhope Forbes' pet mediaeval garments' bearing 'an air of magic and enchantment about her which both delighted the imagination and enchained the eye!'

The Newlyn School of Painting, she warns, was not intended for elementary instruction. All those wanting to be admitted had to submit examples of their work which had to be of a sufficiently high standard before the Forbeses would agree to take them on. However, once the students arrived, Elizabeth believed in making the work as interesting as possible for them and even the most inexperienced student was encouraged from the start to draw the local models in carefully constructed poses. She always urged her students to get into the habit of making a charcoal drawing of every subject before

BELOW
4.129 *The Harvest Flask*
chalk, 47 x 39.5cm
image courtesy of Leon Suddaby

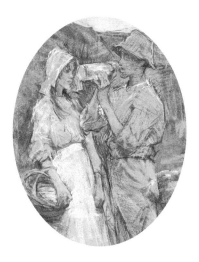

moving on to developing it in paint or pastel.

Mrs. Crozier writes gushingly of the beauties of the area, the coves, the beaches, the pretty cottages, the quaint villages and the picturesque harbours, and also of the 'rugged fishermen smoking their pipes', declaring west Cornwall to be a 'sketcher's paradise'.

On Saturday mornings students would submit unnamed pieces of work for 'The Crits' when Elizabeth and Stanhope would hold up each in turn for criticisms received 'with breathless interest'. Both gave 'delightfully spontaneous and helpful criticism on each piece of work in turn – often not knowing to which students it belongs'. These would be greeted with 'irresistible bursts of laughter', not least because Elizabeth was 'the possessor of a keen sense of fun'.

If there were any male students in Newlyn while Gladys Crozier was there, she does not mention them and, as she describes some

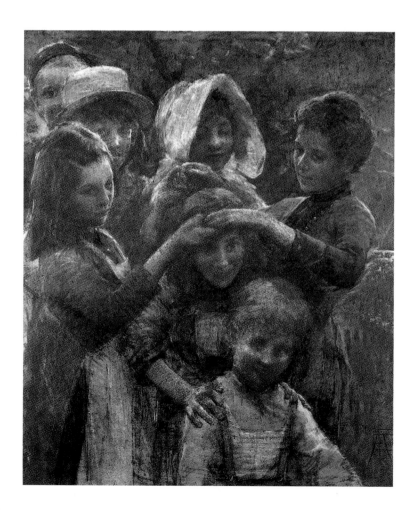

4.197 *Oranges and Lemons*
pastel, 78.7 x 72.8cm
Private Collection, courtesy of the
Belgrave Gallery, London and St. Ives

4.177 *Midday Rest*
watercolour and bodycolour,
45.7 x 33cm
image courtesy of Christie's Images

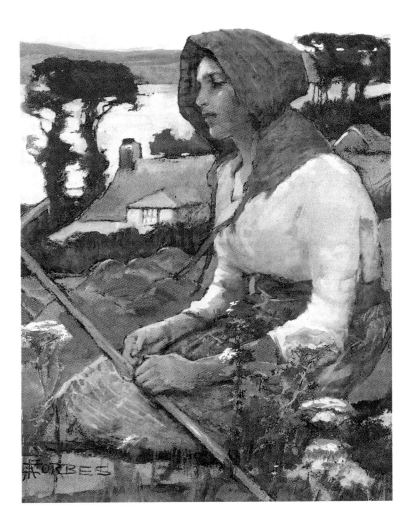

thirty or forty girls as being present at the time, there could hardly
have been room for many more. Obviously any magazine promoting
an art school had to be seen to be extremely responsible and the
writer emphasized that all the girls were well cared for. With regard
to accommodation there were cottages personally approved by
Elizabeth where a bedroom and sitting room could be obtained 'at
prices ranging from nine shillings to one pound a week, according to
size and situation ... Most of the lodgings have been re-papered and
repainted in artistic fashion by former students which is, of course,

the greatest possible advantage.'

Those living in west Cornwall today and paying premium rates for everything because of the area's distance from the rest of the country, will be interested to know that at the beginning of the twentieth century: 'Living is cheap; delicious Cornish cream, junkets, milks, eggs and vegetables form the staple fare, one's board usually costing from nine to ten shillings a week. Extremes of heat and cold seem unknown in Newlyn, for in winter it rarely or never freezes, whilst at midsummer it is no more than pleasantly warm.'

Gladys Crozier reported that the school year consisted of two terms, from June to mid-September, which cost ten guineas, and from the beginning of October to the end of March (with a two-week Christmas break), costing twelve. Students could join at any time for three guineas a month. Fees included use of studios and models but students were expected to provide their own materials 'which may be conveniently obtained from that excellent artists' caterer, Mr. Lanham of St. Ives, who comes over to the studios at Newlyn once a week for that purpose.'

As a rule, she continued, there are thirty or forty girls taking the courses and life provided 'plenty of amusement in winter and summer alike', not least because many of them had musical talent. A popular custom in the winter was to visit each other's 'diggings' to practise trios and quartettes or songs. Elizabeth would also host impromptu concerts or a 'gay little dance' in her own home. Hardly a week passed in which she reportedly did not arrange some little festivity for the entertainment of the students, neighbours and friends. Rehearsals for the amateur theatricals were also a feature of the winter term, and were held at the Forbes home.

In summer there were boat trips, visits to places of interest such as St. Michael's Mount, picnics, even sea-bathing – the bravest girls venturing a daily dip during their lunch breaks. The account ends with the news that students had been encouraged lately to compete for the poster prizes offered by several of the big railway companies. Elizabeth had said she was highly amused to find posters of Newlyn origin, the work of successful competitors, enlivening the railway hoardings all along the line the last time she had visited London.

The picture of Elizabeth drawn by Gladys Crozier is an attractive

4.156 *June Days*
oil on canvas, 45.7 x 35.6cm
image courtesy of David Messum
Fine Art

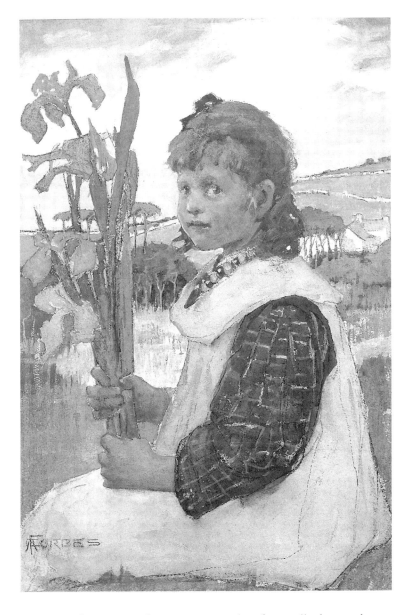

4.104 *Girl with Irises*
watercolour and bodycolour,
44.5 x 32.5cm
Private Collection

one. It is of a woman of great energy – she often walked up and
down the steep hill between Trewarveneth and the Meadow several
times a day. She was at the height of her artistic powers, with a desire
to impart her own enthusiasm and skills to her pupils whose welfare
she cared about, and whom she treated with respect, humour and
common sense.

THE BLACK KNIGHT
OF THE BLACK LAWN

'Mibs'

The decade from the opening of the School of Painting to 1909 can be seen as Elizabeth's golden years. Secure in her ability, regularly exhibited, internationally acknowledged, enjoying her teaching and devoted to her son, she seemed to have everything. Those who knew them spoke of the Stanhope Forbeses as a devoted couple. She certainly played the role of dutiful wife and helpmeet to a 'Great Man', but there were just occasionally hints that Stanhope did not always have things all his own way, or that Elizabeth always deferred to his opinions.[1]

Certainly Elizabeth's own accounts of life in Cornwall, holidays in Europe, working with students, suggest unalloyed contentment quite untouched by anything unpleasant or difficult. So do the diaries and letters of some of the School's young female students, and also the various magazine accounts published in the early 1900s. But it is unlikely that these reflected Elizabeth's life with complete accuracy, as no account fully can. Money had never been a problem for Stanhope; his mother had always seen to this, keeping him supplied until he (or rather, she) was able to sell his pictures in sufficient numbers for him to make money. It must have been necessary to ensure that the School of Painting was a financial success, however, to enable the Forbeses to build their large new house, hire sufficient staff to free Elizabeth from household chores, pay for models and tutors, and then to send Alec to private schools.

All this took up a great deal of time, especially Elizabeth's, who oversaw so much of the routine business of the artistic and school day. She must have sometimes become tired and frustrated by the

PAGE 126
2.28 *The Black Knight of the Black Lawn*
watercolour, 29 x 29cm
Private Collection

127

2.35 *For Myles had grown a Man with a Man's Thoughts and Desires*
charcoal, 43.2 x 30.4cm
image courtesy of W.H.Lane & Son

little time she could spare for her own work. Living with Stanhope brought its own problems. He was still writing to his mother almost daily and one wonders if he confided in Elizabeth as he did in Juliette. He had also become very conscious of his position as the doyen of Newlyn artists as some of his more pompous published declarations over the years show.

Elizabeth had always been a lover of fairy tales and legends and, when Alec was quite young, had told him stories she had invented herself. She decided to develop one of these; *King Arthur's Wood* was published in 1904 by Everards of Bristol. The hero, a small boy called Myles, is heavily based on Alec and it is he who inspired the book's beautiful illustrations. Myles, and a little girl, Noel, come to live in Cornwall in a house belonging to Aunt Patience, whose husband and eldest son were drowned at sea. Her house stands close to the magic King Arthur's Wood which, in the spring, is full of bluebells. 'A flush of azure bloom covered the ground, so blue that "the sky has tumbled upside down"', said Myles.

Myles finds a strange stone table in the middle of the wood and carelessly taps on it. At once a little brown man appears and tells him that he is the Keeper of Merlin's Book. Through him Myles becomes involved in a number of adventures, meeting Sir Gareth of Orkney and the Lady of the Siege Perilous. But as Myles grows older he sees the Keeper of the Book less and less until 'there came a day when he tapped in vain on the stone table and the little brown man made no sign.' Years later when Myles has inherited the house and is married, he discovers that his own children have found the table and seen the Keeper. The dedication reads: 'To my little friend and comrade, Alec. This book is dedicated with his mother's love.'

King Arthur's Wood concludes on a dying fall with the end of childhood: its publication coincided with Alec leaving Cornwall for Bedales. There was no question of a middle-class child in those days going to a local school and virtually all boys were sent away to board. At least Bedales was no conventional public school, but offered an education which paid due respect to the arts. Alec seems to have been happy and to have done well there.

In 1904 the family finally moved into their fine new house, Higher Faugan, on the top of Newlyn Hill. The word 'Faugan' is

4.28 *The Bluebell Wood* (No.1)
oil on panel, 27.9 x 22.9cm
image courtesy of Christie's Images

thought to derive from the Cornish word 'fougou', which describes
the strange underground chambers the purpose of which still remains
undiscovered. Possibly there used to be one on the spot. The house,
which looks across the moors to the sea, is encircled by a rampart of
earth and large stones, then known locally as 'Price's Folly' and said
to have been built by a local squire a hundred years earlier; but it is
far more likely to be one of the castles or forts which date from the
Iron Age and this would also provide a link with a fougou. Stanhope
had designed every aspect of the house himself and had it built
exactly to his requirements. A substantial amount of land ensured he
could also indulge his growing passion for gardening.

In that same year, Elizabeth had the second of two exhibitions
especially devoted to her paintings of children. The first in 1900 at

the Fine Arts Society in London had been entitled 'Children and Child Lore'. The second, 'Model Children and Other People' at the Leicester Galleries, included showing the original coloured sketches for *King Arthur's Wood*.

In the catalogue for this latter exhibition, Elizabeth wrote:

Humorous, quaint and pathetic are the little, irresponsible folk, the volunteer models of the village and countryside. When the painter, filled with energy and anticipation, emerges at the day's beginning, they are already watching afar off. They gather in bands. If permitted to carry the painting kit, it becomes a triumphal procession. Desperate their ambition to be 'put in the picture'. Marvellous their immobility, their large-eyed gravity for a too short space. But their playmates, the wind and sun, call too loud to be resisted. Ambition flickers and dies. The hope of pennies large and brown becomes a hollow and elusive mockery. The smiling mouths begin to droop at the corners, and the little, restless feet refuse to be still.

Then it becomes a duel à l'outrance between artist and model, till

4.204 *The Pied Piper of Hamelin*
pastel, 63.5 x 109.2cm
Private Collection

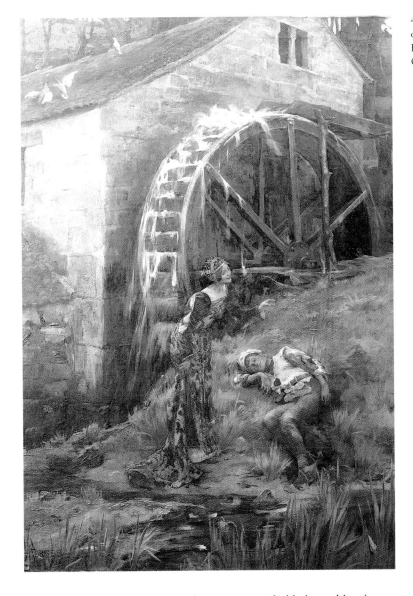

4.66 *A Dream Princess*
oil on canvas, 152.4 x 116.8cm
Royal Institution of Cornwall, Royal
Cornwall Museum, Truro

at last, with the conviction that inextinguishable hatred has been
kindled in those childish breasts, the painter, now weary and
browbeaten, returns on his road. But the children keep no
grudges; the same row of eager, smiling eyes watch for his coming
next day, and the day begins anew. Dear little people! To the
painter who goes back year by year to the same hunting grounds,
the memory of them becomes glorified and tender. The little
sun-burnt faces and the little calico frocks become as much a part
of the bright landscape as the patches of pink thrift in the clefts
of the granite boulders. And one marks the flight of the years

with their changing. The yellow-haired baby of one summer is the sturdy brown-legged urchin of the next. Still a little longer, and the tiny schoolgirl with pinafore and satchel is found again in the slim young matron, mothering a yellow-haired baby in her turn. The children change, but always the same wind ruffles the dry grass on the hill-side, and drives the strong blue waves to break on the shore.

Sentimental, perhaps, but Elizabeth always wrote about children with great warmth. Perhaps, after all, it was natural causes, not choice, that ensured Alec was an only child and by the time she wrote these touching words, Elizabeth was forty-five and the prospect of another baby highly unlikely.

Possibly as a result of this exhibition, but also reflecting her growing fame, articles on Elizabeth appeared in a variety of further publications in 1904. The *Lady's Realm*, in November of that year, had Marion Hepworth Dixon writing on 'The Art of Mrs. Stanhope Forbes', the title setting her firmly in place as an appendage of her husband. Marion Dixon begins by noting that a critic had recently deplored the absence of work by Elizabeth Armstrong from gallery walls, unaware that she had married and changed her surname to Forbes:

> A mistake so ludicrous would hardly be worth recording, were it not that an almost identical error has crept into the press during the last few months. Thus Mrs. Stanhope Forbes has been recently described as a young Canadian who, visiting England with her mother, was attracted to Newlyn where she met the husband who was destined to influence her life-work.

The writer then seeks to put the record straight with a brief account of Elizabeth's artistic career previous to her marriage.

After noting the titles of some of the early works, she continues: 'The artist's life, in a word, has been so strenuous a one, so full of a rounded and sustained achievement, that it is difficult to say where her far-reaching capacities should end. Whether as a designer, a painter, a teacher, a writer, we find Mrs. Stanhope Forbes's work stamped with a thoroughness and a distinction which mark her out as one of the specially endowed. I have used the word "distinction"

in describing the peculiar quality of this artist's output, and no other epithet so nicely describes her clear-cut handling.' She praises in particular Elizabeth's economy of line and mastery of so many different media.

The article is illustrated with reproductions of *The Firefly, A Knight, A Windswept Avenue* – showing two little girls and a dog – *A Minuet, Jonquil*, a portrait of a young woman, the portrait of Alec and two of the 'mediaeval' paintings, *If I were as once I was* – three young damsels encountering a lute-player in a wood – and *A Dream Princess*, a mediaeval lady standing over a sleeping young man beside a watermill. There is also a portrait of Elizabeth painted by Stanhope; she is wearing an elaborate dress and looking stiffly uncomfortable.

Having described something of Elizabeth's success and quoted from her writings when on her travels, Marion Dixon is quick to assure her readers that Elizabeth has lost none of her femininity, indeed 'her ultimate analysis of the thing seen is not only feminine, in the best sense of the word, but joyous and stimulating. However difficult it may be to diagnose the charm of a particular talent, it is obvious that a passionate love of outdoor life and a tender regard for children are the mainsprings of Mrs. Stanhope Forbes's powers.' The piece ends with a brief account of the setting up of the School of Painting and the part Elizabeth plays in it, commenting that both this and domesticity has 'conspired to keep the artist tethered to the spot where she has set up her household gods'. 'Tethered' is a curious word to use of someone who appears totally contented with her lot and the writer continues: 'Mr. Stanhope Forbes is less a wanderer at heart than is his Canadian wife...' There is no way of knowing if the writer was guessing that Elizabeth would have preferred rather more adventure.

In 1905 Hodder and Stoughton published *Women Painters of the World*. Edited by William Shaw Sparrow, this Volume III in a series entitled *Art & Life Monographs* spans five centuries of painters of the female species in some 350 pages. The sub-title, 'from the time of Caterina Vigri 1413-1463 to Rosa Bonheur and the Present Day' suggests a grandeur in sweep which, of course, could not be carried out in fact. On a specially inserted sheet at the front of this volume, a type of disclaimer makes this clear: 'It is hoped that the Women Painters of To-day may be studied again in a second volume. In the

6.5 *Portrait of Cicely Tennyson Jesse,* 1909-10
charcoal, watercolour and bodycolour, 34.3 x 24.1cm
Penlee House Gallery and Museum

present book, dealing with 450 years of work, the living painters could not be fully represented, for there are thousands of ladies who now win a place in the art exhibitions of Europe and America.'

Volume I was *Etchings by Van Dyck* and Volume II was *Ingres - Master of Pure Draughtsmanship.* That Volume III should attempt to encompass the work of over 200 female artists stands as its own comment upon the contemporaneous judgement concerning women's art. The editor, though, shows a more open mind in his preface:

What is genius? Is it not both masculine and feminine? Are not some of its qualities instinct with manhood, while others delight us with the most winning graces of a perfect womanhood? Does not genius make its appeal as a single creative agent with a two-fold sex?...

As examples in art of complete womanliness, mention may be made of two exquisite portraits by Madame Le Brun, in which, whilst representing her little daughter and herself, the painter discloses the inner essence and the life of maternal love, and discloses them with a caressing playfulness of passion unattainable by men, and sometimes unappreciated by men...Why compare the differing genius of women and men? There is room in the garden of art for flowers of every kind and for butterflies and birds of every species...

The present book, then, is a history of woman's garden in the art of painting, and its three hundred pictures show what she has grown in her garden during the last four centuries and a half...

Included in this international survey book are the women painters of Italy since the fifteenth century, early British women painters, modern British women painters, those of the United States of America, France, Belgium, Holland, Germany & Austria, Russia, Switzerland, Spain, and Finland. In such a wide selection, it is certainly illustrative of their standing that Elizabeth Forbes and Marianne Stokes (an Austrian, née Preindlsberger, who had met and married her artist husband, Adrian Stokes, in Pont-Aven in 1884, both active in St. Ives and Newlyn) were chosen for the 'British School'. Mrs. Stanhope Forbes, A.R.W.S., was represented by four

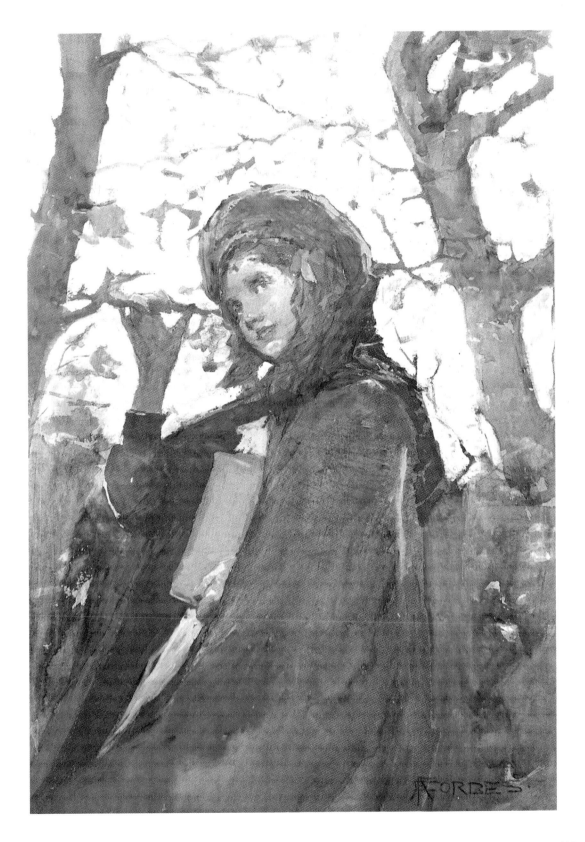

works, *The Fisher Wife, In With You!, Cuckoo*, and *May Evening*, while Mrs. Marianne Stokes was illustrated by two of hers.

There are no detailed accounts of Elizabeth's work in any of the serious art magazines of the time. What comes down to us are pen portraits geared to a readership of mainly leisured ladies who might be interested in a woman who was married to a prominent painter of the day, and who helped her husband run the Newlyn School of Painting, while overseeing the running of her lovely home, devoting herself to her son, loving children and who happened to draw and paint as well.

For accounts of Elizabeth's last years, we are largely indebted to letters, notes and diaries kept by some of her students and interested visitors. In a letter[2] to her sister in March 1902, Frances Hodgkins, the artist, complains first of the weather. 'We have been here now three weeks and it has blown & rained & drizzled & fogged in what the Cornish people try to make us believe is an unprecedented manner but we know better – we have had two or three fine days and everyone seemed so inordinately proud of them & swaggered so much that we saw at once how unused they are to good weather. Penzance is not beautiful tho' they try and make you believe it is – but Newlyn, a mile along a muddy road, is charming.' Frances visited a number of artists' studios both in Newlyn and St. Ives and a new exhibition at the Newlyn Gallery:

> The next day was *our* show – that is Newlyn. *We* have a gallery of *our* own & are very proud of it. It was a brave show & the Stanhope Forbes' work raised it to a much higher level. *Her* work was magnificent – much better than her husband's – they were mostly Shakespearean, mediaeval things – but they sang with colour & light & brilliancy – no one could touch her. She is head and shoulders above them all down here or in fact in England.

She was delighted when Elizabeth invited her to visit her. 'I am to go this Saturday. I am at Mrs. Forbes' feet – she wins one with the strength of colour & design – tho' I don't want to be influenced by her – merely seeing her work helps one.'

By 1906 the School of Painting had acquired some students of note, including Ernest Procter and Dod Shaw (later to become Mrs.

Procter). They were joined by a young woman, Wynifrid 'Fryniwyd' Tennyson Jesse, a young relative of the poet. Known as 'Fryn' she came from a troubled background; her parents had split up and her relationship with her neurotic Catholic mother was a deeply unhappy one.

Having finally persuaded her mother to let her study in Newlyn, Fryn embraced the life and all the freedom it brought her, with tremendous enthusiasm.[3] She lived with a small group of female students in lodgings at Myrtle Cottage (which they called 'the Myrtage'), under the careful eye of the landlady, the redoubtable Mrs. Tregurtha. 'Any notion of the *vie Bohème* can be discarded,' writes Fryn's biographer, Joanna Colenbrander, firmly: 'Their gaiety was schoolgirlish rather than reckless...' The girls used to talk to each other in a form of backslang and 'rarely fell into normal speech', wrote Fryn in her own diary. Her own nickname came from a reversal and shortening of Wynifrid and soon 'everyone had a new name derived in this fashion.' Mrs. Forbes (Elizabeth) first became 'Forces Mibs' and finally 'Mibs', a nickname which stuck for the rest of her life. Fryn, starved of affection at home and young enough to be her daughter, adored Elizabeth.

Fryn gives an account of the students' busy day.[4] They were expected to get the studios cleaned up and ready, the floors rubbed with French chalk, the models' thrones set with the required drapes and sandwiches made ready for lunch, before Elizabeth arrived at 9 o'clock to begin work. There was also a busy social life: the Forbeses were now responsible for a substantial number of young people, most of whom had never lived away from home before and who came from the kind of families, able to pay the tuition fees and give their children sufficient to keep themselves, who expected that they would be kept out of trouble. Organised entertainment, therefore, helped ensure there was less time for more unorthodox and dangerous activities.

At weekends there were often fancy-dress parties known as 'drencies' as Fryn noted:

> I used to borrow a cart and pony from a neighbouring farmer
> and fill the cart with dog-daisies, cotton-grass and branches and

4.167 *Lovers in the Wood*
oil on canvas, 83.8 x 68.6cm
image courtesy of David Messum Fine Arts

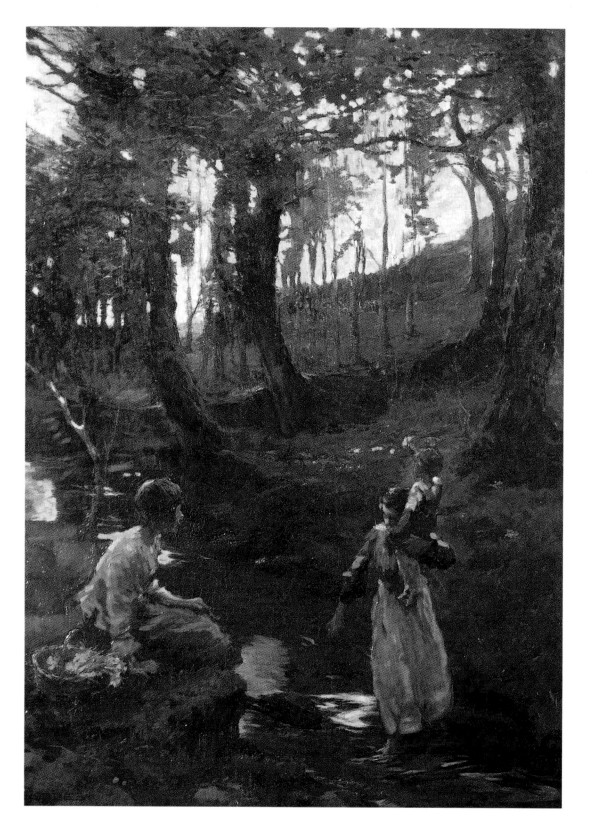

festoon them everywhere. Then we fled on to the Myrtage, had a hurried wash-down in a flat tin bath and dressed up in whatever was our fancy-dress for that evening. Dod never cleaned or polished or drove out to pick flowers. She always appeared dressed in time for the dance, looking superbly handsome.

As was the practice, Fryn began by drawing in charcoal under Elizabeth's tuition but the fun of living away from home in such an unusual community was at least as important as studying at the art school. Famous painters, such as Alfred Munnings, paid visits. A nearby cottage was home to young male students, including Denys and Crosbie Garstin. Arms-length romances continually sprang up between the art students. Fryn writes with excitement that she has received a proposal from a fellow art student, a much older man.

From Fryn's diary it is clear that by 1908 'the Professor' had finally been persuaded that life drawing should mean just that, and his students were allowed to draw from the nude. To this end professional male and female models were hired from London but the young female students also sat for each other as well in the privacy of their lodgings. 'Mother thinks it is disgusting,' Fryn confided to her diary, 'she thinks it immoral to work from the nude model as we do down here and with the Professor to "crit" us. But we all sit to each other at the Myrtage and sometimes Dod and Cicely and I have birthday-suit evenings, posing on the big bed with nothing on but a silver belt to make us feel barbaric; and a hand-glass so that we can judge the effect.' This was dashing stuff for well-brought-up young ladies before the 1914-1918 War.

A very real affection seems to have developed between Elizabeth and Fryn, who was often invited to Higher Faugan. She found 'Mibs' gentle, humorous and understanding, wise yet approachable, with an abundant store of literature and history 'to feed her mind upon the same poetic vision'. She contrasted her with her own cold, hysterical, unloving mother in a way that makes her deeply sympathetic. 'I owe to Elizabeth Stanhope Forbes my first friendship with an adult, sensible, talented human being. She helped to teach me how to express myself and not to be hide-bound. After I had my appendix trouble...Mibs took me up to Higher Faugan and let me convalesce there, and I listened to her

PAGE 138
4.91 *The Ford*
oil on canvas, 104.1 x 81.3cm
Private Collection

BELOW
4.6 *Alec in Whites*
watercolour and charcoal,
45.7 x 31.7cm
Private Collection
image courtesy of Giles Spencer,
Pickwick Papers, Weybridge

amazingly clear and liberating comments on life generally.'

Elizabeth was full of ideas. When Fryn confided that she wanted to write, Elizabeth asked her to try her hand at a play for the School's Christmas party. The result was *The Corpse, the Coffin and the Coughdrop – a Melodrama in Three Palpitations*. It was set in 'the fastest flat in Fulham', Fryn starring in it as the evil Vivian de Rouge Coeur (dressed in a scarlet gown used by Elizabeth for models), as the owner of a marriage bureau to which she lured young girls for nefarious purposes. It was performed twice, with great success, and had 'the artists and the County laughing their heads off'.

It was Elizabeth, too, who thought up the idea of a magazine about the local artists and their work. She would be the publisher and Fryn the editor. The first copy of *The Paper Chase*[5] appeared in 1908, lavishly illustrated and printed by a local, amateur village print shop on expensive hand-cut paper. There were grandiose dreams of publishing it quarterly, even monthly, but in the event it was all they could do to bring out one that year and a second in 1909. There were no others.

The first issue is notable for its fine illustrations and abysmal writing: presumably Fryn was happy to put in anything that she was offered. The female contributors, including Elizabeth and Fryn, went in a sentimental and twee approach only too reminiscent of Norah, in Ibsen's *The Doll's House*, playing at being a little squirrel to please her appalling husband. Fryn, as editor, called herself 'The March Hare', inspiring Elizabeth to come up with a description of her in that role which does justice to neither of them. A flavour will suffice.

'Come out, you young people, and follow me! I am a merry irresponsible little fellow, by many called Mad, but those who lift their faces to the brightness of the morning love me, and the light of heart follow where I lead. Some call me the Path-finder, the Enthusiast; some, Imagination; some the Crack-brained March Hare.

'My Wallet is stuffed with fancies and I scatter them as I run. Follow my trail, if you care to pick up my vagabond toys! Under one you will find a primrose, one has blown down by the river, and is caught in a tangle of yellow catkins; one whirls aloft, and you would think it a little white butterfly against the blue. In my Wallet are whimsies, quaint and laughter-moving...' which shows the general tenor, though Elizabeth's interview with 'Lamorna' (Samuel John or S.J.) Birch, who was now

4.282 *A Woodland Scene: As You Like It*
gouache and charcoal on paper, laid onto canvas, 91.4 x 71.1cm
Royal Institution of Cornwall, Royal Cornwall Museum, Truro

teaching at the School of Painting, is of a better standard.

Later Fryn was to acknowledge that 'nothing I wrote for it was very good'. Nor were the male contributors any better, as can be judged from this excruciating verse of a poem by Crosbie Garstin, who had taken something of a shine to Fryn:

White is the moon
But my sword is whiter
Light is the wind
But my heart is lighter.
Bright are the stars,
But my star is brighter.
Heigh ho! Tally ho! Drink with me!
All the world is my field of glory,
On her hills will I carve my story
Drink! Drink down to a calling free!

The setting up of *The Paper Chase*, while full of good intentions can only be described, apart from some of the illustrations, as a consciously 'arty' piece of self-indulgence.

Fryn continued writing her 'Intermittent Diary'[6] as she called it throughout the years she spent in Newlyn. In 1908 she exhibited paintings in Liverpool and Leeds but acknowledged that she now realised she did not have a genuine talent. She did not, however, want to leave Newlyn and Elizabeth. 'As far as I was concerned, this carefree life – although I knew I should never become a painter – might have gone on forever with interesting people coming and going.'

As well as organising amateur dramatics, Elizabeth also hosted musical evenings, at which Stanhope could usually be prevailed upon to play the 'cello, joined by one of the local printers of *The Paper Chase*, Adeodato Gilardoni, on the viola. They were often accompanied by one of the students, 'a girl called Maudie Palmer [who] played the piano gloriously.' Unlike Dod Shaw, who usually managed to get out of doing any chores, Maudie was always willing to make herself useful, happily assisting Elizabeth with the sandwiches and dispensing claret-cup.

Fryn's diary, on the whole, is caught up in her immediate concerns, with such matters as what she wore at the 'drencies', when

ABOVE
The Paper Chase magazine, front cover, 1908
Poem by Cicely Jesse, reproduced in the magazine, 1909
Penlee House Gallery and Museum

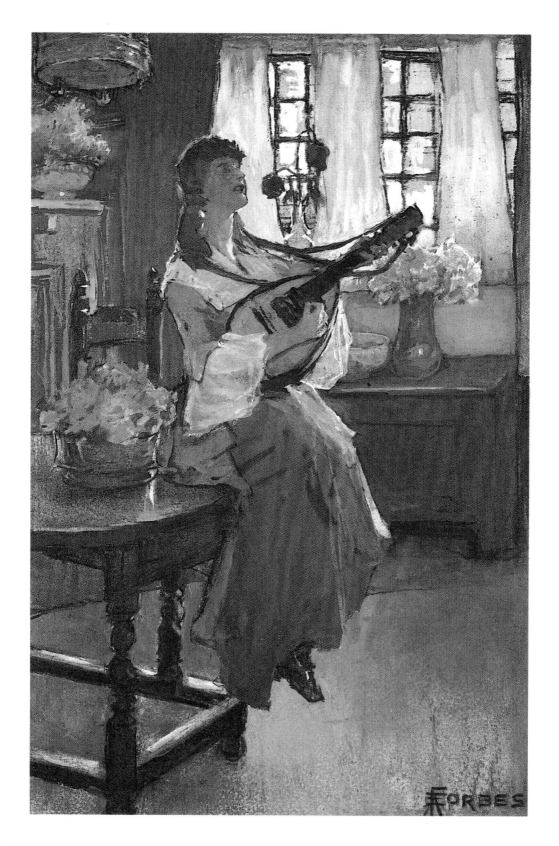

on one occasion 'I was a Bacchante and looked better than ever before...I wore a blue-green silk dress lent me by the Gotches, and my gold girdle twice around my waist and hanging down in front. Dod did my hair in a wild mass of curls all over my head, and on them a cluster of brown-gold leaves. I borrowed a cheetah-skin, and one paw was slung over my shoulder. The effect was choice.'

There are descriptions of country picnics, alfresco evenings when they disguised themselves as gypsies, a Walpurgis Night party. There are hints of romance. But underlying all the jollity was Fryn's worsening relationship with her mother which made her draw ever closer to 'Mibs'. After reading a particularly unpleasant letter from home in which her mother had demanded she join her in a convent for an Easter retreat, she 'went up to the Faugan for lunch and walked round the garden with Mibs and she told me I had a future before me. And I mean to have. And I will.'

Her mood swings from wild gaiety, such as the episode when she and the Gotches' daughter, Phyllis, dressed themselves as young widows (after buying two wedding rings in a pawn shop) and went off to Carbis Bay under assumed names, to bouts of depression over anything to do with her mother. For several months she had been suffering from what had been diagnosed as a grumbling appendix and in May, 1908 she went up to London for an operation in a private clinic. Her mother, a devout Catholic, had sent a priest to hear her confession before the event, a move which had appalled her. She was feeling very sorry for herself a few days after the operation when Elizabeth came to see her on her way back from a holiday in France. She was 'simply sweet, as always, bringing masses of white flowers, roses and lilies and said: "Goodbye little golden-head" as she kissed me and left.' Her own mother did not come near her for ten days once the immediate trauma of the operation was over and when she did, hearing of Elizabeth's visit and how much this had affected her daughter, she raged and called her 'a little beast, a devil, evil and utterly without heart'.

Fryn was reduced to utter despair, writing in her diary: 'Oh, I can't bear it. I sometimes wonder why I have not hit out at that cold jeering face and watched it grow frightened. What on earth am I to do if I have to go back to it next summer?' It was then that she returned to Cornwall and was nursed back to health at Higher Faugan by Elizabeth.

PAGE 142
2.1 *Soft Music,* illustration from *The Poems of Herrick*
watercolour gouache over black chalk, 55.9 x 43.2cm
image courtesy of Leon Suddaby

BELOW
4.170 *The Lute Player*
oil on canvas, 40.6 x 55.9cm
Private Collection, image courtesy of Leon Suddaby

In 1908 Elizabeth wrote another piece for *The Studio*,[7] not this time an account of painting in France or Spain but of what she described as 'An April Holiday', an account of a painting expedition undertaken with a party of her Newlyn students. The winter had been a bad one with black nights, gloomy days and gales from all four quarters when 'we poor painters cowered over studio fires, the rain streamed on skylights, the sodden mist blew up from the sea; mackintoshes and sea boots were the only wear.'

A dreary spring wore on without respite, driving the artists and students to distraction until, towards the end of March, given a small glimmer of sunshine Elizabeth decided that come what may, a means must be found of allowing the students to paint *en plein air*. Reconnaissance led to the discovery of a sheltered valley not too far away 'where the blackthorn and wild plum already begin to whiten and the primroses have ventured forth...Picturesque in its decay, it offers sheltered nooks where the painter may unfurl his kit. "Show us your valley," cried the Art Students in chorus, shivering but with enthusiasm.'

An arrangement was made with a nearby farmer for the use of his barn as a headquarters, where painting materials could be stored and the students paint if the weather was too ferocious to work outside. So, accompanied by a cart laden with easels, paint-boxes, palettes, canvasses and provisions, Elizabeth and her party set out for the valley. Gradually, as April wore on, the weather improved. Sandwiches eaten inside the barn were replaced by picnic lunches out of doors.

They discovered the ruins of an ancient manor house, over the stone doorway of which was carved the 'three veales', the arms of the defunct 'house of the Le Velis'. The farmer's wife gave them the key to it and allowed them to explore the derelict rooms. In some they found the remains of broad window seats under windows whose remaining panes were covered with cobwebs and mildew. Near the manor was a fougou, called the Fugoe Hole by Elizabeth, who decided it must have been used by escaped Royalists during the Civil War. As she painted, musing on the manor's history and wondering if it held ghosts, she was brought sharply back to earth by the arrival of two children, the older of the two saying, after looking critically at the work in hand, 'Look, Sammy, look, they're cows she's paintin''.

Word of the strange antics of the artists soon got around and local children began to turn up regularly to see what was going on. Among these was a little girl 'with a pair of the loveliest eyes I have ever seen, too big for the thin little face, with its delicately pointed chin. She wore a faded frock of velveteen which had once been blue and round her neck a string of quite beautiful beads, Moorish or old Venetian. "What pretty beads, where did you get them?" said I. The little girl fingered them lovingly. "My gran'mother gived 'em to me. She was a real gypsy, she was, and lived in a caravan worth sixty pounds!"' Her own mother, she told Elizabeth, 'has a face like a rose'.

Nothing dramatic happens. Elizabeth charts the changing seasons from spring into early summer as she and her students struggle together to capture what they see in paint, an ancient orchard proving particularly difficult. 'The apple-branches show only the tiniest buttons of pink as yet, here and there, among the silver of their bewildering tracery: that fascinating but elusive apple-pattern which drives us to despair.' Her article is illustrated with drawings by Dod Shaw, Ernest Procter and by Elizabeth herself with *The Apple Orchard*, showing a young girl leaning against a tree, looking up through a mass of twisted and tangled boughs.

The account of the April holiday is particularly idyllic as day follows fulfilling day. There is no hint that it was all about to fall apart.

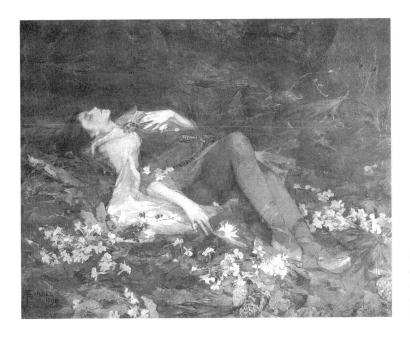

4.145 *Imogen Lying Among the Flowers That's Like Thy Face, Pale Primrose* 1898
oil on canvas, 70 x 90cm
Plymouth City Museum & Art Gallery

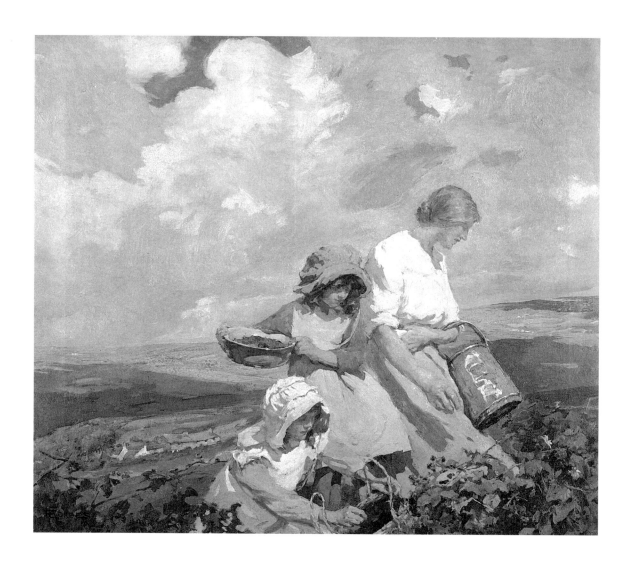

146

The Blackberry Gatherers

The second edition of *The Paper Chase* had been planned for
Christmas, 1908, and Elizabeth wanted it to be twice the size of the
first. This would strain the budget, something that concerned Fryn,
who noted: 'Mibs is keen on an edition of only five hundred, but it is
to be very fine and big, with many aquatints, etchings and
lithographs. I think we should see our five hundred, but even so – will
Mibs not lose on it?'[1] In the event it did not appear until the summer
of 1909, by which time Elizabeth had more things on her mind and
probably knew that the June edition would be its swansong.

Just before Christmas, 1908 Elizabeth's excellent health and
energy gradually began to desert her. At first there seemed to be little
cause for anxiety but eventually it was decided that she should go to
London to seek further advice.

After her death the received wisdom was that Elizabeth died of
tuberculosis but her death certificate shows that it was the result of
cancer of the uterus and exhaustion. Whether or not the local
doctors were able to diagnose what was the matter with her we do
not know, but presumably it was they who suggested she seek
specialist advice. Certainly they would have recognised the symptoms
of tuberculosis, for 'the consumption' had been endemic in Cornwall
for centuries, ravaging in particular the mining communities of mid-
and west Cornwall. Indeed it is likely that Stanhope and Elizabeth
would themselves have had a good idea of what was wrong since
they had seen its effects at first hand when the wife of their friend
Edwin Harris was dying of the disease in 1897. She had contracted it
shortly after giving birth to her son three years previously and her

PAGE 146
4.27 *The Blackberry Gatherers,* 1912
oil on canvas, 83.8 x 100.3cm
Board of Trustees of the National
Museums and Galleries on
Merseyside, Walker Art Gallery,
Liverpool

Royal British Colonial Society of Artists
Certificate, 1911
Penlee House Gallery and Museum

death, at the early age of twenty-five, had a profound impression on the Forbeses. She had not faded gently away like the heroine of a Victorian novel but suffered great pain and distress. Elizabeth, along with the wives of other artists, had taken it in turns to sit with the patient while the men did their best to support Harris.

So, even if consumption, rather than cancer, was at first suspected, the impact on Elizabeth and Stanhope would have been devastating. It was not until the discovery of antibiotics well into the twentieth century that the medical profession could hold out hope of a permanent cure. In Cornwall, as late as the 1960s, elderly people would speak feelingly of the deaths from the disease of their loved ones. They said that a doctor's decision to send a patient to Tehidy, the local TB hospital housed in the old mansion which had belonged to the Basset family, was equivalent to being told to order the coffin.

Presumably the London consultants correctly diagnosed what was wrong with Elizabeth while realising then that little could be done about it. Nonetheless, she did undergo several operations. Uterine cancer is particularly difficult to treat even today with the full resources of improved surgery and radio and chemical therapies unless it is caught very early. Throughout 1909 Stanhope took Elizabeth to London for further unsuccessful treatments until finally it was decided she should spend time in a warmer and drier climate. In Fryn's 'Intermittent Diary' of the time, she reports that it was definitely established that Elizabeth was tubercular and that what she needed was rest.

After yet more consultations in London, the place chosen was Vence in Provence. Elizabeth did not stay in a hospital or sanitorium but lived in a small hotel, accompanied by a nurse. It was impossible for Stanhope to accompany her as the full burden of overseeing the administration and teaching at the School now fell on him and both of them knew that he had to keep it going. A number of students left at the end of 1909, including Fryn who decided to try her fortune as a freelance journalist. Some of those who stayed behind turned to, and helped as much as they could, including Maudie Palmer who had accompanied Stanhope on the piano so 'beautifully' when he played his 'cello at Elizabeth's musical evenings.

Whether or not Alec was told of his mother's illness is not

known. He had done well at Bedales in all his subjects: maths, French, Latin, history, surveying, joinery and drawing and was working towards his Oxford and Cambridge certificate and a place at an architectural college.

In 1910 Stanhope achieved his ambition and was elected a full Member of the Royal Academy. From then, almost to the time of his death in 1947, he always submitted his allotted six works. Tom Cross, writing in *The Shining Sands* says: 'In Newlyn Forbes was a much respected leader in the arts, but as the town changed he found the modern fishing port meant less to him and he increasingly found his subjects in the lanes and farms near his home. His studies of figures and landscape seen in brilliant sunshine form an intimate record of the working people of Newlyn and Penzance. The dark tones of his early work were replaced by a brighter, more highly coloured palette. Water is a recurrent feature – sea, ponds, river of glistening sand – serving to bring the reflected light of the sky into the lower part of his compositions.'

Presumably it was in 1910 (although the date is not specified) that Fryn visited Elizabeth in Vence and found her at first to be relatively well and, far from being confined to her room, busy drawing and painting in the nearby olive groves. She was delighted to see Fryn, who lodged at a small convent for four francs a day where 'the food was good and there was *vin compris*. On Fast Days though we only had a boiled egg with a Huntley and Palmer ice-wafer but on ordinary days I fared excellently. Sometimes they gave me a roll with meat in it and half a bottle of wine, and I used to take it out into the olive groves and lie and write, while Mibs painted me there.' Fryn stayed in Vence for several weeks but at the end of that time, Elizabeth's health suddenly worsened and she returned to England, leaving Fryn to go on to Tuscany.

In 1911 Elizabeth was elected a member of the Royal British Colonial Society of Artists, which had been officially founded by Edward VII. She received a crested memorandum or scroll to that effect signed by George V. It is topped by a royal crest under which are three representative figures: Australia (a muscular fellow in a large hat kneels with a sheep under his arm), Canada (a winsome lass with a sheaf of corn) flanking India (a Britannia figure seated on

a throne representing the jewel in the crown). It was a handsome honour, and considered by all to be well deserved.

In July, 1911 Alec passed his Oxford and Cambridge certificate, First Class, and was duly awarded a place at the Architectural Association School in Westminster where he was to take a three-year degree course. In that year Elizabeth spent what time she could at Higher Faugan, continuing to work whenever she felt able to, but spent spells in London hospitals. The seriousness of her condition was known only to a few very close friends, 'an inner circle'.

Cancer was then almost unmentionable, synonymous with a death sentence (indeed remaining so throughout most of the twentieth century), so it is perhaps not surprising that friends were allowed to assume she had tuberculosis and, deadly though that disease was, that she still hoped for a cure. She apparently did not disabuse them even though, towards the end, the symptoms must have been very different from those of tuberculosis. Strangely, Fryn stated categorically in her brief biography of Elizabeth that the disease was tuberculosis; she was close to Elizabeth and must surely have realised the truth when she was with her in Provence.

The prolonged treatment and hospital visits were proving very costly and strained Stanhope's finances. A note in the Minutes of the General Meeting of the Newlyn Gallery Committee on March 23, 1911 records that it was agreed 'that the Artists' Benevolent donation should be given to the Mrs. Forbes' Fund this year'. The Fund had been set up to defray the cost of nursing services since Elizabeth now needed full-time nursing when she was at home.

Some time during 1911 Elizabeth worked on the painting that was to be her last, designed for submission to the 1912 Royal Academy Summer Exhibition: *The Blackberry Gatherers*. Its subject is children picking fruit set against an open Cornish landscape with swirling clouds. She would not live to see it hung.

By early 1912 it was only a matter of time. The unspecified operations had not only failed to halt the spread of the disease but caused Elizabeth a great deal of extra suffering. Fryn visited her again in a London nursing home and found her 'already greatly changed from the Mibs who had painted me sitting under the olive trees in Provence', but throughout that last year Elizabeth, as might

be expected, showed great courage and stoicism. Finally, at the beginning of March, Elizabeth and Stanhope were told that nothing more could be done and Elizabeth at once insisted she be brought back to Newlyn to die at home.

Stanhope's letters to his mother chart the history of the next week. On Saturday March 8, arrangements were made for Elizabeth, accompanied by Stanhope, Alec and a nurse, to be taken down by train overnight from Paddington to Penzance. 'Everything went admirably on the journey', Stanhope wrote, 'and I do not think my dear one suffered any very great inconvenience or was in any way affected by it.' She had been a little sick when the train first started but after that had quietened down and slept for most of the journey. Stanhope and Alec shared a sleeper next door though neither slept much. For the last half mile the railway line runs beside the beach with a splendid view of St. Michael's Mount and when the curtains were drawn back with the dawn 'it was a lovely morning'. The Garstins and Bramley were waiting on the station to see if they could help but did not intrude into the carriages and after a quiet greeting, a small ambulance took the sad little party up to Higher Faugan.

'She was so very happy to be home and it did look so lovely that morning. The border of white arabis was in full bloom and looked perfectly lovely. Ella had the house in perfect order and her [Elizabeth's] bedroom arranged exactly as she wanted it. We had a very good day yesterday and she slept a great deal...She is very, very weak but at least I have got her home and her wish has been gratified.' He and Alec had slept all night, felt better for it, and were taking it in turns to sit with Elizabeth.

A letter four days later informs Juliette that Elizabeth is steadily growing weaker but, 'thankfully, today she still has no acute pain.' He repeats how happy she is to be back home and that she has told him how much she has enjoyed the last few days.

On June 17, he wrote: 'At ten minutes to five yesterday afternoon my darling passed away, very peacefully, in the presence of Alec and me. She was wandering in the morning but seemed happy and she frequently told the nurses that "she had no fear."'

Gradually Elizabeth had slipped into unconsciousness and never woke again. Stanhope and Alec were supporting each other in their

4.139 *Hide and Seek*
pastel, 43.2 x 27.9cm
Private Collection, image courtesy of
Christie's Images

4.113 *Girl on a Window Seat*
watercolour and charcoal,
47.5 x 60.9cm
image courtesy of W.H.Lane & Son

grief but both were comforted by 'seeing our darling beloved one looking so calm and sweet. She looks just like she did when she was a girl as all traces of pain and suffering have passed from her face.'

The funeral was set for June 21 to allow friends and colleagues time to attend. It was decided between Stanhope and Juliette that the latter would not attend the funeral but would come down immediately afterwards 'to look after him'. Again Stanhope emphasized how peaceful Elizabeth looked 'after all the terrible suffering which she has born with such heroism' and continued, 'I shall never be sufficiently thankful that she breathed her last under her own roof in the house she and I built together and close to where her boy was born.' She would lie, he said, with her dear mother who had been buried in nearby Sancreed churchyard.

Fryn was among those contacted and she immediately left London for Newlyn. Now estranged from her mother, she had built up a good relationship with her father and it was to him she wrote:

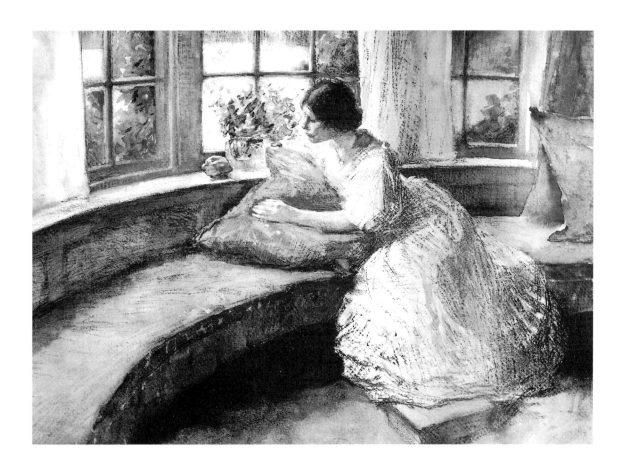

I have lost the best friend I ever had and know it…I don't know what to say. I have more work than I can do but my brain refuses to budge. I can't believe it yet but know that some night soon I shall wake up and know it's true. For all these years she has never once failed me in the smallest thing when I wanted sympathy or advice.

The Professor sent a cab for me to come straight up. It wasn't her. I never saw anything look so unutterably dead. Everyone was very good and Norman Garstin and Lionel Birch were at the station to see us off. I do nothing but sleep all day; I suppose it's the shock. I don't even cry now. What's the good? It can't make it not true.[2]

In spite of his great grief, Stanhope rightly made the day of the funeral a true celebration of Elizabeth's life. Her coffin, banked by flowers, was placed in her studio. At its foot, were her palette and brushes and over them a laurel wreath, tied with heliotrope ribbon.

At the head, on her easel, stood *The Blackberry Gatherers*. Full of life, exuberant, singing with colour, it incorporates all she had most loved to paint: the landscape of West Penwith with its dramatic light and shade, and happy children. There is not the slightest sign of loss of ability or that she was terminally ill when she painted it. Sure and certain in technique, it is the work of an artist at the height of her powers. There could be no more fitting tribute to that bright spirit.

Epilogue

Elizabeth was buried with her mother in Sancreed churchyard, her coffin borne on the shoulders of past and present artists of the Newlyn School. The contemporary issue of *The Cornishman* described the scene in Elizabeth's studio and how she had been brought down from London earlier 'wishing to be in Newlyn at the last'. Her failing health, it reported, had been noticed with great regret and the operations she had to undergo, but only her 'inner circle' of friends had known it was serious.[1]

Her obituary in the *Pall Mall Gazette*,[2] headed 'The Queen of Newlyn' concluded: 'She excelled in particular in depicting the waywardness of spring sunshine falling through tree-boughs on a winding lane or a group of print-clad girls and children; these [paintings] have been eagerly acquired for permanent exhibitions in the colonies and wherever the English genre is cherished'.

According to a local source one of whose great-grandparents had been in service at Higher Faugan, a few days after the funeral Stanhope had a fire made outside on which rubbish was burned. He then came out with bundles of letters and a large sheaf of Elizabeth's sketches and pastels which he gave to the servant and ordered that they should be burned. Most of the sketches were life drawings. The servant was so upset that what he considered 'beautiful pictures' were to be consigned to the flames, he kept two which his family have to this day. What also gives this story the ring of truth is that while literally hundreds of Stanhope's letters to his mother and other people survive, as do a fair number of letters to him, there are virtually no letters from Elizabeth either in the Tate archive or

anywhere else. We know from Stanhope's letters that she was never as keen as him on letter writing, but one feels there should be more than two or three in a lifetime. [3]

In 1915 Stanhope married Maudie Palmer, the pupil who had worked so devotedly for both himself and Elizabeth and who had played the piano for him at those now far-off musical evenings. Maudie had become the School of Painting's 'massière', a term used in French art studios to describe a student-in-charge who was usually also the treasurer. Stanhope had begun to grow dependent on her in that role during Elizabeth's final illness and had continued to turn to her after Elizabeth's death. Not surprisingly tongues wagged locally. Fryn noted: 'The Professor, knowing my affection for Mibs, was afraid of what I might say, but when he told me he had grown to love Maudie and wanted to marry her saying "otherwise I should lose my little friend", I was delighted. Mibs might, I think, have been glad too.'[4]

Fryn then voices what had only been hinted at previously: 'Maudie loved the Professor, and was undoubtedly less alarming as a wife than Mibs sometimes had been....' Her musical talent, she continued, was a joy to him. Maudie suited Stanhope very well. Her artistic talent was only modest but it gave her an understanding of his needs and the world in which he moved. Along with Stanhope she participated fully in the activities and exhibitions held at the Newlyn Art Gallery. She was to look after him with total devotion until his death at the age of ninety.

And what of Alec, the son who had meant so much to both Elizabeth and Stanhope? He graduated from the Architectural Association's School in the ominous summer of 1914 and was awarded the Association's Travelling Scholarship for 'best work done during the Third Year Course'. His teachers prophesied a brilliant future.

Like so many of his generation, Alec became caught up in that tide of patriotic jingoism which swept the country. After several months, he decided that he must turn his back on his chosen career and do his duty until after the war. There would be ample time to take it up again then. He did not actually join up until the spring of 1915 but Stanhope's letters to his mother are full of pride at the decision Alec had taken. 'He is busy buying his uniform,' he wrote

on April 25. 'I am thinking a great deal about it all, but more and more feel it is the best thing that could have happened. How proud he will be'. How proud they would *all* be. There are others in a similar vein, reminiscent of, among others, those written by Rudyard Kipling about his only son: full of patriotic fervour and the belief that it would all soon be over.

Alec had attended his father's wedding and seemed happy at the choice he had made. Fryn noted that 'he and Maudie had always liked each other and had been thrown much together, so he, too, welcomed the marriage.'

He joined the Duke of Cornwall's Light Infantry in May 1915 and was commissioned as a sub-lieutenant. Stanhope wrote to his mother: 'I trust you will join with me in prayer that God will bless him in his new life. We know he will do his duty.'[5] At first Alec remained in England as after he had undergone his basic training, he developed medical problems connected with the glands in his neck and one wonders if it might have been thought he was tubercular. Certainly the trouble was considered serious enough for him to have an operation and under normal circumstances he might well have served out the rest of his time in a home posting. But, by the summer of 1916, every possible man was needed to fill the monstrous gaps caused the wholesale slaughter on the Western Front.

Alec joined the First Battalion of the Duke of Cornwall's Light Infantry on the front line in the middle of August 1916. Three weeks later he was dead, shot through the head in a charge as he went over the top. Coincidentally, Fryn was spending a month with a friend in Lamorna at the time when the son of one of the artists arrived on a bicycle. 'May was making blackberry jelly, and I shall always link the smell of blackberry jelly in warm sunshine with the news I was given: Alec Stanhope Forbes had been killed and the Professor wanted me to go over at once.'

She borrowed a farmer's trap and drove to Higher Faugan where Maudie, in tears, took her up to Elizabeth's old room where 'Stan was lying on the big double bed. He was distraught, grieving for Mibs all over again as well as Alec. What he wanted me to do was to take all the flowers that Maudie and I could pick to Sancreed churchyard and put great bunches of them on Mibs' grave in memory of Alec.'

Elizabeth's gravestone at
Sancreed Church
Photograph: Steve Tanner

When Stanhope had recovered from the initial shock, he wrote at once to the military authorities begging for details of how Alec had died and where he was buried. Some time later he received a letter, scrawled in pencil, from a Lieutenant A. O'Connor headed only 'somewhere on the battlefield'.[6] O'Connor told him that the Battalion had been in action more or less continuously for days before Alec was killed. 'On 4 September I went over the battlefield to see if any wounded had been left lying out. As I went, I found the body of your son.' After first seeing to the removal of the wounded, he had turned his attention to the dead. Two other officers had been killed with Alec but then 'there were so many, many dead'.

It had, he explained, been impossible to carry all the dead from the field to a military cemetery: there were simply too many of them. It was not even possible to bury them properly in any numbers or with any system as every available man 'is engaged on some task or necessary work of some kind...hence the dead lie unburied for weeks, and so when buried it is often impossible to identify them.' Whenever possible officers buried as many of their comrades as they could where they fell as all too often the Battalion was then pulled back after an assault and they feared they would fall into the hands of strangers.

'I tried to bury as many as I could and mark their graves, especially those with whom I'd lived and whom I'd known and loved.' Among these, he said, he included Alec. 'On 4 September your son was the first of those I buried.' He had removed his identity disc, but had found virtually nothing in his pockets or haversack. He had then dug a grave beside the body, put it in, covered it, and then looked round for some pieces of wood. He found two which he fashioned into a rough cross. 'He lies where he fell. After hostilities he should be removed to an official cemetery. As to the permanence of your son's grave, I can't say more than this. A week later the grave was still intact.'

Military necessity, he continues, knows no sentiment but Alec's father must believe he had told him the details, albeit with reluctance 'because your heart-rending letter forced me to do so.' 'And now, dear sir, on account of the name I am going to sign I make a confession, perhaps an apology. I am a Roman Catholic priest. If there had been an Anglican chaplain available I would have asked him to read the burial service over the grave, but as there was not, I

said a Mass.' This was in no way to criticise the chaplains and indeed Catholic priests were not encouraged to do what he had done but his fellow clergy had been totally overwhelmed as they had tried to perform the same office for the hundreds and hundreds of dead: it had been easier for him as he had fewer men to look after. 'Here, of all places, Christian charity is surely universal.'

Stanhope wrote back full of gratitude, but also enquired why only Alec's identity disc had been found on his body when he knew there were some very personal things he had always carried on him whatever the circumstances. O'Connor wrote back with the brutal truth: 'your son and many other officers had been robbed. I don't want this to be published as there is no reason why we should add to the sufferings of the relations.'[7] It was, he said, impossible to police the battlefield during engagements but unfortunately men had been made so brutal and so callous by what they had undergone that in Alec's case, as in many others, they had been prepared to loot their own dead comrades. His pockets had been emptied, even his revolver taken. 'All that was left in his haversack was two letters that I handed to the adjutant, smeared with blood and mud.' According to Stanhope, the thief must have taken his son's watch, his pocket book, papers, money, and a variety of other things, including one of Elizabeth's rings.

He was just twenty-three. Stanhope's last link with Elizabeth had been severed. Only her drawings and paintings of Alec remained: at four in his sailor frock; at the age of about ten, reading under a tree in *The Half Holiday*, and as the little boy, Myles, of *King Arthur's Wood* who grew up and so was unable any longer to rouse the Keeper of Merlin's book, but whose children inherited both the wood and the magic. Unlike Alec.

This story ends sadly. There is no reason why Elizabeth, had she not been struck down, could not have continued working for another twenty years or more, nor that Alec would not have gone on to make his mark as an architect as had been predicted.

But Elizabeth, at least, left behind a substantial body of work and while she may have been, and still remains, underestimated her pictures hang in galleries and give pleasure not only in this country but all over the world.

Michael Canney, teacher, writer, artist and curator of the Newlyn Gallery from 1956 to 1964, wrote an unpublished commentary on Elizabeth's work. Having briefly detailed her early work,[8] he recognises how from the mid-1890s her style broadened into a flickering brushstroke, which suggested the influence of Manet, while her colour became increasingly high key, reflecting both the heightening in tone and colour of French art at that time and also, in her gouaches and watercolours, a hint of the acid clarity of the Pre-Raphaelites. He writes:

> Her real strength lay, however, not in the Pre-Raphaelite gentlewomen that she painted so often, yearning in the shade of Cornish woods, but in her sympathetic and observant studies of children in their straw hats, tam o'shanters and pinafores, searching the flower-decked hedgerows around Newlyn for posies and garlands. Although sentimental, these works possess genuine charm. This is heightened by a sound organisation of the picture surface, a confident and painterly touch, and an acute observation of movement and gesture under the changing effects of sunlight and shadow in a landscape.

But if one is looking for influences and similarities then surely one must be with Gauguin's pictures of Breton girls and children painted when he, too, was in Pont-Aven working with the same group and the same teachers, albeit very slightly later. He and Elizabeth almost overlapped.

In her introduction to the catalogue for the exhibition 'Artists of the Newlyn School - 1890-1900' Fox writes: 'Almost every critic of her work anxiously expresses concern that Elizabeth Forbes should not appear to receive special treatment because she was a woman or because she was Stanhope Forbes' wife.' Hardie corroborates this concern in a wider perspective:

> It is a known phenomenon, written about by many commentators, that 'success' in the arts is more accessible to women who through birth or marriage are familiar with the art world. Each of the women... Stokes, Forbes, Knight, Procter and Winifred Nicholson were all married to artists and as such have been comparatively discussed in relation to their spouses, and sometimes said to have

been given special place due to that relationship.[9]

Norman Garstin, a contemporary and friend to both the Forbes artists, summed up this problem in the closing paragraph of his article in *The Studio*, entitled 'The Art of Stanhope Forbes, ARA':

Mrs. Stanhope Forbes' work does not ask you for any of that chivalrous gentleness which is in itself so derogatory to the powers of women. As an artist she stands shoulder to shoulder with the very best; she has taste and fancy, without which she could not be an artist. But what strikes one about her most is summed up in the world 'ability' - she is essentially able. The work which that wonderful left hand of hers finds to do, it does with a certainty that makes most other work look tentative besides hers. The gestures and poses that she chooses in her models show how little she fears drawing, while the gistiness of her criticism has a most solvent effect in dissolving the doubts that hover round the making of pictures. These things show, Daudet notwithstanding, that it may be a valuable thing to have such a critic on the hearth.[10]

The judgement of another younger contemporary, however, is the one from which the title of this book is taken. The artist Frances Hodgkins recognised in Elizabeth's work that magic which music can also induce, a quality of work that sings from the walls.

4.4 *Alec Reading*
watercolour and bodycolour,
31 x 44cm Private Collection

Notes

NOTES

Preface
1 'Studio Talk', in *The Studio*, Vol. 20, 1900.
2 Ibid.
3 Melissa Hardie (editor), *A Hundred Years in Newlyn, Diary of a Gallery (1895-1995)*, Patten Press in association with Newlyn Art Gallery, Penzance, Cornwall, 1995.

Introduction
See pages 28-29.

Chapter 1
1 *Stanhope Forbes RA and Elizabeth Stanhope Forbes, ARWS*, by Mrs. Lionel Birch, London, Cassell & Co., 1905. This book contained an account of her early life written by Elizabeth Forbes, which has been used as part of the background material for this period.
2 Her information sheet lodged with the National Gallery of Canada states her place of birth as Kingston, Ontario, and other sources list Ottawa. See Bednar (1999) *Every Corner Was a Picture*.
3 The anecdotal quality of Elizabeth's report of her time in London sweeps many memories of separate events into close quarters. Rossetti lay dying in Kent in 1881-82, by which time Elizabeth had spent time in Canada and three winters in New York City. Rossetti was certainly in and about his Chelsea residence while she lived there in younger years, though they never met. See Gaunt (1942) *The Pre-Raphaelite Tragedy*.

Chapter 2
1. Mrs. Lionel Birch, op.cit.

Chapter 3
1. Mrs. Lionel Birch, op. cit.

Chapter 4
1 *Boswell's 18th Journal*, Limited publication, Yale University, 1933.
2. Cook, Judith, *Close to the Earth*, Routledge & Kegan Paul, London, 1980.
3 Fox, Caroline and Francis Greenacre, *Artists of the Newlyn School*, Introduction, Newlyn Art Gallery, 1979.
4 Ibid.
5 Mrs. Lionel Birch, op. cit.

Chapter 5
1 *The Cornish Magazine*, Vol. 1, 1895.
2 Fox & Greenacre, op. cit.
3 Garstin, Norman, 'The Work of Stanhope Forbes, ARA' in The Studio, Vol. 23, 1901.
4 All of the following letters quoted are from the Stanhope Forbes Archive in the Tate Gallery, London.
5 Bourdillon's Letters, 7.8.1890.

Chapter 6
1 Stanhope Forbes Archive, Tate Gallery, London.

2 Fox & Greenacre, op. cit.
3 Ibid.
4 Stanhope Forbes Archive, op. cit.
5 Ibid.

Chapter 7
1 Forbes, Elizabeth, 'On the Slopes of a Southern Hill', in *The Studio*, Vols. 17-18, 1900.

Chapter 8
1 Hardie, op. cit.
2 Ibid.
3 Ibid.
4 Tate Archive, A9015.
5 Mrs. Lionel Birch, op. cit.
6 *Girls' Realm*, November 1904.

Chapter 9
1 Joanna Colenbrander, *A Portrait of Fryn*, Andre Deutsch, 1984.
2 Linda Gill (Editor), *Letters of Frances Hodgkins,* University of Auckland Press, 1993.
3 Colenbrander, op. cit.
4 Ibid. and following.
5 *Paper Chase*, March, 1908, and June 1909.
6 Colenbrander, op. cit.
7 *The Studio*, Vol 43, 1908.

Chapter 10
1 Colenbrander, op. cit.
 Letter 9.3.1912.
2 Colenbrander, op. cit.

Epilogue
1 *The Cornishman*, 28.3.1912.
2 *The Pall Mall Gazette*, 28.3.1912.
3 Information given by source to the author.
4 Colenbrander, op. cit.
5 Letter 4.5.1915.
6 Tate Archive, Letter undated, probably end-September, 1916.
7 Ibid.
8 Michael Canney, Newlyn Notebook (unpublished), West Cornwall Art Archive.
9 Melissa Hardie, 'Painting with their eyes wide open - Women Painters in Cornwall', *Women Artists in Cornwall*, 1880-1940, Falmouth Art Gallery, 1996.
10 Norman Garstin, 'The Art of Stanhope Forbes, ARA', *The Studio*, 1901.

Catalogue Raisonné

The dating of works by Elizabeth Forbes is often not easy. Unlike that found for Stanhope Forbes in his sales book, there is no extant sales record for Elizabeth. Sometimes she did sign or monogram and then date a piece of finished work, and other dates are known from catalogues, biographical texts and articles in journals. It is clear that most of her etchings and engravings were early work, tapering off after her migration to Cornwall and as explained in the main text. Also events in her life such as visits to Pont-Aven, Cancale, Holland and the Pyrenees date work approximately, but equally studies were used at later dates when brought back from her travels. Some dates given are approximate in that they reflect exhibition times (end dates) as opposed to execution dates, which may of course have been much earlier or over a span of months and years.

Works in private collections were usually not available for current scrutiny except through historical and published visual records. The current location of much work is unknown, and inevitably spread widely in private and public collections. No claim is made that this first catalogue is exhaustive. It is, however, based on the collation of all known and original sources of information: the Forbes's scrapbook of news cuttings, their photographic album, the sales records of the Newlyn Art Gallery, contemporaneous exhibition records of the Royal Academy, contemporaneous reviews and articles relating, together with subsequent catalogues and critiques. Frustrating to the present cataloguer is the lack of detail, even related to medium, of works listed in some records, making cross-referencing difficult, from anything but visual comparison.

PAGE 164
4.190 *Off to School*
oil on panel, 33 x 25.4cm
image courtesy of Leon Suddaby

Sales information (in auction) dating from 1971 has been made available by courtesy of the Art Sales Index & Art Quest, Virginia Water, Surrey. Acknowledgement & thanks are due for their patient and generous help to the following: Graham Bazley, W. H. Lane & Son, Penzance; the late Hazel Berriman Burston, then of Royal Cornwall Museum, Truro, later, Director, Penlee House Gallery & Museum; Professor John Heckenlively, California; Jonathan Holmes, Alison Lloyd and Katie Herbert, Penlee House Gallery & Museum; staff of the Victoria & Albert Museum, Prints & Drawings Department; Canadian Prints & Drawings Department, National Gallery of Canada, Ottawa; the Getty Museum & Research Institute, Los Angeles; David Messum Fine Arts, London and his team, especially Dr. Corinna Halbrehder; Susan Gabriel, Newton Abbot, Devon; the late Michael Canney, former Curator, Newlyn Art Gallery; Dr. Joanna Mink, Mankato University, Minnesota; Professor Betsy Cogger Rezelman, St. Lawrence University; the late Dor Varcoe, Luxulyan; Mr. and Mrs. Richard Gilbert, Bodmin; John Foster Tonkin, Falmouth; Hugh Bedford, Twickenham; Catherine and Paul Feiler, Trewarveneth Studios, Sancreed; Professor Charles Thomas, Truro; James Kington, Saltash; Mrs. M. Ellis, Salisbury; Virginia Walker, Oxford; Dr. Richard Pryke, Hereford, and George Bednar, Exeter. Very special thanks are offered to Archie Trevillion of St. Erth, for many hours spent trawling through auction catalogues.

Some of the following works listed may be duplicates, due to the absence of an authoritative record of paintings, drawings, and etchings together with consistent titles produced by Elizabeth Armstrong Forbes herself. Within her lifetime, the same painting was identified in several differing ways. See, for example, the entry for *A Dream Princess* which was found in three separate sources with slightly different titles. Also, a title was occasionally shared by more than one painting. See, for example, *Hide & Seek*, one a children's game, another given to an adult 'love scene'. The same applies to *An Attentive Companion* that in one picture refers to a child with her dog, and in another to a child with her cat. Where visual comparison was possible with titles, duplication could be eliminated.

Inevitably, some of the designations made as titles are descriptive only, as decided upon 'with imagination' by agent or dealer disposing

of the work at any given time. It is not uncommon when chasing a particular picture offered at auction, to find that if it is not sold, it may be offered in further sales with different names, making transfers of particular paintings hard to track. Even measurements of the same picture may vary slightly. Nevertheless, some works bearing the same name are obviously different both in size and medium. Often one may be the study for the other. They are listed here as found in published records.

The works have been divided into six categories by medium where known, and within categories are alphabetical as far as possible with artificial titles. For ease of reference, each separate work has been given a number, and this number should be referred to in any correspondence.

An asterisk * before a title denotes that the work or a published image/illustration for this work has been viewed by the current cataloguer and can be seen in the image catalogue of the West Cornwall Art Archive, even though details may be incomplete.

Parenthetic (illus.) refers to illustration appearing in the sales catalogue for the dealers referenced. Preceding the list of paintings is a chronology of exhibitions and paintings exhibited in that year (i.e. end dates).

The cataloguer would be grateful for any corrections and additions which readers may be able to volunteer. In due course, a second edition of the Catalogue is planned. Please contact in the first instance, Dr. Melissa Hardie, West Cornwall Art Archive (WCAA), The Hive, The Old Post Office, Newmill, Penzance, Cornwall, TR20 8XN. Tel: 01736 360549; Fax: 01736 330704; e-mail: melissa@hypatia-trust.org.uk.

Melissa Hardie
Honorary Archivist,
West Cornwall Art Archive

Abbreviations used in catalogue: MMC (Mortimer Menpes Collection); NGC (Canadian Prints & Drawings Dept, National Gallery of Canada); V&A (Victoria & Albert Museum, London); NAG (Newlyn Art Gallery, aka from 1974-1994 incl. Newlyn Orion Art Gallery, Penzance, Cornwall); NOB (Newlyn Orion Benefit Sale 1981, comprising Forbes studio remains); Penlee (Penlee House Gallery & Museum, aka previously as Penzance & District Museum at Penlee House); RA (Royal Academy, London).

PAGE 168
4.186 *The Mushroom Gatherers*
1886-7
oil on panel
image courtesy of Leon Suddaby

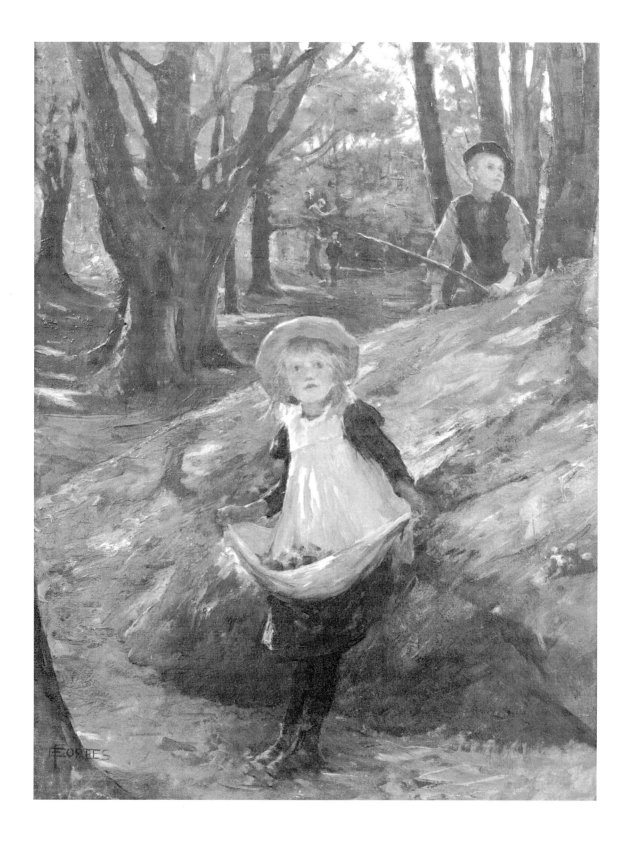

(Exhibitions, paintings and significant events)

BIRTH

Born December 29, 1859, Ontario, Canada, the last and only daughter of the three/four (?not recorded) children of Frances and (late in his life) William Armstrong.

1873

About this time departed Canada for schooling in England, with mother Frances Armstrong. Father died in Canada two months later. Living with uncle, Dr. Hawksley, on Chelsea Embankment, London. Attended Kensington Art School.

1877

Frances and Elizabeth return to Canada for family reasons.

1878

Joins Art Students' League of New York City and remains there 'three winters'.

1881

Elizabeth returns to London accompanied by Frances.
Three pictures accepted, Royal Institute of Painters in Water Colours.

1882

First, spends five months in Munich painting and studying, then visits Pont-Aven, accompanied by Frances. Encouraged by Dr. Hawksley to return to London to further her career in art.

1883

Admitted to Membership of the Royal Society of Painters in Water-Colours.

1883-89

In the name of Miss Elizabeth Armstrong (Speciality listed as 'Domestic') she participated in 63 principal London exhibitions:

14 at the Royal Academy
16 at the Society of British Artists, Suffolk Street
13 at the New Water-Colour Society [afterwards Royal Institute]
4 at the Grosvenor Gallery
2 at the New Gallery
14 various exhibitions
Total: 63 exhibitions in this period*

1883

Studio address: 18 Lupus Street, St. George's Square, London, SW
The Apple Pickers
Summer, RA
Boy with a Hoe

1884

Studio address: as above
Visit to Zandvoort, Holland, joining up with the Art Students' League (NY)
Exh: Grosvenor Gallery, London; Society of British Artists
Please Stay to Breakfast
Chelsea Pensioner
At the Edge of the Wood
Zandvoort Fisher Girl

1885

Studio address: as above
With Frances, she moves to Cliff Castle, Newlyn
Exh: Birmingham
Corner of the Galery (sic) (London)
Saying Grace, RA
Study in White, NAG (Dec)
Antoinette
Narcissus
Pets
Begins *The Forge* (-1886)

1886

Studio address: as above
Meets and becomes engaged to Stanhope Forbes
Exh: The New Gallery, London; RA; Society of Painter-Etchers

After Dinner, RA
Little Sister, RA
Self-Portrait
The Mushroom Gatherers
The Shipbuilders
Begins *The Critics*
Begins *School is Out*

1887

Studio address: c/o Dr. Hawksley, Victoria Street, London SW1
New English Art Club (2 paintings)
Studio address: (Cornwall) St. Ives
Suspense
Cuckoo
First Love
The Critics (continues)

1888

Studio address (London): as above
Studio address (Cornwall) St. Ives
Apprentices
Matinée Musicale
The Red Admiral
Victors & Vanquished

1889

Medallist, Paris Universal Exhibition
Marriage to Stanhope Forbes, July, St. Peter's Church, Newlyn
The couple move back to Cliff Castle, Newlyn
The Accordion Player (end date)
Portrait of Alice Elizabeth (Mrs. Percy) Craft
Portrait of Stanhope Forbes
School is Out, RA

1890-1893

In the name of Mrs. S. A. Forbes (Speciality listed as 'Domestic') she participated in 8 principal London exhibitions:
4 at the Royal Academy
1 at the Grosvenor Gallery
2 at the New Gallery
1 various exhibitions
Total 8 exhibitions in this period.

In the period 1874-1893 (19 years), Stanhope Alexander Forbes, ARA (Speciality also listed as 'domestic') participated in 42 principal London exhibitions, whereas Elizabeth participated in 71 within a 10-year period, only 8 of which occurred after her marriage.

1890

Dowdeswell & Dowdeswell,
Exhibition of pictures by artists
residing in, or painting at, Newlyn, St.
Ives, Falmouth, etc. in Cornwall; Dec,
London.
Mignon

1891

Summer Painting Trip - Cancale,
Brittany
The Braid
A Game of Old Maid, RA
Jean, Jeanne et Jeannette, RA
A Trespasser
The Witch

1892

Husband Stanhope elected ARA
Breton Scene, Girl with a Barrow
A Minuet, RA

1893

Move to Trewarveneth Farm: Alec
born
Gold medallist, oil painting section,
Chicago Exposition
Moorland Princesses
A New Song

1894

Nottingham Castle Museum & Art
Gallery, Special Exh. of pictures by
Cornish Painters
Re-visit to Holland
Design and building of Higher Faugan
with Stanhope
At the Edge of the Wood, RA

1895

Move to Higher Faugan
Exh: Guildhall Exhibition, London;
Opening Exhibition at Passmore
Edwards Art Gallery at Newlyn
(NAG), Oct 22
Sunday in Holland
The Sunny Path
Second Exhibition (Sketches), NAG,
December
Cast Shadows
Dutch Interior
The Farmyard Gate
Firefly, RA
The Japanese Doll
A Quiet Valley

1896

3rd Exhibition, NAG, February
5th Exhibition, NAG, July ['Record
price paid for Mrs. Forbes' *The Sage
of the Wood*', news cutting, £80.]
Sketch Exhibition, NAG, November
A Fairy Story, RA
By Mount's Bay

1897

Death of mother, Frances, November 8
Alec, son of Mrs. Stanhope Forbes
A Dream Princess, RA

1898

Private view of work, NAG,
December 20
Elected to Royal Watercolour Society
(ARWS)
Visit to the Pyrenees
Hop o' My Thumb
Imogen lying among the flowers ...
An Interior: Basses Pyrenees
A Shepherdess of the Pyrenees

1899

Opening of Forbes Painting School
(Newlyn School of Art) with Frank
Bramley and Lionel Birch
Elected to the Royal Watercolour
Society: *King Arthur's Wood*
illustrations
12th Exhibition, NAG
Marie
Self-Portrait
Three Blind Mice

1900

'Children & Child Lore', Fine Art
Society, London (solo show)
Will o' the Wisp

1901

16th Exhibition, NAG, April
Charcoal Drawing
Esmeralda
The Gipsy
The Braid (from 1891)
17th Exhibition, NAG, August
On the Seine
Ora Pro Nobis

1902

18th Exhibition, NAG, Nov. 1901-
March 1902
Whitechapel Art Gallery, Spring Exh.,
March 27-May 7
The Old Mill Steps
Take, Oh Take Those Lips Away

1903

23rd Exhibition, NAG, August
Iris Pastel (KAW)
The Little Fern Cutters
On a Fine Day, RA

1904

24th Exhibition, NAG, January
'Model Children and Other People',
solo show, Leicester Galleries
26th Exhibition, NAG, August
St. Louis International Exhibition of
1904
If I Were As Once I Was
Jonquil (end date)
Lamorna Valley
May Evening
O Wind a-blowing all day long ...(end
date)
A Wind-Swept Avenue (end date)
Publication of *King Arthur's Wood*
(Christmas)

1905

In with you! (end date)
Trewarveneth, Oct
The Woodcutter's Little Daughter
29th Exhibition, NAG, September
30th Exhibition, NAG, November

1906

Book about Stanhope and Elizabeth
Forbes, published by Mrs. Lionel Birch
Establishing 'end dates' for the
following:
Charity
The Fisher Wife
*Here We Come Gathering Nuts in
May*
Mrs. Percy Sharman, Portrait
Primroses
32nd Exhibition, NAG, September
*The Winter's Tale, When Daffodils
Begin to Peer*, RA

1907

33rd Exhibition, NAG, January
Call the Cattle Home

1908

37th Exhibition, NAG, April
The Ford, RA
Hay & Pink Clover, RA
Gipsy, NAG
Publication of *Paper Chase*

1909

The Half-Holiday, RA
June Days
Portrait of Cecily Tennyson Jesse
Publication of second edition of
Paper Chase

1910

Honours: Merit Award, Royal British
Colonial Society of Artists
End of Harvest, RA
Royal Watercolour Society Liverpool

1911

June at the Farm, RA
Royal Society of Artists
Birmingham, Autumn Exhibition

1912

Died March 16, aged 52.
Posthumous exhibitions in 1912:
RA: *The Blackberry Gatherers*
Royal Society of Painters in Water-
Colours Summer Exhibition

Significant posthumous exhibitions

1958

'Artists of the Newlyn School, 1880-
1900', Newlyn Society of Artists,
Touring to Truro, Plymouth and
Bristol. Curator, and author of
exhibition catalogue: Michael Canney.

1978

'Painting in Cornwall', Royal
Institution of Cornwall, Truro.

1979

'Artists of the Newlyn School (1880-
1900)', Newlyn Art Gallery, Penzance.
Touring exhibition to City Art
Gallery, Plymouth, and City of Bristol
Museum & Art Gallery thereafter.
Exhibition catalogue by Caroline Fox
& Francis Greenacre.

1981

'Stanhope Alexander Forbes &
Elizabeth Armstrong Forbes, A
Selection of paintings, watercolours,
drawings & etchings', June 20-July 21,
1981, in aid of Newlyn Orion Gallery,
Newlyn. [In this exhibition 70 listed
works were shown by the two artists,
only 12 of which were by Stanhope,
four of which were not for sale. Of
Elizabeth's 58 works, 12 were not for
sale, leaving 46 etchings, oils,
charcoals, and gouaches which were
available for sale.] Provenance is often
quoted from this sale, the largest of
their work since the deaths of these
two artists.

1985

'Painting in Newlyn, 1880-1930',
Newlyn Orion Galleries Ltd.
Exhibition following up the 1979
survey of painting and extending into
the second generation of Newlyn
painters. Catalogue 1, by Caroline Fox
& Francis Greenacre. Toured to the
Barbican Art Gallery, July 11 -
September 1, with an expanded
number of exhibits. Revised &
enlarged catalogue 2 by Caroline Fox.

1987 (APR) - 1988 (FEB)

'Painting Women, Victorian Women
Artists', Rochdale Art Gallery
travelling exhibition to Camden Arts
Centre, London; Victoria Art Gallery,
Bath; and Southampton Art Gallery.
Exhibition catalogue by Deborah
Cherry.

1989

'The Last Romantics: the Romantic
Tradition in British Art: Burne-Jones
to Stanley Spencer', Barbican Art
Gallery. Exhibition catalogue by John
Christian and others, in association
with Lund Humphries.

1993

'An Artistic Tradition, Two Centuries
of Painting & Craft in West Cornwall
1750 - 1950', Penzance & District
Museum, Penzance, May, 1993.
Exhibition catalogue by Jonathan
Holmes.

1996

'Women Painters in Cornwall 1880-
1940', Falmouth Art Gallery.
Exhibition curator & ed., catalogue,
Catherine Wallace, with critical essays
by Melissa Hardie, Valerie Reardon
and Marion Whybrow.

'Now and Then Painters from West
Cornwall, 1890s-1990s', David
Messum Fine Art, Cork Street,
London. Exhibition catalogue by
Elizabeth Knowles & David Messum.
Over many years the David Messum
galleries have shown and sold the
work of the Newlyn School.

'Regional Collections Exhibition',
Royal Academy, 1998.

2000

'Singing from the Walls: The Life and
Art of Elizabeth Forbes' exhibition
curated by Penlee House Gallery &
Museum, Penzance then touring to
Djanogly Art Gallery, University of
Nottingham. Book of same title
published by Sansom & Company
Ltd.

PAGE 172
4.254 *There Was a Knight Came
Riding By*
oil on canvas, 127 x 83.8cm
image courtesy of Leon Suddaby

THE WORKS

Dimensions are in centimetres, height before width.

I. The Writings of Elizabeth Forbes:

*1.1 The autobiographical portrait of herself, contained within the main biographical source about the two Forbes artists by Mrs. Lionel Birch: *Stanhope A. Forbes, A.R.A., and Elizabeth Stanhope Forbes, A.R.W.S.* [1906] and around which much of this new biography is structured. The author Constance Mary Birch was an artist in her own right, and the wife of the artist, Lionel Birch, who took weekly classes of pupils for tuition at the Forbes School of Painting from 1899 when it opened. Mr. & Mrs. Lionel Birch were early supporters of the Passmore Edwards Art Gallery at Newlyn (opened in 1895), the prime mover of which was Stanhope Forbes, together with his wife, Elizabeth.

The Lionel Birches are not related to nor to be confused with the Samuel John 'Lamorna' Birch family of artists though they are regularly 'miscast' in some indexes and books about the Newlyn school of artists. It is said that Stanhope Forbes gave S. J. Birch the title 'Lamorna' to differentiate between the two men in everyday communications but even then the initials were not different. Unfortunately within the formalities of the time, their wives were not clearly differentiated, and Mrs. Constance Mary Birch [c1865-1926], the biographer of the Forbeses, has often been thought to be the wife of the more famous R. A. painter, 'Lamorna' Birch. Partly this may have been assumed since Elizabeth Forbes and Lamorna Birch were also good friends as well as comrades in art. Until George Bednar (1999) was persistent enough to obtain her personal details, Mrs. Lionel Birch was 'hidden' under the simple name of 'Mrs. Birch'.

*1.2 *King Arthur's Wood* An illustrated fairy tale for Alec, her son.

*1.3 'Two Painters of St. Ives', an article for *The Paper Chase*, 1909, about Julius Olsson and T. Millie Dow.

II. Book illustrations:

Poems of Herrick, The Golden Poets series, Selected with Introduction by Rev. Canon Beeching DD, London: Caxton Publishing Company. No date. Illustrated by Elizabeth Stanhope Forbes – cover designation.
Coloured Illustrations by Elizabeth Stanhope Forbes – half-title page. Eight illustrations by EAF.

2.1 Facing page 4: *Soft music: The mellow touch of music most doth wound/The soul when it doth rather sigh than sound*. Muse of Herrick, following, is probably the same painting/illustration.
Note: *Muse of Herrick, I sing of brooks, of blossoms, birds and bowers*, watercolour gouache over black chalk: 55.9x43.2cm, signed. Sold as Lot 225 (illus.) at Sotheby's, Billingshurst, October 22, 1991, for £1,000.

2.2 Facing page 10: *Cherry-ripe, ripe, ripe, I cry, Full and fair ones; come, and buy*
Note: The original watercolour over charcoal (42.8x32.5cm.) Paris number 24013819, Institution number 13819, (Acc. 1289) is in the Canadian Prints & Drawings department of the National Gallery of Canada (Ottawa). Its end date (date by which work was done) is specified as 1910.

2.3 Facing page 16: *A sweet disorder in the dress/Kindles in clothes a wantonness; A lawn upon the shoulders thrown/Into a fine distraction*
Note: *A sweet disorder...etc.* Charcoal, watercolour & gouache: 33.6x23.5cm, signed EAS Forbes (lower left) offered for sale, Christie's, London, March 5, 1999 (Lot 78, illus.), est. £10-15,000. Provenance quoted: J & W. Vokins, London.

2.4 Facing page 54: *Gather ye rosebuds while ye may: Old time is still a-flying*

2.5 Facing page 138: *Bright tulips, we do know/You had your coming hither*

2.6 Facing page 150: *When I behold a forest spread/With silken trees upon thy head*

2.7 Facing page 154: *Come sit we under yonder tree/Where merry as the maids we'll be*

2.8 Facing page 180: *A little garland fits a little head*
Note: *A little garland fits a little head* (Robert Herrick) Charcoal, watercolour & gouache: 33.6x23.5cm, signed EAS Forbes (lower right) signed again and inscribed Elizabeth Stanhope Forbes/ Higher Faugan, Newlyn/with title on a label attached to backboard. For sale at Christie's, London, March 5, 1999 (Cat. No. 79, illus.), est. £10-15,000.

*King Arthur's Wood (KAW), a series of 28 major illustrations, plus occasional decorations (illuminated lettering), charcoal and watercolour, black and white and full vivid colour, for her book of this name, published in 1904 by E Everard, Bristol.

Most of the original illustrations are in a distinguished private collection in Cornwall and generously have been made available for exhibition. The book loaned for the exhibition is part of the Hypatia Collection, The Jamieson Library, Newmill.

Elizabeth Forbes was elected in 1899 to the Royal Watercolour Society upon presenting a portfolio of these illustrations for the book. The whole set of original illustrations were exhibited at the Leicester Galleries in 1904. Titles listed below are those given by the artist in the 'List of Illustrations' indexed within the book.

2.9 Facing p.11: I. *The sky had darkened for rain* (frontispiece) Charcoal.

2.17 *Noel Slid Down into a Cosy Nest of Fern*

2.10 Facing p.12: II. *Once there was a little old house that stood on the side of a hill* Watercolour.

2.11 Facing p.16: III. *Pictures out of the past glowed and flickered among the ashes* Charcoal.

2.12 Facing p.20: IV. *She rose and bent over the sleeping children* Watercolour: 25.5x41.5 cm.

2.13 Facing p.24: V. *On the other side of the stile was a whole new world* Charcoal.
The other side of the stile Charcoal & wash: 54.6x33.6cm, signed. Original for *KAW*. For sale at Newlyn Orion Benefit, 1981 as No. 69, £250.

2.14 Facing p.28: VI. *A flush of azure bloom covered the ground* Watercolour.

2.15 Facing p.32: VII. *The frogs croaked in the reddened pools* Charcoal.

2.16 Facing p.36: VIII. *The Little Brown Man settled himself more comfortably on his elder tree branch and began the story* Watercolour.

Study for *The Little Brown Man...* Mixed Media.

2.17 Facing p.40: IX. *Noel slid down into a cosy nest of fern* Charcoal & wash: 35.6x52cm, unsigned. Original for *KAW*. Exh. Newlyn Orion Benefit, 1981 as Cat. No. 70 (NFS).

2.18 Facing p.44: X. *Then up spoke the lad with a modest air* Watercolour.

2.19 Facing p.48: XI. *'We shall see about that,' said Sir Gareth, and followed the man to the glen* Charcoal.

2.20 Facing p.52: XII. *La Demoiselle Sauvage. 'You are an uncourteous knight,' said she* Watercolour.
Illustration employed as the lead design for the establishment of the Elizabeth Treffry Cornish Collection of Women's Writings, Hypatia Trust, Penzance, 1997.

2.21 Facing p.56: XIII. *Sir Gareth and the Damsel in the Wood Perilous* Charcoal.

2.22 Facing p.60: XIV. *So then in sign of peace and good fellowship they clasped hands* Watercolour.

2.23 Facing p.64: XV. *Sir Gareth ate and drank and rested him well* Charcoal.

2.24 Facing p.68: XVI. *The Lady Liones* Watercolour. Illustration employed for notelet, The Hypatia Trust, Penzance, 1998.

2.25 Facing p.72: XVII. *The wild creatures of the wood would come on furtive padded feet* Charcoal.

2.26 Facing p.76: XVIII. *The Green Knight* Watercolour: 17.5x42cm.

2.27 Facing p.80: XIX. *'Let go my dwarf, thou traitor!'* Charcoal.

2.28 Facing p.84: XX. *The Black Knight of the Black Lawn* Watercolour: 29x29cm.
Watercolour drawing from *KAW* reprinted in black & white in Mrs. Lionel Birch, p.83 by permission of Edward Everard, Esq. Bristol, the publisher.

2.29 Facing p.88: XXI. *'What have you done with my son, O King?'* Charcoal.

2.30 Facing p.92: XXII. *At that word Sir Gareth put forth a mighty effort* Watercolour: 30x42.5cm.
Study for *At that Word...* Mixed Media: 29x39.5cm.

2.31 Facing p.96: XXIII. *And so making great dole he came to a broad and gloomy water* Charcoal: 38.5x56.5cm.

2.32 Facing p.100: XXIV. *But when the Lady of the Castle had sent Sir Gareth away* Watercolour.

2.33 Facing p.104: XXV. *The short dark days with the good brown earth laid bare under the plough* Charcoal.

2.34 Facing p.108: XXVI. *And then came riding Sir Gareth* Watercolour: 30.5x42.5cm [See entry in Paintings for *A Knight Came Riding By...*]

2.35 Facing p.112: XXVII. *For Myles had grown a man with a man's thoughts and desires* Charcoal.
Reprinted in Mrs. Lionel Birch, by permission of Edward Everard.
Charcoal: 43.2x30.5cm, unsigned original illustration for *KAW*. For sale at Newlyn Orion Benefit (NOB), 1981 as Cat. No. 50, £200. *Miles has grown* Charcoal: 43.2x30.4cm, signed. Sold as Lot 222 (illus.) at Bearnes, Torquay May 23, 1984 for £340. [Note: if this was the

same original, signature to be questioned.] Offered for sale as Lot No. 46, entitled *A farm worker* (illus.) signed, framed & glazed at W. H. Lane, Penzance, July 28, 1994.

2.36 Facing p.116: XXVIII. *'Then man your boats, yo ho! For a'sailing I will go'* Watercolour.

Note: Within the book there are other small decorations at chapter beginnings and ends, especially illuminated first letters or words of chapters. Some of these may have been parts of larger works, or studies which did not result in a major illustration as above.

2.37 Frontispiece: *Alec reading book - lying on floor with legs bent up - in a wood* Charcoal

2.57 *A Painter Sportsman* (Samuel John 'Lamorna' Birch)

2.38 Page 11: *Cottage and trees - large letter 'O' in black and small white letters 'NCE' making the first word of the story* Charcoal

2.39 Page 16: *Picture of the fireplace, with kettle hanging over it, picture framed by benches either side* Charcoal

2.40 Page 20: *Closed book with clasps next to a candle. The flame is being blown as if by a breeze* Charcoal

2.41 Page 23: *Landscape - sunset, cottages upper right, lane winding through picture, sheep in foreground* Watercolour

2.42 Page 27: *Grandfather clock with moonlight shining in from window behind. 'IC-TAC' in black letters next to it (clock represents 'T')* Charcoal and Gouache

2.43 Page 31: *Trees by the edge of the riverbank* Watercolour and Gouache

2.44 Page 35: *Letter 'T' with cobweb on left and 'swirls' around stem, trees in background* Watercolour and Gouache

2.45 Page 39: *Servant boy carrying platter on which sits a steaming hot turkey* Charcoal and Watercolour

2.46 Page 57: *Branch entering picture on left* Watercolour

2.47 Page 59: *Letter 'F' - to right is a figure holding an umbrella and basket, walking along the road* Charcoal and Gouache

2.48 Page 63: *Irises - cottage in background, hidden by the flower stems* Charcoal

2.49 Page 76: *Sepia picture of a foxglove*

2.50 Page 79: *Word 'AND' with maid in front holding long stick, castle in background*

2.51 Page 92: *Landscape - bushes in foreground, path leading to cottage on right, trees on left, moonlit scene*

2.52 Page 95: *Letter 'B' with moon sat on hilltop. Knight lying injured on floor, little brown man sat on letter 'B'*

2.53 Page 108: *Knight standing by stream, trees on left and in background*

2.54 Page 111: *Letter 'T' in landscape, two people on cart led by two horses behind*

2.55 Page 120: *Boy sat on wall (right foreground), village in distance, hay fields between*

2.56 a. *A Knight* from the painting by Mrs. Stanhope Forbes, reprinted in black & white in *The Lady's Realm* (1904-5). Perhaps a model for *KAW*. Critique: 'Of the many excellent drawings in *King Arthur's Wood, Sir Gareth & the Damsel in the Wood Perilous* and *The Black Knight of the Black Lawn* are perhaps the most successful.' *The Lady's Realm* (1904-5).

b. *King Arthur's Wood* Gouache & charcoal: 45.7x33cm, signed. Sold as Lot 33 (illus.) by Sotheby's, London, June 18, 1985, for £1,500.

c. *Illustration for the book King Arthur's Wood* Watercolour: 10.2x12.7cm, monogrammed in w/c. Sold as Lot 526 (illus.) by W. H. Lane, Penzance, October 16, 1986 for £450.

d. *Study of Irises* Black chalk, ink & white gouache: 43.8x17.8cm, signed. Illustration for *KAW*. Sold as Lot 140 (illus.) at David Lay Sale of Paintings, February 11, 1993 for £400. Offered for sale at Phillips, London, March 8, 1994.

The Paper Chase
[A Journal published by Mrs. Stanhope Forbes, edited by F. Tennyson Jesse, to chronicle creative life in west Cornwall. Begun in 1908 (March) and continued for a further volume in summer, 1909. Abandoned at the outset of Mrs. Forbes's terminal illness.]

2.57 *A Painter Sportsman* [Samuel John 'Lamorna' Birch] Frontispiece charcoal sketch portrait, reproduced in *The Paper Chase*, Vol. 1, 1908. Reprinted in *100 Years in Newlyn*, (1995) and *A Painter Laureate, Lamorna Birch & his circle* (1995).
Watercolour, red on grey paper: 19x29.2cm, inscribed below mount 'With apologies to Mrs. S. J. Lamorna Birch', framed & glazed. Offered for sale as Lot 518 at W. H. Lane, Penzance on October 16, 1986.

2.58 *And nature, the old Nurse took*
The child upon her knee,
Saying, here is a Story-book
Thy Father has written for thee.
A reproduction of a painting of a young woman, with lace head-scarf, and wide lace collar, reading a book in the wood. Black & white, signed Elizabeth Stanhope Forbes, A.R.W.S. Vol 1, 1908 [See entry for *Daydreaming* in section **IV Paintings.**]

2.59 *Norman Garstin*, a sketch portrait (Swan-Type Process), in *The Paper Chase*, 1909, signed EA Forbes. Reprinted in *100 Years in Newlyn, Diary of a Gallery* (1995).

III. Medium unknown:

3.1 *The Braid Catalogue* No. 15 in the 16th Exhibition (April, 1901) at the Newlyn Art Gallery. Sold to C. McNaughten of South Norwood Park, London, for 5 guineas. No details.

3.2 *Call the Cattle Home* Sold from the 33rd Exhibition (March 1907) of the Newlyn Art Gallery, to Richard W. Doherty of Bandon, Co. Cork for 10 guineas.

3.3 *D____yrock Cliffs* (indecipherable handwriting) Sold from the 26th Exhibition (August, 1904) of the Newlyn Art Gallery, to Mrs. Rutherford for 9 guineas.

IV. Paintings:
(Oils, mixed media & watercolours)

*4.1 *The Accordion Player*
Repr. in *The Art Journal* (1889) as selected by the editor & author (Alice Meynell) to illustrate one of the 'Newlyn works painted in or prior to 1889.' Exh. 1888, RA.
Subject: A group of three figures, two young girls listening to the male accordion player seated right in the light of a casement window.

4.2 *After Dinner* (1886)
Painting listed as Cat. No. 46 (?catalogue unknown) for 1885/6, priced at 8 guineas.
Painting mentioned as among four displayed at Burlington House, in 1886, by *The Lady's Realm*, p.190 (1904-5), along with *Little Sister*.
EAA address: 18 Lupus Street, St. George's Square, London, SW

4.3 *Afternoon Piano Solo*
Oil on board: 30.5x25.4cm
Subject: An elegant lady playing piano, young girl seated.
Sold as Lot 346 (illus.) at Phillips, Bath, April 18, 1994, £11,000.

4.4 *Alec Reading*
Watercolour and bodycolour: 31x44cm. Private Collection

*4.5 *Alec, son of Mrs. Stanhope Forbes* (1897)
111.8x66cm, signed and dated in verso. [William Alexander Stanhope Forbes] One of two works exh. at RA, 1897 [Cat. No. 163, illus.]. Photo of painting repr. in *The Lady's Realm* (1904-5). Photo included in Forbes's personal album, Newlyn Archives. Subject: Portrait of Alec in a sailor dress, standing on a chair, framed by a Newlyn copper charger.
Sold as Lot 40 (illus.) at Phillips, London, April 23, 1985, £9,000.

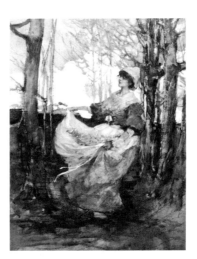

4.12 *An Apron Full of Flowers*

*4.6 *Alec in Whites*
1. Watercolour & charcoal: 45.7x31.7cm, signed.
Sold, Michael Newman, Plymouth, (Lot 122, illus.) June 22, 1988 £7,500. April, 1999, with Ackermann's, New Bond St., London. Provenance: Collection: Mr. & Mrs. Corkett.
2. *Alec in Whites* Charcoal: 30.5x40.6cm, monogrammed. For sale, NOB, 1981, Cat. No. 67, £300.
3. *Alec in a Cap*
Watercolour: 12.7x9cm, unsigned. For sale at NOB, 1981, Cat. No.62, £50.
Allegory of Spring – see *Pied Piper, Allegory of Spring*

4.7 *Anemones & daffodils in a vase*
Painting: 38.1x27.4cm, signed.
Sold, Sotheby's, London, March 4,1987 (Lot 100, illus.),£1,500.
– see *Spring Flowers in Glass*

4.8 *The Apple Gatherer*
Watercolour & gouache: 62.2x38.1cm, signed.
For sale, Sotheby's, London, (Lot 12, illus.) June 30, 1993. Provenance quoted as Charles Keyser, London.
Girl (Young) Raking Apples in Garden aka Girl in an Orchard – ? study for or same as above. Gouache. Exh. Penlee Focus Exhibition, 1997-8.

4.9 *Apple Orchard, The* (Ascain) c.1899
No details.
Exhibited, Fine Art Society, 1900, in 'Children & Child Lore'
Noted in Mrs. Lionel Birch, 1905: 'showing Ascain in the white glory of spring blossoming.'

*4.10 *The Apple Pickers* 1883
Oil on canvas: 86.4x66.1cm, signed EA & dated.
Private Collection.
Illus. in colour in C. Fox, *Stanhope Forbes & the Newlyn School*, p.46.

4.11 *Apprentices* 1888
Exh. New Gallery 1888; whereabouts unknown.
Subject: Two very tired girls with worn and pinched features working at dainty sewing.

4.16a **An Attentive Companion**

4.16b **Two Terriers**

*4.12 *An Apron Full of Flowers*
Gouache: 35.6x26cm., unsigned.
For sale, NOB, 1981, Cat. No. 53, £350.

4.13 *Ardent Prayer*
Pastel: 43.1x30.5cm, signed.
Sold, Christie's, Kensington December 13, 1982, (Lot 23) £750.

4.14 *Antoinette* 1885
Cat. No. 444 (?unknown catalogue),
Price: £5.
EAA address: 18 Lupus Street,
London, SW

4.15 *The Art Critics*
Mixed Media: 30x29.5cm.
Private Collection
Subject: Two girls looking at a book.

As you like it – see A Woodland Scene: As you like it

At Prayer – see The Fisher Wife

*4.16 a. *An Attentive Companion*
Watercolour, signed. Subject: A young girl in pink dress reading a magazine in a hammock, her dog looking up at her in rapt attention.

Reproduced on notelets and postcards as part of 'The Newlyn Collection' (NO11/111) by Natura Designs in 1990s, by courtesy of Fine Art Photographic Library Ltd.
4.16 b. *Two Terriers* (study for above)
Oil on canvas laid on board: 37.5x49cm.
Private collection.
Provenance: Major C. Gilbert Evans from Mrs. Maud Forbes, c.1950.

* 4.17 Watercolour. Subject: A young girl with blonde hair reclining in a chair with intricate needlework throw over her left shoulder upon which sits a small kitten looking raptly down at her.

*4.18 *At the Edge of the Wood* 1894
Oil on canvas: 134.6x81.8cm, signed EA Forbes.
Collection: Wolverhampton Art Gallery.
Exh. at RA, 1894 (illus., p.13), *Pictures of the Year*, 1894. Illus. in *The Studio* as 'The Edge of the Wood', Vol. IV, p.189.
Exh. at Newlyn Orion, 1979 (No. 79); 'Painting Women', Rochdale, 1987-88.

4.19 *Autumn Breeze*
Oil on panel: 49.5x58.42cm, unsigned.
Private collection.
Provenance: bought from David Messum Fine Art, 1986, £10,000.

*4.20 *Autumn Leaves*
Watercolour/body colour over black chalk: 25.4x17.8cm, signed.
Sold, Phillips, London, June 16, 1987, (Lot 26, illus.), £4,500. Illus. in *Lyle Official Arts Review*, 1989.
Subject: Girl in tam & pinafore holding a rake.

4.21 *Basque Farm*
Painting illus. in *The Studio*, Vol 18, p.28. No details.

4.22 *Bedtime*
Chalk & coloured washes highlighted in body colour: 45.7x30.5cm, signed.
Sold, Sotheby's Belgravia, London, December 1, 1981, (Lot 249 illus.), £1,650. Same described as watercolour gouache over chalk, Sold, Sotheby's, London, May 13, 1987 (Lot 10, illus.), £7,000.

*4.23 *Beneath the Pines*
Reproduction in full colour published by Natura Designs as part of 'The Newlyn Collection'(1990s) by courtesy of David Messum, Ltd. London & Marlow. (Card 646/NO/E)

4.24 *Best friends*
Chalk & gouache: 43.2x30.5cm, signed.
Sold, Sotheby's, London May 19, 1982, (Lot 4, illus.) £1,800.

4.25 *Betje* - a Dutch girl
Oil on panel: 33x22.9cm, signed.
Sold, Sotheby's, Chester, July 10, 1986 (Lot 3310 illus.),£1,500.

4.26 *The Bill-Sticker* 1890
Exh. Dowdeswells, No. 88. No details.

*4.27 *The Blackberry Gatherers* 1912
Oil on canvas: 83.8x100.3cm.
Collection: Walker Art Gallery, Merseyside.
The final painting of EAF, exhibited posthumously at RA.
Illus. in colour in *Stanhope Forbes and the Newlyn School*, p.51.

*4.28 *The Bluebell Wood* (No.1)
Oil on panel: 27.9x22.9cm, signed EA Forbes.
Subject: Two children standing in wooded patch of bluebells, one girl higher to right, standing beside tree.
Sold at Christie's, London, June 23, 1994, (Lot 1 illus.), £14,000. Provenance: 'A gift from the artist to Cecily Tennyson Jesse, later Mrs. Charles Cardale Luck, who was a pupil, with her husband, at the Forbes's art school in Newlyn ... thence by descent to Tom Luck in 1948, by whom gifted to the present owner.'

4.29 **The Bluebell Wood** (No.2)

*4.29 *The Bluebell Wood* (No.2)
Oil on panel: 29.2x24.1cm
Private Collection.
Subject: One child standing in bluebell
patch, wooded area, with a seated
young woman reading beside a tree.
For sale at Christie's, London,
November 6,1998 (illus): lst notice of
this painting.

*4.30 *The Bluebell Wood* (No.3)
Oil on panel: 36.5x24cm.
Private collection.

*4.31 *The Book*
Black chalk & gouache: 45x30.5cm,
signed.
Sold, at Phillips, London, November 15,
1988, (Lot 8, illus.) £5,000. Subject:
Breton woman reading.

4.32 *Boy with ball*
pastel, 31.5x45cm
Private Collection

*4.33 *Boy in Cornfield*
Oil on canvas: 48.3x33cm
David Messum list, 1996.
Subject: Boy sitting in hayfield with
stick in left hand.

4.34 *Boy with Cat*
33x25.4cm.
Sold, Bearnes, Torquay, September 3,
1987, (Lot 142, illus.), £1,100.

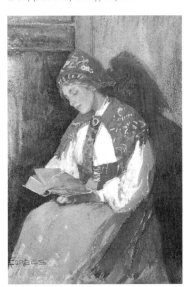

4.31 **The Book**

4.35 *Boy and Girl (young)*
Watercolour: 45.5x32.5cm.
Private collection.

*4.36 *Boy with a Hoe* c.1882-3
Oil on canvas: 48.3x58.4cm,
monogrammed with initials EA.
Private Collection.
Exh. Plymouth Museum & Art Gallery,
1923, and 'Artists of the Newlyn School
1880-1900' Exhibition, Newlyn Art
Gallery, 1979, 'Painting in Newlyn 1880-
1930' Exhibition, Barbican (No. 48),
1985. Repr. in full colour in *Stanhope
Forbes and the Newlyn School*, p.43.

4.37 *Boy's Head, Study of*
Oil on panel: 33x22.9cm monogram.
Sold, Phillips, London March 3, 1998
(Lot 32, illus), £8,500.
Provenance: Thomas Cooper Gotch and
thence by descent to Mrs. P. D.
Maclellan, from whom acquired by the
present owner.

4.38 *Breton Girl*, head and shoulders
portrait
Watercolour over charcoal:
30.5x27.9cm.
Sold, W. H. Lane, Penzance, October 21,
1997, (Lot 70), £525.

*4.39 *Breton Girl with Gorse*
Oil on canvas: 55.9x45.7cm, unsigned.
For sale, NOB, 1981, Cat. No. 35,
£1,500.

*4.40 *Breton Girl Harvesting*
24.1x30.5cm monogrammed EA.
Offered for sale at W. H. Lane,
Penzance, as Lot No. 290 (illus.) on
November 28, 1985, & at W. H. Lane,
Penzance as Lot No. 533 on October
16, 1986.
Subject: A girl in a cornfield with the
distant prospect of a village beyond.

4.41 a. *Breton Peasant*
Oil: 49.5x59.7cm Signed EA, undated.
Private Collection.
b. *Old Breton Woman* (? study for
above)
Watercolour: 20.3x19cm, unsigned.
Exh. NOB, 1981 as Cat. No. 59 (NFS).
Sold, W. H. Lane, Penzance July 20,
1982 (Lot 260), £335.

*4.42 *Breton Scene*
Oil on panel: 30.5x22.2cm, signed EAF.
Painted in 1892 in Cancale. Exh.
Newlyn Art Gallery, 1979. Repr. b/w as
Cat. No. 76, p.197 in *Artists of the
Newlyn School*.

4.43 *Breton Scene, Girl with a Barrow*
c.1892, Cancale
Oil on canvas: 34.2x24.8cm, signed EA
Forbes.
Private Collection.
Exh. Newlyn Art Gallery, 1979, as Cat.
No. 77.

* 4.44 *The Bride, Lady Forbes*
Oil on canvas: 84x80cm.
Exh. Penlee House Gallery & Museum,
May 1993 as Cat. No. 37.
Subject: The Bride is Stanhope Forbes's
sister in law. Repr. in *The Lady's Realm*
and called *Portrait of Mrs. W. Forbes* for
that purpose. Collection: Penlee House
Gallery & Museum.

4.45 *By Mount's Bay* 1896,97?
Watercolour over charcoal on wove
paper: 45.7x32.3cm.
Collection: NGC. Paris no. 24013820,
Acc. No. 1290.

*4.46 *By the pond*
Watercolour & bodycolour:
39.3x27.9cm, signed.
Sold, Christie's, London 10 Nov 1988,
(Lot 174, illus.), £3,200. Illus. in 1990
Art Review, p.186, as valued by
Christie's at £3,520.

4.47 *Carlo*
Pastel: 45.7x33cm signed.
Title first used 1999. Sold, Phillips,
London, March 2, 1999, (Lot 1 illus.),
£2,200.

*4.48 *Charity*
Watercolour & pastel drawing, signed
EA FORBES.
Repr. in colour facing p.86 of Mrs.
Lionel Birch.
Subject: depicting a mother with
mediaeval swathed-headcloth holding
golden-haired child.

4.49 *Chateau at Lac d'Annecy*
Watercolour and bodycolour on
linen laid on card: 35x24cm,
monogram, lower left.

4.50 *Chelsea Pensioner* 1884
Watercolour
For sale at £6.6s (Cat. No. 651 ? cat.)
EAA address at time of this painting: 18
Lupus Street, St. George's Square, S.W.

4.51 *Chestnut trees beside Lake Annecy*
Gouache: 20.8x33cm.
Sold, Phillips, London, April 23, 1985
(Lot 38, illus.), for £3,400.

4.52 *The Christmas Tree*
Black crayon & watercolour, body
colour: 45.7x35.6cm, signed EAS
Forbes.
Offered at Phillips, E. Anglia, Dec 1994.
Sold, Christie's, London, Nov 21, 1995
(Lot 82, illus.), £7,500. Provenance in
cat.: 'Colonel Edward Penrose, thence
by descent to the present owner.'

4.53 *A Clifftop Cottage*
Oil on panel: 21x26cm, monogrammed.
Offered for sale at Phillips, London
June 13, 1989 at £3,500-4,500.

4.54 *Consuela*
Watercolour: 15.2x12.7cm,
monogrammed.
Exh. NOB, 1981 as Cat. No. 56 (NFS).

4.55 *Corner of Galery* [sic] 1885
Cat. No. 442 (?catalogue)
EAA address: 18 Lupus Street, London,
SW

4.56 *Cornish bay with thatched cottage*
20.3x22.9cm, monogrammed.
Sold, Bracketts, Tunbridge Wells, May
5, 1989 (Lot 101), £4,700.

4.57 *Cornish Hedge*
Oil on canvas: 61x45.7cm
Exh. NOB, 1981 (NFS)

4.58 *Costume Study I*
Watercolour, gouache over charcoal:
45.8x32.4cm on blue wove paper.
Collection: NGC. Paris no. 24013821,
Acc. No. 1291.

4.59 *Costume Study II*
Watercolour, gouache over charcoal:
45.7x32.4cm on blue wove paper.
Collection: NGC. Paris no. 24013822,
Acc. No. 1292.

4.60 *Country Road, On a*
Oil on panel: 25.4x35.6cm signed.
Title first used 1998. Sold at Christie's,
London, November 6, 1998, (Lot 98a
illus.), £9,000.

*4.61 *The Critics* 1886-7
Oil on panel: 22.9x15.2cm, indistinct
monogram.
Cat. No. 330 (?cat. unknown),
Price £13.13s.
Contact address for EAA: c/o Dr.
Hawksley, Victoria St. (?offices)
Noted in *Stanhope Forbes and the
Newlyn School.* Repr. b/w facing p.56 in
Mrs. Lionel Birch, by permission of W.
A. Duncan Esq., who probably owned it
at the time.
Sold, Christie's, Kensington July 18,
1983 (Lot 174, illus.), £1,600. Exh. by
Richard Green, 'Modern British
Paintings', May 1984 (No. 10); 'Painting
in Newlyn, 1880-1930', Barbican (No.
50), 1985.

*4.62 *Crossing the Stream*
Black crayon, watercolour &
bodycolour: 61x45.7cm, signed EAS
Forbes.
Offered for sale at Christie's London,
November 22, 1994 (Lot 243).

*4.63 *Cuckoo* 1887
Pastel, watercolour gouache:
43.2x30.5cm, monogrammed.
Cat. No. 256 (?cat. unknown) £10.10s
Exh. 'Model children & Other People',
Leicester Galleries, Nov. 1904.
Repr. in *Women Painters of the World.*
Attr: Mrs. Stanhope Forbes, A.R.W.S.,
Painter. (British School of Water-
Colour, Contemporary)1905.
Sold, Christie's, London, June 12 1986
(Lot 101, illus.),£7,000.
Exh. 'British Impressions', David
Messum Gallery, 1994.

4.64 *Daffodils & tulips*
Watercolour: 38.1x27.9cm, signed. Sold
as Lot 3334 (illus.) by Sotheby's,
Chester, October 4, 1985, £450.

4.60 **Country Road, On a**

*4.65 *Daydreaming*
Orig. *And Nature the old nurse, etc.*
Oil on canvas: 61x50.8cm.
Subject: Girl seated in woods with an
open book over which she is knitting,
while looking inattentively into the far
distance. Full, lacy collar and cap and
Victorian dress. An inserted
'reproduction' in *Paper Chase*, 1908.
Sold, Phillips, London, Nov 12, 1985,
(Lot 79, illus), £12,500.
David Messum list, 1996.

*4.66 *A Dream Princess* 1897
Oil on canvas: 152.4x116.8cm.
One of two works exh. at RA, 1897
[Cat. No. 679] and indexed with this
name. Exh. Whitechapel, 1902 with
subject: 'A young miller of old, in his
ragged leather hose and jerkin has
fallen asleep to the droning music of
the water-wheel, and in his dream a
princess in rich array appears to stand
and smile beside him.'
Illus. b&w in catalogue, entitled 'A
Princess of Dreamland' under the
photo. Called 'The Dreamland
Princess' under b&w photo by Henry
Dixon & Son for *The Lady's Realm*
(1904-5), p.195. Given by Stanhope
Forbes & Alec Forbes (husband & son
respectively) in memory of her work in
Cornwall to the then new Royal
Cornwall Museum, Truro, 1913, where
it remains. [Accession 1913.10].

4.67 *Driving Home the Geese*
May be the same as *In with you* See
entry.
Watercolour gouache over chalk:
43.2x30.5cm, signed. Sold, Sotheby's,
Billinghurst November 26, 1990 (Lot
135, illus.) £9,200.

*4.68 *The Duck Pond*
Gouache: 53.3x38.1cm, signed.
Private Collection.
Exh. NOB, 1981 as Cat. No. 52 (NFS).

4.69 *The Duet*
Watercolour & charcoal: 44.4x30.5cm, signed.
For sale at NOB, 1981, Cat. No. 68, £275.

4.70 *A Dutch Interior*
Exh. but not sold at the Opening Exhibition (Oct., 1895) of the Newlyn Art Gallery. Described as a 'charming reminiscence of Holland'.

*4.71 *Dutch Landscape I*
Oil on panel: 26.8x17.8cm, unsigned.
For sale at NOB, 1981, Cat. No. 36, £750.

*4.72 *Dutch Landscape II*
Oil on panel: 33x25.4cm, unsigned.
For sale at NOB, 1981, Cat. No. 37, £500.

4.73 *Dutch Landscape III*
Oil on panel: 33x13.9cm, unsigned.
For sale at NOB, 1981, Cat. No. 38, £750.

4.74 *Dutch Scene* c.1884
Oil on canvas: 56.5x41.3cm,
Private Collection
Subject: Two young girls in caps and sabots posed on high ground before a flat panoramic landscape.
'Probably painted during the artist's visit to Holland in 1884' *(Artists of the Newlyn School)* Exh. NAG, 1979 as Cat. No. 73.

4.75 *Edge of the pine wood*
Chalk, brush, ink highlighted in white: 40.6x22.9cm, signed.
Sold, Phillips, London January 26, 1988 (Lot 4), £450.

*4.76 *The Enchanted Wood*
Oil on panel: 64 x 51 cm.
Subject: Woman looking right back to a tree, holding a small child against her, also looking right as if to a mysterious scene.
Private Collection.
Exh. Penlee May 1993 as Exh. No. 35.

4.77 *End of Harvest*
Exh. RA, 1910, with *June at the Farm.*

4.78 *Esmeralda*
Cat. No. 50 sold in the 16th Exhibition, NAG, (April, 1901) to Mr. Charles Bidwell of Ely, Cambridgeshire for 12 guineas.

*4.79 *A Fairy Story* 1896
Oil on canvas: 121x91.4cm.
Exh. RA, 1896 [Cat. No. 328, illus. b/w]; Whitechapel, 1902 No. 145.
Repr. b/w facing p.68 in Mrs. Lionel Birch. Illus. in colour, p.50 in *Stanhope Forbes and the Newlyn School.* Exh. at NEAC, 1958, lent by Miss Monica Anthony. Described as: 120.6x96.5cm, Lot 5 (illus.), signed, and sold at Christie's London, June 8, 1989 for £170,000 [$258,400]. Highest known price paid for EAF painting.
Fairy Tale - see Will o' the Wisp

4.80 *The Fan* c.1900-04
Noted in Mrs. Lionel Birch as illus: 'the illumination a Japanese lantern casts on the figure of the lady in a ball dress is wonderfully real in its strength and glow. The colour forms, with the charcoal below it, half-tones, suggesting atmosphere most happily.'
Exh. Leicester Art Galleries, 1904, in 'Model Children and Other People'.

4.81 *The Fandango*
Painting. Illustrated in *The Studio,* Vol XVIII, p.33.

4.82 *Farm Glimpsed through Irises*
Bodycolour: 43.2x17.8cm, signed.
Sold, D. Lay, Penzance, February 11, 1993 (Lot 140, illus.), £400.

4.83 *The Farmyard Gate*
Sold at NAG Opening Exhibition, Nov. 1, 1895 to Mrs. Foster. No details.

4.84 *Feeding Chickens* (Ascain, Pyrenees) c.1898
Oil: 30.5x41.9cm Signed, undated
Exh. Newlyn, 1958.

4.85 *Feeding time*
Watercolour gouache: 55.9x22.9cm.
Sold, Bonhams, London, March 25, 1998 (Lot 41, illus.), £3,800.

*4.86 *Fetching water*
Gouache over black chalk heightened with white: 45.7x33cm, signed.
Sold, Phillips, London, November 13, 1984 (Lot 43, illus.), £4,400. Sold, Sotheby's, London, May 13,1987 (Lot 9, illus.), £7,500. Offered for sale at Phillips, London, November 6, 1990 (Lot 9, illus.).

*4.87 *Firefly*
Painting: 106.7x91.4cm.
Exh. RA, 1895 [Cat. No. 804, illus. b/w].
Repr. in *The Lady's Realm* (1904-5).

4.88 *First Love* 1887
Noted in Rezelman, 1984, as painting accepted by New English Art Club for 1887 exhibition, but suspended due to objection to subject.
Subject: Young man carrying a basket to/from young woman for whom he has romantic feelings.

4.89 *Fir Trees*
No details.
Exh. Fine Art Society, 1900, in 'Children and Child Lore'.
Exh. Whitechapel, 1902. Lent by the artist.

*4.90 *The Fisher Wife*
Black chalk & watercolour heightened with white: 43.8x30.5cm.
Repr. in Mrs. Lionel Birch. Photographed by W. E. Gray, London, for *Women Painters of the World (British School, Contemporary)* 1905.
For sale entitled 'At Prayer', Phillips, London, June 12, 1990 (Lot 4, illus.)

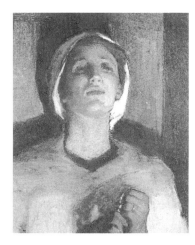

4.90 **The Fisher Wife**

*4.91 *The Ford*
*(Possibly the same as Primrose Wood
4.217)*
Oil on canvas: 104.1x81.3cm, signed.
Private Collection.
One of two works exh. RA,, 1908, (Cat.
No. 374, illus. b/w). Sold, Sotheby's,
July 22, 1973(Lot 168),£350. Sold,
Christie's, May 13, 1977 (Lot 50) £680.
Sold, Phillips, March 5-6 Sale, 1987
(No. 59).
Exh. Penlee Focus Exhibition, 1997-8.

4.92 *Forest Glade in Spring*
45.7x35.6cm.
Sold, W. H. Lane, Penzance September
28, 1989 (Lot 170, illus.), £940.

*4.93 *The Forge* c.1885-6
Oil on panel: 25.4x30.5cm
monogrammed.
Subject: Children outside a forge.
Proprietor standing in door.
Sold, Bearnes, Torquay, January 14,
1987 (Lot 397, illus.), £21,500.
Noted in *Stanhope Forbes and the
Newlyn School*. Reproduced by
courtesy of David Messum Ltd. in card
form by Natura Designs (1990s) as part
of 'The Newlyn Collection' (Card
706/NO2/E)

*4.94 *A Game of Old Maid* 1891
Oil on canvas: 101.6x63.5cm,
monogrammed EAF.
Private Collection.
Exh. at RA 1891, the Glasgow Institute
of the Fine Arts, March, 1892, 'Special
Exhibition of Pictures by Cornish
Painters', Nottingham Castle,
September, 1894, The Fine Art Society,
1969, Newlyn Art Gallery, 1979,
Barbican Exhibition of Artists of the
Newlyn School, 1985 (No. 51); 'Painting
Women', Rochdale, 1987-8 (illus). Repr.
in *Artists of the Newlyn School* in black
& white, as Cat. No. 75, p.195. Illus. in
colour in *Stanhope Forbes and the
Newlyn School*, p.47. Repr. by Natura
Designs as part of 'The Newlyn
Collection' by courtesy of Newlyn
Orion Galleries (1990s). (Card 4/NO3)
Reviewed in *The Scotsman*, of February
2, 1892 thus: (No. 64) 'a work by Mrs.
E. Stanhope Forbes, the wife of the new
Associate of the Royal Academy,

depicting a group of little girls playing
cards. Though rather sketchily treated,
the heads are cleverly characterised, and
the interior light of the room is skilfully
managed.'

4.95 *Garden*, aka *An Old Woman's
Garden* (EAA title) 1885/6
Cat. No. 216 (Cat. Unknown),
Price £6.6s.
EAA address: 18 Lupus Street, London,
SW

4.96 *Gathering chestnuts*
63.5x48.3cm, signed.
Sold, Phillips, London, March 25, 1986
(Lot 57, illus.), £15,000.

4.97 *The Gipsy*
Painting: 46.5x121.9cm.
Exh. RA, 1901 [Cat. No. 315, illus.
b/w]. Sold at the 32nd Exhibition
(September, 1906) of NAG to W.
Tinker Esq. of Brockenhurst, Hants
for 10 guineas. *The Gipsy* signed &
dated 1901, as No. 130 sold at
Sotheby's, London, February 22, 1972.
[One of these two paintings (or
possibly 3 or more with this name) -
called *Gipsy* or *The Gipsy*, is reprinted
facing page 80 in Mrs. Lionel Birch
(1906), with the permission of then
owner C. D. Morton, Esq.]

4.98 *Gipsy* Sold at the 37th Exhibition
(May, 1908) of the Newlyn Art Gallery
to G. R. Redsdale Esq. of Staffordshire
for 8 guineas.

4.99 *Girl with a basket*
Watercolour: 26.5x39cm.
Private collection.

4.100 *Girl in Blue Bonnet*
Gouache, 43.2x33cm, signed.
Sold, Stephan Welz, Johannesburg,
August 23, 1993 (Lot 238, illus.) £6,733.

4.101 *Girl in boy's clothes*
Sold from the 30th Exhibition (Dec-Jan,
1905/6) of NAG to Mrs. Ashington of
Stoke Bishop nr. Bristol, for 8 guineas.

4.102 *Girl on chaise longue*
Painting: 58.4x43.2cm, monogrammed.
Sold at Christie's, Kensington,
November 1, 1982 (Lot 21), £380.

*4.103 *Girl (Young) in a green headscarf*
Gouache 25.4x15.2cm, monogrammed.
For sale, W. H. Lane, Penzance,
February 27, 1992 (Lot 175, illus.).

4.104 *Girl with Irises*
Watercolour and bodycolour:
44.5x32.5cm.
Private collection.

4.105 I. *Girl (Young) with her dog*
Chalk watercolour & body colour:
45.7x30.5cm, signed.
Sold, Christie's, London, (Lot 196) July
21, 1981, £480.

4.106 II. *Girl and dog*
Watercolour: 43.2x27.9cm.
Sold, Sotheby's, London, Nov 23, 1994
(Lot 9, illus.), £3,000.

*4.107 III. *Girl (Young) with her puppy*
Black crayon, watercolour & body
colour heightened with white:
43.2x30.5cm, signed.
Sold, Christie's Kensington March 17,
1994 (Lot 52, illus.) for £1,500.
[The above three works may be the
same or different. All are measured
differently, II is not listed as signed.
Children and animals were a common
theme for EAF, so these may well be
different.]

4.108 *Girl (young) knitting*
Panel: 17.8x10.1cm, monogrammed.
Sold, Christie's, Kensington, March 31,
1994 (Lot 127) £480.

4.109 *Girl on a Hay Barrow*
Watercolour: 23.5x30.5cm, unsigned.
Exh. NOB, 1981, Cat. No. 55 (NFS)
Private Collection.

4.110 *Girls by a Stream*
Watercolour: 62.2x44.4cm, unsigned.
Exh. NOB, 1981, Cat. No. 32 (NFS).
Girls by a Stream, the drawing for above
in charcoal: 55.9x43.2cm, unsigned.
NOB, 1981, Cat. No. 33, £250.

4.111 *Girl looking at a drawing*
Watercolour: 14x20.3cm,
monogrammed EA
NOB 1981 (NFS)
Private Collection.

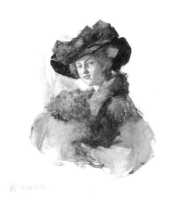

4.121 Girl with Violets (and a cat)

4.112 *Girl looking through a window*
Stated to be 'in the style of Elizabeth Forbes' (poss. a pupil)
Oil on canvas: 60x50cm. Unsigned.
For sale D. Lay, Penzance, Sale of Paintings, August 28, 1986 (Lot 422).

*4.113 *Girl on a window seat*
Watercolour & charcoal: 45.7x60.9cm, unsigned.
Sold, W. H. Lane, Penzance February 19, 1987 (Lot 448, illus.), £7,000.
Provenance: Newlyn Orion Exhibition, 1981.

4.114 *Girl with an orange headscarf*
Watercolour: 20.3x17.8cm, monogrammed.
NOB, 1981 Cat. No. 58, £110.

4.115 *Study of a Seated Nude Girl holding a Pipe*
Oil on canvas laid on board: 68x49cm.
For sale as No. 333 in W. H. Lane, Penzance, October 15, 1987, with the provenance: 'Given by Stanhope Forbes to a builder friend who worked for him at Higher Faugan.'

*4.116 *Girl with pink headscarf & white shawl* (head & shoulders)
Oil on canvas relined: 50.8x61cm, monogrammed & dated 1891.
For sale, W. H. Lane, Penzance, March 29, 1994 (Cat. No. 98 & 'attributed to EAF').

4.117 *Girl Peeling Onions*
Oil on canvas, 38x28cm
Private collection

4.118 *Girl (young) Reading* c.1900
Owner: Sims Gallery.
Exh. Penlee Focus Exhibition, 1997-8.

*4.119 *Girl with red cape & blond hair*
Pastel: half portrait, 45.7x35.6cm, signed.
Sold, W. H. Lane, Penzance, February 19, 1987 (Lot 447, illus.),£620.

4.120 *Girl in silk kimono*
Painting: 40.6x30.5cm, signed.
Sold, David Lay, Penzance, October 6, 1988 (Lot 383, illus.), £9,000.

*4.121 *Girl with Violets (and a cat)*
Watercolour & body colour: 41x29cm, signed. (Newlyn Orion Gallery label to reverse)
Sold, D. Lay, ASVA Sale of Paintings, February 25, 1988 (Lot 118, illus.).
May be same as *Woman with Violets,* Private Collection, Cornwall.

4.122 *Girl in a Wood*
Gouache: 35.6x25.4cm, signed.
Exh. NOB, 1981, Cat. No. 51 (NFS).

*4.123 *The Glade of Enchantment*
Oil on canvas: 61x45.7cm.
David Messum list, 1996.
Subject: Girl in blue dress with white apron standing amongst trees.

4.124 *The Goose Girl & the Prince*
Oil on canvas: 40.6x27.9cm.
Sold, Phillips, London, November 12, 1985 (Lot 81, illus.) £3,800.
David Messum list, 1996. Provenance: The Artist's Studio.

4.125 *Goodnight* c.1890 quoted
Charcoal, Watercolour & body colour: 43.2x30.5cm, signed in verso.
Title first used 1999.
Sold, Christie's, London, (Lot 186 illus.), £9,000.

4.126 *The Grey Muff* c.1903-4
Mixed media, watercolour
Noted in Mrs. Lionel Birch as demonstrating 'the fair, bright, girlish face has the soft charm of pastel while the darks which surround it are transparent.'
Exh. Leicester Art Galleries, 1904, 'Model Children and Other People'.

*4.127 *The Half-Holiday* (Alec home from school)
Painting: 121.9x96.5cm.
Private collection.
Exh. RA, 1909 (Single work shown, illus. b/w).
Subject: Long-legged boy reclining while reading on river bank with leash holding a puppy.

4.128 *Harvest Field*
Watercolour & bodycolour: 31.1x45cm, signed E. Forbes.
Private Collection.
Exh. Royal Institution of Cornwall, Truro, 1978, and NAG, 1979 Cat. No. 90). Owned at that time by the Queen's Hotel, Penzance. Sold, Phillips, London, November 13, 1984 (Lot 44, illus.) £6,200.

*4.129 *The Harvest Flask*
Coloured chalks, oval: 47x39.5cm.
Mis-attributed to Stanhope Forbes when offered for sale at Phillips East Anglia, December 7/8, 1994 (Lot 488, illus.).
Offered at Christie's London, March 23, 1995 and called *Two children* (Lot 19, illus.) [Ed. note: Very old children!]
Sold, entitled *Slaking their thirst* at W. H. Lane, Penzance, July 11, 1995 (Lot 175) £3,200. [Ed. note: This chalk oval appears to have been the figure study for the larger painting, *Slaking their thirst.* See title].

*4.130 *Harvest Moon*
Oil on canvas, 50x68.5cm
Private Collection
Subject: A harvest scene with young man seated to right on haystack, girl reclining to back left, both with forks/rakes. A moon at top at off-centre angle.

4.131 *Hatching Mischief* (EAA title)
1887
Pastel
Cat. No. 251 (Cat. unknown), Price £10.10s.
EAA contact address: c/o Dr. Hawksley, Victoria St, London SW

4.132 *Hayfield with a woman and child*
c.1910.
Watercolour over charcoal on wove paper mounted on linen: 64.0x53.3cm. NGC. Paris no. 24013818, Acc. No. 1288.

4.133 *The Hayfield*
Watercolour, black chalk: 30.5x43.2cm., signed.
Sold, Phillips, London, November 11, 1986 (Lot 14), £3,800.

4.134 *Haymaking*
45.7x63.5cm, signed.
Sold, Christie's, London March 15, 1985 (Lot 22, illus.), for £6,800.

4.135 *Haymaking*
Watercolour highlighted in white on paper: 50.8x33cm.
Sold, Phillips, London, November 10, 1987 (Lot 17, illus.), £1,150.

4.136 *Hay & Pink Clover*
91.4x71.1cm.
One of two works exhibited, RA, 1908 [Cat. No. 277, illus. b/w].

4.137 *Here We Come Gathering Nuts in May*
Watercolour. Repr. in colour in Mrs. Lionel Birch, p.52.
Entitled 'Here We Go Gathering Nuts in May' in *The Lady's Realm* (1904-5). Reviewed therein 'as recently seen on view in town, [one must only see] to realise the grip and verve which the artist brings to her work. What a merry group of youngsters here tread the springy grass, as hand in hand they bound forward on their joyous errand!'

*4.138 *Hide and Seek I*
Pastel, paper on linen: 38.1x48.3cm, monogrammed.
Sold, Phillips, London, Nov 14, 1989 (Lot 20, illus.), £28,000.
Subject: Children in field with Paul Church in background.

*4.139 *Hide and Seek II*
Pastel: 43.2x27.9cm, signed. Inscribed on a label attached to the backboard: 'Hide & Seek'.
Sold, Christie's, London, July 1, 1993 (Lot 44, illus.), £26,000.
Subject: A young woman in Victorian dress with sunbonnet dangling from left hand, 'hiding' behind a gnarled tree. Private Collection.

*4.140 *Homewards*
Oil on canvas: 30.5x35.6cm
David Messum list, 1996 (illus.) Vol. V, *British Impressions.*

4.141 *Hop o' My Thumb* 1898
'Whereabouts unknown' painting noted in *Stanhope Forbes and the Newlyn School*, page 49. Photograph in EA & Stanhope photo album, Newlyn Art Gallery Archives, Penzance.

*4.142 *The Hunt*
Watercolour & pencil, a lunette (half moon) in shape: 11.4x16.5cm, signed.
Sold, Phillips, London, September 13, 1988 (Lot 12, illus.) £620.

4.143 *Idle Moment*
Chalks, watercolour gouache: 35.6x17.8cm, signed.
Sold, Phillips, London 1 November 13, 1984 (Lot 42, illus.), £2,400. *Idle Moments* Watercolour: 33x17.8cm, signed, sold, Christie's, London, March 5, 1987 (Lot 61, illus.) £2,500.

*4.144 *If I Were As Once I Was*
Title given in 'The Art of Mrs. Stanhope Forbes' (*Lady's Realm*, 1904-5), by M H Dixon for painting known at RA (1904) as *The Poet & Some Country Girls.*

*4.145 *Imogen lying among the flowers that's like thy face, pale primrose* 1898
Oil on canvas: 70x90cm.
Noted as the best of Mrs. Forbes's pictures in the current exhibition at the Newlyn Art Gallery, by *Cornish Post*, March 24, 1898.
Collection: Plymouth City Museum & Art Gallery.
Exh. Penlee Focus Exhibition, 1997-8.

*4.146 *In the Beech Wood*
Watercolour gouache
Private Collection, Cornwall
Subject: Woman and child on path going into trees, child is son Alec.

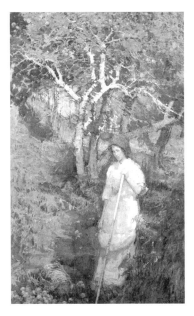

4.147 **In the Orchard**

*4.147 *In the Orchard*
Black crayon, watercolour & body colour: 59.7x36.8cm, signed EA Forbes. Offered, Christie's London, November 22, 1994 (Lot 245).

4.148 *In the Spring*
Watercolour over pencil: 27.9x17.8cm, monogrammed.
Sold, Phillips, London, November 11, 1986 (Lot 29, illus.), £3,800.
Private collection.

4.149 *In the Very End of Harvest*
Painting: 106.7x86.4cm.
Exh. RA, 1910 (illus., b/w in catalogue).

*4.150 *'In with you!'* 1905
Repr. for *Women Painters of the World.* Attr. to Mrs. Stanhope Forbes, A.R.W.S., Painter. (British School of Water-Colour, Contemporary)

4.151 *Iris Pastel*
Exh. Whitechapel, 1902 aka 'Iris',
No. 148.
Sold from the 23rd Exhibition (August,
1903), NAG to Geo. Gribble, of nr.
Biggleswade for 10 guineas.

4.152 *The Japanese Doll*
Exh. but not sold at Opening
Exhibition of NAG, Oct., 1895).
Described as 'one of the studies of
girlhood in which Mrs. Forbes excels'.

*4.153 *Jean, Jeanne et Jeannette* 1891
Oil on canvas: 55.6x44.4cm, signed EAF.
Collection: City Art Gallery,
Manchester.
Repr in b/w facing p.58, Mrs. Lionel
Birch. Illus. in *The Studio*, Vol. IV,
p.192.
Exh. The New Gallery, Summer
Exhibition, 1892; London, Guildhall
Loan Exhibition, 1894; Plymouth Art
Gallery, 1923, NAG, 1979, and repr. b/w
as Cat. No. 78, p.198, in *Artists of the
Newlyn School*, Barbican Exhibition,
1985, 'Painting in Newlyn 1880-1930'.
'Painting Women', Rochdale, 1987-8.
Reviewed in *Queen* (May 14, 1892) after
exhibiting at the New Gallery, thus: 'In
this amusing design the artist indulges
in humorous vein, showing us a rustic
lass seated on a wheelbarrow, a lad
fishing in the adjacent stream, and a pet
goat. The subject recommends itself,
whilst it is worked out with infinite
skill.' (prolific cuttings/notices)

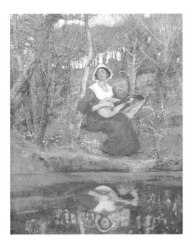

4.168 **The Lute,** aka **The Witching
Pool, The Muse of Herrick**

4.154 *Jos* or *Joe* (handwritten/
indecipherable)
Cat. No. 52 of the Sketch Exhibition at
NAG, Nov., 1896. Sold to F. Berrill of
Kettering for 5 guineas.

*4.155 *Jonquil*
Painting.
Subject: A contemplative young woman,
full face forward, with long plaits.
Photo by Henry Dixon & Son in black
& white for *The Lady's Realm* (1904-5).

*4.156 *June Days*
Oil on canvas: 45.7x35.6cm.
Study for *June at the Farm*. Provenance:
the artist's studio. For exhibition & sale
at David Messum Fine Art, 1996. Sold,
Phillips, London, March 25, 1997 (Lot
41, illus.) £15,000.

*4.157 *June at the Farm*
Oil on canvas: 137.2x116.8cm.
Exh. RA, 1910 (1 of 2 works shown,
illus., b/w in catalogue.)

4.158 *King Arthur and Guinivere*
Watercolour: 12x14.6cm, signed and
inscribed on mount: 'To Phyllis - from
her friend Elizabeth Stanhope Forbes.
Provenance: Phyllis Gotch and Deirdre
McClennan.
Exh. Belgrave Gallery, 'British Post-
Impressionists and Moderns, NO.7',
1987.

*4.159 *The Kiss*
Pastel. Signed EA FORBES
Subject: Mother (lower) kissing a child
(reaching down to her, hand in her
mother's hair). Repr. b/w facing p.78 in
Mrs. Lionel Birch.

4.160 *A Knight came riding by...*
Oil on canvas: 127x83.8cm
Repr. Lady's Realm, 1904-5, D.
Messum list, 1996.

4.161 *Lamorna Valley*
Sold from the 24th Exhibition (July
1904), NAG to Miss Behrens, for 12
guineas.

4.162 *Landscape near Paul, Cornwall*
Watercolour gouache: 43.2x30.5cm,
signed. Sold, Sotheby's, London May 2,
1990 (Lot 9, illus.), £15,000.

*4.163 *La Seine pres de Caumont*
Coloured chalks, paper laid down on
board: 45.7x33cm, signed & inscribed
with title on backboard.
Sold, Sotheby's, Billingshurst, January
16, 1990 (Lot 177, illus.), $4,800. Exh.
as No. 21 in 'A Breath of Fresh Air'
exhibition, spring, 1990. Sold,
Christie's, New York May 25, 1994
(Lot 345, illus.), £3,667.[$5,500].

*4.164 *The Leaf* (sub-titled *Autumn
No.1,* if same painting)
Illus. in colour in Mrs. Lionel Birch.
Listed as 56x38cm Watercolour, Lot
870 (illus.) Peter Webb, Auckland,
September 23, 1999, & sold £14,610.
Subject: lady in red medieval dress
sitting on a granite outcrop facing
right, with her reflection and that of
the wood behind in the pond below.

4.165 *The Little Fern Cutters*
Sold from the 23rd Exhibition (August,
1903), NAG to Sir H Havelock Allan
£10.

4.166 *Little Sister* 1886
Painting mentioned as amongst four
shown at Burlington House, in that
year, along with *After Dinner*, by *The
Lady's Realm*.
Little Sister Oil on panel: 30.5x22.9cm,
monogrammed, Sold, Christie's,
London, March 4, 1983 (Lot 1, illus.),
£750.

4.167 *Lovers in the wood*
Oil on canvas: 83.8x68.6cm.
Sold, Phillips, London, November 12,
1985 (Lot 78, illus.), £3,500. For
exhibition & sale, David Messum Fine
Art, 1996, £18,500.

4.168*The Lute* aka *The Witching
Pool, The Muse of Herrick.*
Subject: Woman playing lute reflected in
pool.

4.169 *The Lute Player*
Black chalk & gouache on paper:
43.2x30.5cm, signed.
Sold, Phillips, London, Jan 28, 1986
(Lot 16), £550. Sold, W. H. Lane,
Penzance, September 27, 1990 (Lot 105,
illus.), for £1,350.

*4.170 *The Lute Player*
Oil on canvas: 40.6x55.9cm.
Private Collection
For sale at Sims Gallery, St. Ives, 1995 in an 'Exhibition of works by Newlyn School Artists (1880-1950)'. Cover illustration of invitation card. Exh. Penlee Focus Exhibition, 1997-8.

*4.171 *The Maids were in the Garden, hanging out the clothes* (1897)
Pastel: 71.1x96.5cm, monogrammed on label verso.
Exh: 'The Victorian Era Exhibition', Women's Section (Fine Art) No. 2. Sold, Bearnes, Torquay September 4, 1991 (Lot 196 illus., & cover illustration), for £48,000. Provenance in catalogue: 'the family of the present owner since 1897'.

4.172 *Matinee Musicale* (EAA title) 1887-8
Cat. No. 316, (Cat. unknown), Price £50 [Highest set price of this period for her work.] Contact address: c/o Dr. Hawksley, Victoria St., London, SW

4.173 *Study of nude young man*
Oil on canvas laid on board: 95x45cm.
For sale, W. H. Lane, Penzance, October 15, 1987 (No. 334), with the provenance: 'Given by Stanhope Forbes to a builder friend who worked for him at Higher Faugan.'

*4.174 *May Evening* 1904 (end date)
Watercolour: 58.8x89.8cm.
Collection: NGC. Paris no. 24010517, Acc. No. 298.
Photo after the original picture, for *Women Painters of the World*. (British School of Water-Colour, 1904) 1905: book publication.
Subject: Children approaching up the hillside from Mount's Bay at Newlyn.

*4.175 *Maytime*
Watercolour: 58.4x53.3cm.
Sold, Christie's, London June 8, 1989 (Lot 6, illus.), £13,000.

4.176 *Marie* 1899
Watercolour sketch. Catalogue No. 110 in the 12th Exhibition (1899-1900) at NAG. Illus. in colour in *The Studio* Vol 18, p.29. Sold to Mrs. Scott of Eltham, Kent for £5 in March, 1900.

*4.177 *Midday Rest*
Watercolour/body colour: 45.7x33cm, signed.
Sold, Christie's London, March 11, 1994, (Lot 70 illus.) £18,000. Cat. date for painting: executed c1905.
Subject: Model is posed out of doors with long stick in front of a Cornish cottage; probably same model as used in photo taken for *Girls' Realm* (1905) where Mrs. Forbes is pictured posing a model indoors in her studio.

4.178 *Mignon* 1890
Interior noted in *Stanhope Forbes and the Newlyn School*, as owned by Sydney Art Gallery, Australia. Originally purchased from the British Art Gallery at the Exhibition-building, London, by the National Art Gallery of New South Wales. (prolific notices).

*4.179 *A Minuet* 1892
Oil on canvas: 88.9x120cm.
Exh. at RA, Summer, 1892 (No. 343) and reviewed widely: 'A Century of Art in Cornwall, 1889-1989' (No. 18); Cornwall County Council Centenary, Barbican Exhibition, *Painting in Newlyn*, 1880-1930 (No. 53, illus.). Described in *The Times*, May 15, 1892 as 'charming in its delicate grey tones and in the grouping of the figures. There is something a little lackadaisical in the expression of the girl at the piano, which a retouch by the artist would easily alter.' Reviewed in the *Cornish Telegraph* (no date) as 'another of those charming studies of English family life in its hours of innocent and health recreation by which she has in great measure gained her deservedly high reputation among lady artists. The children are as delightful as the children in Mrs. Forbes' pictures always are, and the general effect is eminently pleasing.' Owned by Cornwall County Council & Mr. Alverne Bolitho.
Reviewed in *Woman* (dated 4/5) when exhibited at the New Gallery, 'I was struck with the prominence of the women contributors. Mrs. Stanhope Forbes, in her 'Minuet' (343) is by no means an insignificant rival of her husband.' Photographed, b/w *The Lady's Realm* (1904-5) by Henry Dixon & Sons. (prolific notices) Exh. Penlee Focus Exhibition, 1997-8.

*4.180 *Miss Faulks* (head of a girl)
Watercolour: 36x22cm, monogrammed.
For sale, David Lay, ASVA Sale of Paintings, August 28, 1986. (Lot 303, illus.)

*4.181 *Moorland Princesses* 1893
137.2x106.7cm. Exh. at RA, 1893, and illus. in catalogue. Illus. in *The Studio*, Vol. 4, p.191. Exhibited Nott., September 1894, No. 20. Sold at the Third Exhibition (opening February 14, 1896) of NAG for £105 to Mrs. Foster of London SW.
Subject: Cows coming down from the moorlands.

*4.182 *Morning Ride*
Watercolour & body colour, black crayon heightened with white: 43.2x30.5cm, signed lower left EA Forbes.
Sold, Christie's, London November 9, 1989 (Lot 5, illus. & cover illus.) £31,000.

*4.183 *Mother & child*
Oil on canvas: 55.9x38.1cm. Offered as Lot No. 13 (illus.) at Phillips on March 10, 1987. Provenance quoted as 'The artist's studio'.
Sold, Phillips, London, May 12, 1987 (Lot 10) £2,200.

*4.184 *Mother & Child*
Watercolour & charcoal: 43.2x40.6cm, unsigned.
NOB, 1981, Cat. No. 65, £200.

4.185 *Museum Interior*
Oil on panel: 13.7x8cm.
Private Collection.

4.186 *The Mushroom Gatherers* 1886-7
Oil on panel.
Cat. No. 195 (Cat. unknown), Price: £13 guineas.
EAA living in Cornwall; London address c/o Dr. Hawksley, 11 Albert Mansions, Victoria Street, SW. David Messum list, 1996.

4.187 *Narcissus* 1885
Painting, Cat. No. 262 (Catalogue)
Price: £7.7s.
EAA address: 18 Lupus Street, London, SW
And Nature the old nurse, etc. – see Daydreaming

*4.188 *A Newlyn Maid*
aka *Head of a Village Maid* Oil on canvas, 27.9x22.9cm, unsigned.
Exh., NAG, Cat. No. 1, 1981 (NFS)
Owned by the John Halls Memorial Fund. Exh. Penzance & District Museum, May, 1993, No. 36; Penlee Focus Exhibition, 1997-8. Collection: Newlyn Art Gallery.

*4.189 *A New Song*
Exh. the New Gallery, London, 1893, and illustrated in *Pictures of the Year, 1893*, p.85.
Subject: Woman in white standing with song sheet, and young woman seated & turned toward the singer.

*4.190 *Off to school*
Oil on panel: 33x25.4cm, signed.
Sold, Sotheby's, Billingshurst, May 22, 1989 (Lot 597, illus.) £29,000.
Subject: Boy & girl in lane looking back to mother at garden gate.

*4.191 *The Old Mill, Penryn*
a. Oil on panel: 26.7x16.5cm, monogrammed.
Illus. in the *Art Review*, 1990, p.187 as valued at Christie's as £440.
b. Could be the same as: *The Old Mill Steps* (Penryn) No details.
Sold on March 8, 1902 from the 18th Exhibition of the Newlyn Art Gallery, to C. H. Thompson c/o Address in Preston Lancashire for 12 guineas. *The Old Mill Steps* contains the background scene to *A Dream Princess* (1897) and was perhaps a study for that painting.

4.192 *The Old Salt*
Oil on board: 53.3x45.7cm.
Sold, Christie's, New York, May 25, 1988 (Lot 440, illus.) £811 ($1,500).

*4.193 *On a Fine Day* 1903
Oil painting: 38.1x50.8cm, signed.
Exh. 1903 at RA. Repr. in colour facing p.70 in Mrs. Lionel Birch. Sold, Phillips, London, November 11, 1986 (Lot 31, illus.),£12,000.
Study for it in private collection.

4.194 *One, Two, Three, and Away!* c.1890
Pastel: no details
Exh. Grosvenor Gallery Pastel Society, 1890
Noted in Mrs. Lionel Birch as showing 'The spontaneous grace of children's movements attracts her powerfully, and realised as they were in her picture...she received the highest praise from well-known critics, and exhibiting it later at the Paris International Exhibition, a medal was awarded her.'

4.195 *On the Oise* 1897
Exh. Royal Cornwall Polytechnic Society, with review: 'small but skilfully crafted bit of river scenery'(*Cornish Telegraph*).

4.196 *On the Seine,* twilight
Sold at 17th Exhibition (October 30, 1901) of NAG to Arthur Hayes of St. Buryan for 12 guineas.

4.197 *Oranges and Lemons*
Pastel: 78.7x72.8cm, signed with monogram.
Private collection.
Provenance: Belgrave Gallery.

*4.198 *Ora Pro Nobis*
Watercolour: 43.8x23.5cm
Sold at 17th Exhibition (October 8, 1901) of NAG, to Frank Berrill, Esq. of Kettering for 12 guineas. Repr. with his permission facing p.62 in Mrs. Lionel Birch. Fine Arts Society exhibition: 'Channel Packet', March-April 1969.

4.199 *O wind a-blowing all day long, O wind that sings so loud a song*
Picture reviewed in *The Lady's Realm* (1904-5) as: 'Another note is struck in the outline of the tender little maiden who wanders across the common in the picture called....For Mrs. Stanhope Forbes' art is an instrument of many strings'

4.200 *Pan*
Chalk & gouache: 45.7x30.5cm, signed.
Sold, Sotheby's, London, March 11, 1981 (Lot 21), £620.

*4.201 *Path to the Village*
Oil on canvas, 74x48.5cm
Private Collection
Subject: Rise of hill to right, stream flowing into bottom left. Man in blue shirt carrying hay on right, white horse and boy beside to left.

4.202 *Pets* (EAA title) 1885/6
Cat. No. 232 (Cat. unknown), £6.6s
Last painting with contact address for EAA: 18 Lupus St., London, SW.

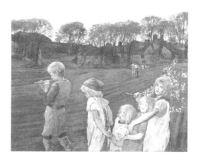

4.203 **Pied Piper, Allegory of Spring**

*4.203 *Pied Piper, Allegory of Spring*
Watercolour & gouache, paper laid on linen: 63.5x88.9cm, signed.
Subject: A young boy (Alec?) with a pipe to left; 4 young girls following. A farm horse and women working the field in far distance.
Exh. 'World of Drawings & Watercolours', Park Lane Hotel, Piccadilly, Jan 22-26, 1991.
Sold, Bonhams, London February 21, 1991 (Lot 61, illus.), £9,000.
With David Messum, 1992.
Repr. as card by Natura Designs. Sold, Phillips, London, March 25, 1997, £26,000. Exh. Penlee Focus Exhibition, 1997-8.

4.204 *Pied Piper of Hamelin*
Pastel: 63.5x109.2cm
Private Collection
Sold, W. H. Lane, Penzance, (Lot 250), £18,000.

4.205 *Please Stay to Breakfast* 1884
Watercolour
Cat. No. 701, (Cat unknown), £5.5s
EAA contact address: 18 Lupus Street,
St. George's Square, SW
*The Poet and Some Country Girls aka
If I were as once I was – see entry*

4.206 *A Point of Interest*
David Messum list, 1996. No details.

4.207 *Portrait of Alice Elizabeth Craft*
1889
Exh. with *School is Out (Cornish
Telegraph)*
Exh. at West Cornwall Art Union, Sept,
1891 and reviewed as 'not her forte', less
good than her husband's on the same
subject which 'was not his best work'.

*4.208 *Portrait of Cecily Tennyson Jesse*
1909-10
Watercolour & body colour:
34.3x24.1cm, signed upper left EA
Forbes, inscribed lower left C. T. Jesse,
inscribed again on the reverse Miss C.
Jesse, Myrtle Cottage, Newlyn.
Sold at Christie's, London, June 23,
1994, Lot 98 (illus.), £1,150.
Provenance in catalogue: 'A gift from
the artist to the sitter, thence by
descent to Tom Luck, 1948, by whom
gifted to the present owner in 1977.
The sitter became Mrs. Charles
Cardale Luck. She was a close friend of
the artist and she attended the Forbes'
art school in Newlyn...'
Sold, Christie's, Kensington, June 21,
1998, Lot 164 (illus.), £1,200.

4.209 *Portrait of Gertie*
Oil on canvas: 43.2x33cm.
Sold, W. H. Lane, Penzance, July 30,
1987 (Lot 180, illus.) £5,000.

4.210 *Portrait of a little girl*
Pastel on paper: 45.7x35.6cm, signed.
Sold, Sotheby's, London October 14,
1987 (Lot 78, illus.), for £1,150.

*4.211 *Portrait of Marion Kerr*
Oil on canvas: 45.7x27.9cm, 'signed
with initials lower left ES'.
Sold, Christie's, London, March 2, 1989
(Lot 58, illus.), for £25,000. Provenance

given in catalogue thus: 'The sitter is the
present owner's mother.' *Attribution
questioned*.
[Ed. note: Elizabeth Forbes was never
known to have signed or monogrammed
any painting with these initials.
Attribution queried by telephone &
letter but no reply received.]

*4.212 *Portrait of Mrs. Percy Sharman*
Watercolour & pastel drawing, signed
EAForbes.
Repr. b/w facing p.64 in Mrs. Lionel
Birch.

4.213 *Portrait of a young boy*
Pastel: 53.3x43.2cm, monogrammed.
Sold, Sotheby's, London, November 12,
1986 (Lot 30, illus.), £3,000.

4.214 *The Post* (or *Pool*)
No detail. Sold from the 29th
Exhibition (September, 1905) of NAG,
to Miss Haycock for 12 guineas.

4.215 *Primroses* 1906
No detail.
Sold from the 32nd Exhibition (October
1906) of NAG to Henry Hunter, Esq.
for 8 guineas.

4.216 *First Primroses of Spring*
Oil on panel: 30.5x22.9cm, signed.
Could be same as above?
Sold, W. H. Lane, Penzance February
27, 1992 (Lot 200, illus.) £6,000.

*4.217 *Primrose Wood* (possibly the
same as *The Ford* 4.91)
Oil on canvas: 106.7x81.3cm, signed
Subject: children by stream in a wood.
Sold at Sotheby's, London May 21, 1986
(No. 18, illus)
Sold at Christie's, London, March 5,
1987 as *Silver Bells & Cockle Shells*.

4.218 *A Quiet Valley*
Exhibited but not sold at the Opening
Exhibition of NAG, October, 1895.
Described as 'a wooded valley scene in
the time of roses and of love-making,
and a man and a maid are apparently
engaged in a little harmless flirtation. It
is bright and cheerful, full of sunshine,
and the geniality of nature, like most of
Mrs. Forbes' work.' Frame is the work
of the Newlyn Art Class.

4.219 *The Red Admiral* (EAA title) 1888
Watercolour
Cat. No. 430, (Cat. unknown),
Price £21.
Last painting in catalogue listing (Cat.
unknown) with EAA contact address
c/o Dr. Hawksley, Victoria St., London,
SW.

*4.220 *Ring-a-Ring o' Roses*
Watercolour: 45.7x56.5cm.
Reproduced as postcard, 1978, by The
Medici Society, Ltd., London, from a
private collection.

*4.221 *Road to the farm*
61x30.5cm, signed in verso.
(First use of this title, 1997 sales
records) Sold at Sotheby's, Billingshurst,
lot 331 (illus) July 29, 1997.
Subject: Two children embracing in
foreground. Woman feeding horse, boy
astride.

4.222 *The Sage of the Wood* 1896
Sold for £80 at the Fifth exhibition of
NAG, which at that time was a record
price for the Gallery, July-October,
1896, to John Jones, Esq. of
Wolverhampton.

4.223 *St. Martins...* 1904
Sold from 26th Exhibition (August,
1904) of NAG for 12 guineas to local
buyer.

*4.224 *School Is Out*, 1886-9 [exh. 1889]
aka *Paul School* and *The Village School
at Paul*
Oil on canvas: 105.4x118.7cm, signed
EA.
Collection: Penzance Town Council,
Penlee House Gallery & Museum.
Exh. RA, 1889; Plymouth Museum &
Art Gallery, 1923, NEAC, 1958, Royal
Institution of Cornwall, 1978, Newlyn
Art Gallery, 1979 and RA, Art Treasures
of England, 1998. Repr, b/w, p.194, in
Artists of the Newlyn School. Repr. in
colour in *The Shining Sands*, p.83. Repr
b/w, p.5 in *An Artistic Tradition*. Repr.
b/w black & white in *Stanhope Forbes
& the Newlyn School*, p.48. Exh.
'Painting Women', Rochdale, 1987-8.

4.229 **September Fields**

*4.225 *Sea Wall, The* aka *On the Sea Wall*
Black chalk, watercolour, heightened with gouache: 24.5x17cm., signed.
Subject: Girl with right arm up to hold large hat onto her head, leaning against the wind.
Sold at Phillips, London, Nov 13, 1984. (Lot 40, illus.), £4,800.

4.226 *Self-portrait of Artist looking out of drawing room window at Higher Faugan*
Watercolour: 45.7x61cm, signed.
Sold, Robin Fenner, Tavistock on March 1, 1993(Lot 155) £5,000.

*4.227 *Self Portrait* 1886
Repr. in *Artists of the Newlyn School, 1880-1900*, p.186, from a photograph of the painting in a private collection.

4.228 *Self Portrait playing the zither*
48.2x63.5cm.
Sold, Sotheby's, London, May 13, 1987 (Lot 3, illus.), £4,400.

*4.229 *September Fields*
Oil on canvas re-lined: 21.5cmx52.3cm.
Private collection.
Provenance: Major C. Gilbert Evans from Mrs. M. Forbes, c. 1950.

4.230 *Sheltering from the sun*
Gouache on linen pair: 33x20.3cm.
Sold, Phillips, London, March 8, 1988 (Lot 3, illus.) £3,200.

4.231 *Shepherdess of the Pyrenees*
Exh. Fine Art Society, 1900 in 'Children and Child Lore' Exhibition.
Pencil, watercolour and bodycolour, 40.6x55.2cm for sale at Christie's London, June 8, 2000.
Based on trip the previous spring (Ascain, Pyrenees).
Noted in Mrs. Lionel Birch. 1905

4.232 *Shipbuilders, The* (EAA title) 1886
Oil painting
Cat. 330 (Cat. unknown), £18.18s.
EAA address: c/o Dr. Hawksley, Albert Mansions, Victoria St., SW

Silver Bells and Cockle Shells – see *Primrose Wood* and *The Ford.*

*4.233 *Sisters*
Pastel: 43.1x30.5cm, signed. Aka *Two Girls by Pond*
Sold, Christie's, London June 23, 1994 (Lot 95, illus.), £9,500.
Provenance: Exh. Newlyn Orion Benefit show, 1981 (No. 57) where purchased by the present owner.
See *Two Girls by Pond*, which is the same picture (sized at 45.7x33cm) sold as No. 57, NOB, 1981, £450.

*4.234 *Slaking their thirst*
Oil on canvas. Repr. as card by Natura Designs by courtesy of David Messum Fine Arts. See *The Harvest Flask*, an oval chalk study for this larger painting.

4.235 *Sleepy Summertime*
Painting: 25.4x38.1cm, signed in verso.
Sold at Christie's, Kensington, July 22, 1981, £9,000.

4.236 *Spring Blossom*
Coloured chalk & body colour: 45.7x30.5cm, signed.
Sold, Sotheby's Belgravia June 14, 1977 (Lot 26), £1,350.

4.237 *Spring Blossoms*
Watercolour & body colour: 45.7x30.5cm, signed in. verso.
Sold at Sotheby's, London June 23, 1981 (Lot 85, illus.), £6,500.(? same painting as above).

*4.238 *Stanhope Forbes* 1889
Illustrated in *The Studio*, XXIII, No. 100, July 1901, p.81, in 'The Work of Stanhope A Forbes, ARA' by Norman Garstin. Repr. in *100 Years in Newlyn, Diary of a Gallery* (1995).

4.239 *Portrait of Stanhope*
Watercolour & charcoal: 43.2x40.6cm, unsigned.
NOB, 1981, No. 66, £300.

4.240 *Portrait of Stanhope*
Oil on panel: 29.2x24.13cm monogrammed.
Private Collection.
Exhibited, NOB, 1981, Cat. No. 30 (NFS).

4.241 *Portrait of Stanhope with 'cello*
Oil on board: 23.5x14.6cm monogrammed.
Private collection.
Exh. NOB, 1981, Cat. No. 64 (NFS).

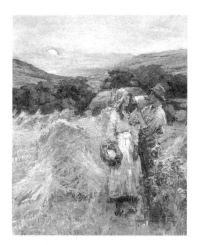

4.234 **Slaking Their Thirst**

*4.242 *Portrait of Stanhope Forbes holding brush & palette*
Charcoal: 33x15.2cm., monogrammed. Sold, W. H. Lane, Penzance, October 16, 1986 (Lot 525, illus.), £1,650. Probably the same as: 6.22 *Stanhope A. Forbes, ARA* Charcoal drawing, monogrammed EAF, and reprinted in Mrs. Lionel Birch, facing p.8.

4.243 *Portrait of Stanhope Reading*
Oil on board: 35.6x25.4cm, monogrammed.
NOB, 1981, Cat. No. 40, £750.

*4.244 *Portrait of Stanhope with Umbrella*
Private collection.
Oil on board: 30.5x26.7cm, unsigned.
Exh. NOB, 1981, Cat. No. 43 (NFS).

4.245 *Spring flowers in glass*
Oil on canvas on board: 38.1x27.5cm, signed.
Sold, Sotheby's London November 9, 1989 (Lot 213, illus.) £31,000.

4.246 *The Stepping Stones*
109.2x81.2cm
Sold, Phillips, Son & Neale, London, July 12, 1971 (No. 199) £300.

4.247 a. & b. *Study* (2 of this title & size)
Oil: 14x8.3cm unsigned and undated
Exh. NEAC, 1958.
Private Collection

4.248 *Still life with candle*
Oil on panel: 14x8cm.
Private Collection

4.249 *Summer*, hung at the Royal Academy, 1883
Stated in The Lady's Realm (1904-5) as showing 'such mastery of her tools as to lift her, at a bound, to a foremost place among the women artists of her time.'

4.250 *A Summer Holiday* 1885/6
Cat. No. 154 (cat. unknown), Price: £6.6s
EAA address: 18 Lupus St., London SW1

4.257 **Trees, Study of**

4.251 *Sunday in Holland*
Sold for 30 shillings to J. Jones Esq. at the Opening Exhibition of NAG, November, 1895.

4.252 *Suspense* 1887
Cross notes that EA was completing work on this painting for the RA in 1887, *The Shining Sands*.

*4.253 *'Take, Oh Take Those Lips Away'* 1902
76.2x91.4cm.
Exh. RA, 1902 [Cat. No. 179, illus. b/w]
Photo repr. b/w facing p.72 in Mrs. Lionel Birch.
Subject: Player with mandolin looking up into the eyes of lady in mediaeval dress. Two large dogs playing in the woods to right.

*4.254 *There was a Knight came riding by*
Oil on canvas: 127x83.8cm.
David Messum list, 1996. Probably original for KAW.

4.255 *Three Blind Mice*
Exh. James Lanham Gallery, St. Ives c.1889.

4.256 *Toddler with a rattle*
Oil on canvas.
Private Collection.

*4.257 *Trees, Study of*
Oil on canvas laid on board: 42cmx25.5cm, unsigned.
Provenance: Major C. Gilbert Evans from Mrs. M. Forbes.

4.258 *A Trespasser* 1891
A 'little' picture reported in a press cutting as hanging in the Institute of Painters in Water-Colours by *John Bull*, October 31, 1891, and in *The Herald*. Described as 'a work reminding one in subject and in treatment of Mrs. Adrian Stoker's [sic] fine picture already mentioned.' Expanded in *The Herald* thus, 'If Mrs. Stokes is first, Mrs. Stanhope Forbes is a very good second, and strangely enough, in the same subject [a goat-herd]. In 'The Trespasser' however, the venue is changed to Cornwall, and the land of Tre, Pol, and Pen is the home of the little rustic maiden left in charge.'

*4.259 *Trewarveneth* 1905
Watercolour & body colour, inscribed & dated Trewarveneth Oct/1905, depicting Alec Forbes on the path in front of the cottage where they lived. Exh. at NAG, 1979, as Cat. No. 89 & purchased by Sir John Betjeman, CBE who gifted it to present owner. Private collection.

*4.260 *A Troubadour*
Watercolour, 31.8x43.2cm, signed EA Forbes,
Private Collection.
Subject: A young person in green tunic. Possibly a study for KAW.

Two children —see Harvest Flask and Slaking their thirst

*4.261 *Two Dutch Girls*
Watercolour.
Private Collection.

*4.262 *Two Girls by Pond*
Pastel: 45.7x33cm, signed. NOB, 1981, as Cat. No. 57, £450.
See *Sisters* (same work).

*4.263 *Two women in woods* (at Lamorna)
Watercolour
Private Collection, Cornwall.
Owner informed that one of figures is Betty Paynter, or perhaps her mother.

4.264 *Tulips*
Oil on panel: 27.9x22.9cm, signed.
Sold, Phillips, London, May 12,1987 (Lot 11) for £700.

*4.265 *Une Hollandaise*
Oil on panel: 33x21.6cm, signed upper right quadrant.
Provenance: Belgrave Gallery.

4.266 *Victors & Vanquished* RA, 1888
Dowdeswells, 1890. aka *Vae Victis*
74.9x62.2cm.
Subject: Two boys maliciously contemplate a captive mouse.
Listed as shown at RA, No. 11, 1909 in 'A Century of Loan Exhibitions', along with *The Witch* and *Jean, Jeanne & Jeanette*, all paintings belonging to George McCulloch, Esq.

4.267 *Village Across the River* (ESF title)
Exh. Fine Art Society, 1900, in 'Children and Child Lore'.
Noted in Mrs. Lionel Birch, 1905.

4.277 **The Witching Pool**

4.268 *Volendam, Holland from the Zuidende* c.1895
Oil 26.8x19.4cm
Tate Gallery, London

4.269 *A Wayside Chapel*
45.7x35.6cm, signed.
Sold, Phillips, London, September 15, 1987 (Lot 9, illus.) £1,600.

4.270 *When the Autumn Fields are Mown*
Exh. No. 45 in the 16th Exhibition (April, 1901) of NAG. Sold to M. H. Woods, of The Avenue, Preston.

4.271 *The White House* c.1900
Exh. Fine Art Society, 1900, in 'Children and Child Lore'.
Noted in Mrs. Lionel Birch as a 'purely landscape theme' work.

*4.272 *Wild Hyacinths*
Pastel.
Repr. b/w facing p.66 in Mrs. Lionel Birch.
Subject: Lady in mediaeval head-swathe holding a bouquet of hyacinths to right. Wood in background.

*4.273 *Will o' the Wisp*
Oil on canvas sealed to panel, triptych: 68.6x111.8cm
Illus. Mrs. Lionel Birch, b/w facing p.76.
Illus. in *The Studio*, Vol 20, 1900, p.183.
Included in SA & EA Forbes personal photographic record album, NAG archives.
Legend inscribed on frame: 'We folk, good folk, trooping altogether. Green Jacket, Red Cap & White Owl's Feather'.
Also described as *Fairy Tale*.
Panel: 116.8x170.2cm, signed panel (triptych).
Sold at Bearnes, Torquay, March 9, 1976 for £750.
Sold at Sotheby's, New York, February 27, 1986 as Lot 86 (illus.) & described as 91.4x121.9cm for £13,698.($20,000).
Collection: National Gallery of Women in the Arts, Washington D.C. on loan from the Wallace & Wilhelmina Holladay Collection. Can be viewed at http://www.artsednet.
getty.edu/ArtsEdNet/Resources/Maps/will.html along with a biographical background sketch for EAAF.

*4.274 *A Wind-swept Avenue*
Repr. b/w in *The Lady's Realm* (1904-5) illus. Two young girls in aprons and hats with their dog coming along a windy Cornish lane.

*4.275 *The Winter's Tale: When Daffodils Begin to Peer* 1906
Oil on canvas: 121.9x96.5cm.
Collection: Later Canadian Art, NGC Paris no. 24013817, Acc. No. 1287.
Exh. RA, 1906 (Cat. No. 83, illus. b/w in catalogue).

4.276 *The Witch* 1891
78.7x91.4cm.
Painting noted in *Stanhope Forbes and the Newlyn School*, p.47 'whereabouts unknown'. Exh. Guildhall Loan Exh. 1895, No. 70.; Dowdeswells, December, 1890, No. 91; RA, No. 332, 1909. Owner: George McCulloch, Esq. at that time.

4.277 *The Witching Pool*
Mixed media: 44.5x32cm.
Nude boy playing flute with sheep in background
Private collection.

Witching Pool aka *The Witches' Pool* – see *The Lute Player*

4.278 *Woman & Cat in sunlit window*
Watercolour/body colour & crayon on board: 45.7x33cm, signed.
Sold, Ritchie, Toronto December 1, 1992 (Lot 257, illus.) for £16,169.

4.279 *Woman and Girl Beneath a Tree*
Pastel on paper, 59.7x44.5cm.
Private collection.

*4.280 *Woman with red/orange sunshade* aka *The Red Sunshade*
Pastel: 45.7x33cm
Private collection, Cornwall.
Exh. NOB, 1981 (NFS)

*4.281 *The Woodcutter's Little Daughter* 1905
Oil on canvas: 106.7x81.2cm.
Collection: Vancouver Art Gallery, Paris no. 9001689, Acc. No. 34.7.
Exh. RA, 1905 [Cat. No. 709, illus. b/w].
Subject: narrative, girl kneeling, praying, pine tree with illuminated pine-cones, woods.

4.282 A Woodland Scene: 'As You Like It'
Gouache with charcoal underdrawing, on thick papers mounted on stretched canvas: 91.4x71.1cm, signed bottom left.
Bequest of Edgar A Rees in 1959 to The Royal Cornwall Museum, Truro [Accession number 1960.4]. Exh. Penlee Focus Exhibition, 1997-8.

4.283 *Young Girl (nude)*
Oil on panel, 49x30cm
Trehayes Collection.

*4.284 *Zandvoort Fisher Girl* 1884
Oil on canvas: 67.3x53.3cm, Exh. NAG, 1979. Barbican Exhibition, 'Painting in Newlyn, 1880-1930', in 1985 (No. 49 illus.). Repr. b/w as Catalogue No. 72, p.193, in *Artists of the Newlyn School, 1880-1900*. Repr. b/w, p.47 in Mrs. Lionel Birch. Published as postcard by Newlyn Orion (1980s). Repr. b/w in *Stanhope Forbes and the Newlyn School*, p.45. Permanent Collection: Newlyn Art Gallery. On permanent loan: Penlee House. Exh.: 'Painting Women', Rochdale, 1987-88; Penlee Focus Exhibition, 1997-8.

V. Catalogue of Dry-Points:

Full list reprinted from the *Print Collectors' Quarterly*, February 1922, Vol. 9, Part 1. J. M. Dent & Sons Ltd., London, by Arthur K. Sabin, with updates as appropriate.

Arthur K. Sabin paid great tribute to the foresight of Mortimer Menpes who became the early inspiration and mentor for Elizabeth Armstrong, in gathering as he did a collection of her dry-point etchings. This collection forms the base upon which Sabin built his catalogue. The following numbers are Sabin numbers, and referred to internationally in relation to these etching plates, Exh. Sabin 1: The first plate. When the Newlyn Orion Benefit Sale was held in 1981, for whatever reason, Sabin numbers and titles were not used (perhaps unknown), and therefore it is sometimes not clear which etchings are referred to in the (unillustrated) catalogue as being for

sale. Equally the number of copies remaining of each edition was recorded in background papers only & in blue dots beside framed etching. Numbers of impressions on offer put in [].

The 41 listings encompass the most complete record of Elizabeth's drypoint etchings in existence, though Sabin did not claim perfection or completeness. Neither does this cataloguer though much information of a later date has been added. A selection made by Sir Frank Short, from those brought together by Stanhope Forbes after Elizabeth's death in 1912, constituted 34 of the 41 executed plates, and were presented in her memory to the Victoria & Albert Museum, London. Those not represented in that selection were 1,2,6,9,23,34 and 41 though an impression of *Louise* (No. 9) was to be gifted later (*not* in V&A Newlyn Collection present-day). The V&A Newlyn Collection of Elizabeth Forbes dry-points constitutes 36 subjects to date with additional two listed below. The proofs of eight of the plates: 11,14,18,20,21,26,27 and 28 are contained in the Print Room Collections of the British Museum.

First period up to 1883 when EA had returned from Pont-Aven to London

*5.1 *The first plate*
The first dry-point made by the artist contained three studies of her mother's head, a copy of a portrait of Fortuny and the head of the figure in Whistler's *Speke Hall*. Only one impression was taken of the sketches on this strip of copper. 3.8x25.4cm Mortimer Menpes Collection (MMC).

5.2 *Wood at Pont-Aven*
A copse with brushwood of several years' growth, stripped of leaves, which slants from the right side of the plate. 10.1x7.6cm
Only known impression in MMC.

*5.3 *Portrait of the Artist*
The head, full face. A drypoint of herself when about 23 years of age, signed with monogram EA, 10.1x7.6cm, impression in MMC.

aka *Self Portrait* Etching, 10.1x7.6cm, monogrammed EA. Exh. NAG, 1979, Cat. No. 86; NOB,1981,[6 copies] Cat. no. 6, £50. Collection: Penlee, gift of George Bednar (GB). Exh. Penlee Focus Exhibition, 1997-8.

*5.4 *A Breton Fisher Girl*
She stands with her back to a cliff, looking to the right out to sea; her left hand touches the prow of a boat just seen in the right bottom corner of the plate. Signed with monogram EA in left upper corner, 15.2x11.4cm. Print: drypoint in brown, in Canadian Prints & Drawings, National Gallery of Canada (NGC), Paris no. 24013818, Acc. no. 1296.

*5.5 *An Old Dame* (No. 1)
Head and shoulders of an elderly Breton woman, full face, turned slightly to the right, wearing a cap with a broad dark band. 19.7x13.9cm. A second state, with additional work in the MMC.

5.6 *An Old Dame* (No.2)
Another plate of the same subject as the preceding. In MMC. Signed with monogram EA, 15.2x8.9cm.

5.7 *A Child of Pont-Aven*
She stands facing to the right, her hair in a plait wound round her head, and her bodice slipped a little down the right shoulder. 14.7x8.9cm.

5.8 *Head of an Old Woman*
The head of an old Breton woman, full face, leaning to the right. Two other states in MMC. 14.7x11cm.
The following may be the other two states of No. 8, or could be as Nos. 5 & 6 above
Head of Breton Woman I Drypoint etching: 15.2x11.4cm, unsigned. NOB, 1981,[1 copy] Cat. No. 20,£55.
Head of Breton Woman II Etching: 15.2x7.6cm, monogrammed. NOB, 1981, Cat. No. 21, £55.
Head of an Old Woman Drypoint: 14.7x11.4cm. Exhibited, NAG, 1979, Cat. No. 85. Plate owned by V&A.(2815)

5.33 *The Lock*

*5.9 *Louise*
A barefooted Breton girl, seated on the banks of a stream: one hand clasps the stem of a slender tree, towards which she leans; the other lies in her lap.19.7x12cm. A watercolour drawing for the above etching in V&A. Reprinted in black & white in Mrs. Lionel Birch (1906), p.49.

5.10 *A Girl of Pont-Aven*
She is seated, turned to the right, with head looking forward; her hands in her lap.1st state: Before monogram. 2nd state: With monogram EA, some of the burr removed from the dress, and with a few more lines on the face. Print in Canadian Prints & Drawings Dept, NGC, Paris no. 24011070, Acc. no. 1297.

*5.11 *An Old Lady of Pont-Aven*
She sits leaning slightly forward, her left hand clasped round her knee. On the ground in the left corner of the plate are an earthenware jug and bowl. Signed Armstrong 82. 15.2x11.3cm. Print, NGC, Paris no. 24011071, Acc. no. 1298. *Old Lady of Pont-Aven* Drypoint: 15.2x11.3cm. Signed Armstrong 82. Exh. NAG, 1979 and repr. in *Artists of the Newlyn School* as No. 80, p.201. V&A (E2817)
NOB, 1981,[3 copies] *Breton Woman seated with Jug and Bowl*, signed, Cat. No. 19, £60.

5.12 *A Recumbent Figure*
A Breton girl lying face downwards on the ground, with bare legs crossed and head raised. A second state, with monogram is in MMC. 9.1x16.5cm. Print: drypoint in brown, in, NGC, Paris no. 24011072, Acc. no. 1299.

5.13 *The Reapers*
Two Breton women with sickles in a field of sparsely grown corn, and a man tying up a sheaf. Signed with monogram EA. 15.2x20.3cm. This and the following plate are the only ones by the artist containing etched work. Print: etching & drypoint in brown, in NGC, Paris no. 24011073, Acc. no. 1300. Aka *Breton Women Harvesting* Drypoint etching: 15.2x20.3cm, monogrammed.
NOB, 1981,[2 copies] Cat. No. 18, £80.

*5.14 *Boy with a Stick*
A (Breton) peasant boy, standing to right, in round cap and wooden sabots, holding a stick in his right hand; a slender tree-stem to the right. Signed with monogram EA. Etching and drypoint. 10.1x7cm. Print: etching and drypoint in brown on wove paper, in, NGC, Paris no. 24011074, Acc. no. 1301.
NOB, 1981, Cat. No. 16,[22 copies] £45. Collection: Penlee: gift of GB. Exh. Penlee Focus Exhibition, 1997-8.

5.15 *A Breton Peasant Woman*
She is seated on an upturned basket, leaning forward, with right hand stretched out towards her bare foot. Signed EA Armstrong, 1882. 11.8x19.8cm.

5.16 *A Breton Peasant Girl (No.1)*
Head and shoulders of a Breton peasant girl, in profile to the right. 1st state: with monogram EA. 2nd state: The monogram has disappeared, and the work has grown fainter on the hair, cap and shoulder. The plate much worn. 20x13.9cm.

5.17 *A Breton Peasant Girl (No.2)*
The same subject as the preceding, with head and shoulders on a larger scale on the plate, but less finished. 20x12.4cm.

5.18 *Dorothy (No.1)* aka *The Night-Dress* and *Good Morning*
A little girl of about three years of age standing in her nightdress, and leaning back against a bed. Her right hand is outspread on the folded-back coverlet. Miss Dorothy Menpes was the subject of this plate. Signed with monogram EA. 16.5x9.4cm. A later state in MMC. Print: drypoint in brown, in Canadian Prints & Drawings, NGC, Paris no. 24011075, Acc. no. 1302. Aka *Child in Nightgown* Etching, 15.2x7.6cm, monogrammed.
NOB, 1981, Cat. No. 11,[4 copies, 2 monogrammed EA, 1 unsigned, 1 damaged] £60.

5.19 *Dorothy (No.2)*
The same subject as that preceding, on a larger plate: the right hand upon the coverlet is folded, and the head is bent a little to the right. Signed with monogram EA. 20x12.4cm. Print: drypoint in brown, in NGC, Paris no. 24011076, Acc. no. 1303.

5.20 *Mother and Child*
A nude woman seated, leaning forward, with a naked child at her knees. Signed with monogram EA. 15.2x9.1cm. A watercolour drawing for the above plate in the V&A. Print: drypoint in brown in NGC, Paris no. 24011077, Acc. no. 1304.
NOB, 1981, Cat. No. 13,[3 copies] £60.

5.21 *The Pigeons*
A nude female figure holding out a shallow bowl with both hands to the right; on the ground are the shadowy outlines of four pigeons. Signed with monogram EA. 25.4x13.8cm. Drypoint in Art Gallery of Ontario, Canadian Historical Dept. Paris no. 28018182, Acc. no. 89/89. Titled: *Nude holding Bowl* Etching: 25.4x15.2cm, monogrammed.
NOB, 1981, titled *Nude holding bowl* [3 copies, 2 monog., 1 unsigned] Cat. No. 29, £50.

5.22 *Portrait of H. de Lapasteur Esq*
A young man in a coat with fur collar and cuffs, is seated looking to the left. One hand clasps the back of the chair, the other rests upon his knee. Signed with monogram EA. 25.4x19cm. *Fair Haired Man with Fur Collar* Etching, 25.4x18.4cm monogrammed; NOB, 1981, [4 copies, all monogrammed], Cat. No. 7, £70.
A working proof of this plate, with the left hand only sketched in, and before the right hand and arm were drawn on the plate, is in V&A.
This Exh. the Society of Painter-Etchers, 1885.

5.23 *Toby* (unseen by Sabin)
Dry-point of the son of Mortimer Menpes. Exh. the Society of Painter-Etchers, 1883.

*5.24 *Dr. Faustus*
A young man, with dark hair and moustache, half turned to the right. He wears a coat with a deep fur collar, and holds a newspaper in his hands. 29.8x19.7cm. A working proof of this plate, the head and coat collar only completed, is in the V&A. Exh., Society of Painter-Etchers, 1885.
NOB, 1981, called *Portrait of a Man with Fur Collar* unsigned etching,[3 copies] £60. Collection: Penlee; exh. Penlee Focus Exhibition, 1997-8.

Second period dates from EAF visit to Zandvoort in 1884 to final departure from London at end of 1885 (Nos. 25-35, & 41)

*5.25 *The Girl at the Window*
15.2x11.4cm Monogrammed EA.
A Dutch girl, seated knitting by an open window, through which two figures and some cottages are seen.
NOB, 1981 [3 copies] £90.

*5.26 *Peeling Onions*
A Dutch girl seated on a chair, with a shallow basket containing onions on her lap, a knife in her right hand, and an onion in the left. 15x8.9cm. Exh. Society of Painter-Etchers, 1885. Print: drypoint on laid paper, NGC, Paris no. 24011079, Acc. no. 1306.
NOB, Unsigned. [4 copies] 1981, Cat.

No. 26, £30.
For sale as No. 407 at W. H. Lane, Penzance, June 30, 1988, stating as provenance the Newlyn Forbes Exhibition of 1981, & previous to that, the Forbes Studio.
Collection: : Penlee; exh. Penlee Focus Exhibition, 1997-8.

*5.27 *The Old Lady and Her Stick*
The old lady, with her stick in her left hand, stands, with her right hand upon a chest of drawers, facing the right; through an open window in front can be seen a fence and farm buildings. Signed with monogram EA. 17.1x10.1cm.
Print in Canadian Prints & Drawings, NGC, Paris no. 24011080, Acc. no. 1307. NOB, 1981,[1 copy] Cat. No. 23, £50.

*5.28 *In the Almshouses, Zandvoort*
A Dutch girl, in sabots and cap, stands knitting, her ball of wool on the ground. Signed with monogram EA. 27.9x12.7cm. Reproduced in *The Studio*, p.188, vol. iv. 1894.
NOB identification: *Breton Girl Knitting* Etching: 27.9x12.7cm, monogrammed. 1981 as Cat. No. 22 [2 copies]. Despite mis-identification, this is probably the same.

5.29 *Saying Grace (No.1)*
A scene in the Almshouses, Zandvoort. A family group sit round a table, upon which tea is laid; leaning against one of the elder girls stands a young girl in the right foreground. 12.3x20.3cm. Exh. Society of Painter-Etchers, 1885. Exh. RA, 1885 (No. 1638) and NAG, 1979 (No. 81). V&A(E2832).

5.30 *Saying Grace (No.2)*
The left half of the previous plate which has been cut in two, leaving only the two elder people seated at the table; the window beside the fireplace has been darkened. 12x10.8cm. Exh. Society of Painter-Etchers, 1886.

5.31 *Chuckstone*
A boy and girl, both barefooted, seated upon a stone wall, playing with small stones. Signed with monogram EA. 15.2x10.1cm. Exh. the Society of Painter-Etchers, 1884. NOB,1981. [3 copies] *Two Children on a Wall* Drypoint etching: 15.2x10.1cm, monogrammed EA and signed Elizabeth A Armstrong. Probably executed in Holland, 1884. Exh. at NAG, 1979 as Cat. No. 87 (misprinted as 81). V&A (E2834) Reprinted on contents page of *Stanhope Forbes and the Newlyn School*. Private Collection.

5.32 *Boys with a Barrow*
Two country lads, one with a small barrow, stand in a back yard; behind are a field and farm buildings. From a drawing made at Walberswick. Signed with monogram EA. 14.6x10.1cm. Aka *Two Boys with a Barrow* 14.6x10.1cm, monogrammed. NOB, 1981,[1 copy] Cat. No. 12, £60.
Collection: Penlee; exh. Penlee Focus Exhibition, 1997-8.

*5.33 *The Lock*
On the wall above the lock a boy sits with a fishing rod in his hand; a house stands by the road beyond. From a drawing made at Walberswick. 13.9x10.1cm.
Aka *Boy Fishing* (from a lock) Etching, 13.9x10.1cm, monogrammed. NOB, 1981,[2 copies] Cat. No. 10, £60.
For sale as No. 406 at W. H. Lane, Penzance, June 30, 1988 (Illus.) Provenance stated as from 1981 sale above.

5.34 *The Water-cress Bed*
In the left foreground a girl is seated on a bank of the dyke which contains the water-cress: at the other end of the dyke farm buildings fill in the background. A scene possibly at Walberswick. Signed with monogram EA. Exh. the Society of Painter-Etchers, 1886.
Reproduced in *The Studio*, p.188, vol. iv., 1894.

5.35 *The Old Model*
Head of an old bearded man, wearing tortoiseshell rimmed spectacles; he holds a lighted candle in his left hand. 10.1x12.3cm.
A drawing for this etching may be in charcoal in Canadian Prints & Drawings, NGC, titled *An Old Man with a Candle*, of similar date (1883-5), Paris no. 24013823, Acc. no. 1293.
Exh. NAG, 1979, Cat. No. 88. V&A (E2837).

Final period of drypoint work by EAF, consisting of Cornish scenes 1885 forward

5.36 *Net Beating*
The net hangs from a nail on the wall, and a woman stands, with a netting shuttle in her hand, working at it, and talking to a girl who is seated on a chair in the left foreground. Scene at Newlyn. Signed with monogram EA. 19x12cm.
Exh. Society of Painter-Etchers, 1886. Print, NGC, Paris no. 24046215, Acc. no. 35919. aka *Net Beating*, Exh. NAG, 1979 as Cat. No. 84. V&A (E2383).

5.37 *The Bakehouse*
A bakehouse at Newlyn. A woman stands before the brick-built oven, a peel in her right hand; by the table to the left stands a girl with a basket. 26.4x20.3cm. 1st state: With monogram EA and heavy burr all over making the room gloomy and dark. 2nd state: The burr has been largely removed, and the monogram has almost vanished.
Exh. the Society of Painter-Etchers, 1887. Print: drypoint in brown in Canadian Prints & Drawings, NGC, Paris no. 24011081, Acc. no. 1308. Exh. NAG, 1979, No. 82.
Print in V&A (E2831).

5.38 *The Carpenter's Shop (Newlyn)*
A bench runs under the window; and by a smaller bench stands a youth with bare feet in a jersey and cap; another youth is seated in the left foreground. Signed with monogram EA. 20.3x26.4cm. Exh. the Society of Painter-Etchers, 1887. Print: drypoint in brown, NGC, Paris no. 24026991, Acc. no. 29227.

5.39 *The Cornish Pasty*
The grown-up daughter is rolling out the pastry on the table, by which a child stands looking on. Grandmother sits knitting beyond, and mother places a kettle on the fire, to the left of which another figure is seated. A Newlyn scene, signed with monogram EA. 20.3x26.7cm. Print: drypoint in brown, in Canadian Prints & Drawings, NGC, Paris no. 24011082, Acc. no. 1309.
aka *The Pastry Cook* NOB, 1981,[1 copy] £80.

5.40 *The Sisters*
An elder girl, with hair in a plait down her back, is seated facing the right, holding on her lap her small sister. Signed with monogram EAF (1889 or after.) 25.4x20.3cm. 1st state: drypoint with heavy burr on background round the figures. 2nd state: background scratched all over to produce an aquatint effect. Print: drypoint in brown, in Canadian Prints & Drawings, NGC, Paris no. 24011083, Acc. no. 1310.

5.41 *Idleness*
On the level sands in the foreground stands a solitary donkey; behind it to the right are two boys seated on the sand, other unoccupied donkeys, and bathing machines, from one of which a flag is flying. A breeze stirs the flag gently, and moves also the bathing garments hung out on a line to dry in the left middle distance. A plate of the same period as Nos. 31-33. Signed with monogram EA. 10.2x17.5cm.
Exh. Society of Painter-Etchers, 1884. Collection: Sydney Vacher. Print: *Beach Donkeys* Drypoint etching: 10.2x17.8cm, monogrammed.
NOB, 1981, [3 copies] Cat. No. 14, £70.

Additional drypoint etchings found listed in exhibition catalogues. Not on Sabin list unless unidentified duplicates.

Add 1. *Across the Sand Dunes*
Etching: 17.8x11.4cm, monogrammed. For sale, NOB, 1981, Cat. No. 25, £50.

Add 2. *Girl in profile*
Etching, 15.2x10.8cm, monogrammed. NOB, Cat. No. 8, £55.

Add 3. *Head of a girl*
Etching: 12x8.3cm
V&A F.439-1919, Presented to V&A by Harold J. L. Wright Esq.

Add 4. *Sir William Richard Drake, F.S.A., in his morning-room at Prince's Gardens, SW c.1880*
Private plate, etching: 26.7x31.6cm.
V&A E.429-1932, Given by Mr. Harold J. L. Wright.

Add 5. *Woman at Cottage Door*
Etching: 19x11.4cm, monogrammed. NOB, 1981, as Cat. No.24, £50.

VI. Prints, Sketches, Charcoals and Drawings:

6.1 *The Blind Girl*
Charcoal: 43.2x30.5cm, unsigned. For sale, NOB 1981, Cat. No. 46, £150.

6.2 *Boy seated* (also called *Seated Boy*)
Charcoal: 38.1x24.8cm, unsigned. For sale, NOB, 1981, No. 54, £90.

6.3 *Boy with Basket*
Pen & ink: 25.4x15.2cm, unsigned. For sale, NOB, 1981, Cat. No. 15, £100.

6.4 *Cast Shadows*
Drawing sold at Sketch exhibition, December, 1895, NAG to Mrs. Howell for 5 guineas, on January 6, 1896.

*6.5 *Cicely Tennyson Jesse, Portrait of 1909-10*
Charcoal, watercolour & body colour: 34.3x24.1cm
Sold, Christie's, London, June 23, 1994 Provenance: A gift from the artist to the sitter, thence by descent to Tom Luck, 1948, by whom gifted to the present owner in 1977.
Charcoal drawing presented to Penlee House Gallery & Museum, 1999 by George Bednar. Employed as cover illustration for *Millennium Diary Project*, The Hypatia Trust, 2000.
Subject: Young woman relaxing against the back of her chair, book in lap. A peaceful scene.

6.6 *Charcoal Drawing*
Exh. No. 3 in 16th Exhibition (April, 1901) of NAG. Sold for £2/12/6 to Miss H. Delamore.

6.7 *Charcoal Study*
Exh. No. 57 at the Sketch exhibition, December, 1895, NAG. Sold to Percy R. Craft for 4 guineas.

6.8 *A Cornish Interior*
Charcoal drawing on wove paper: 43x45.8cm.
NGC. Paris no. 24011067, Acc. No. 1294.

6.9 *The Cracker Cap* c. 1900
One of a number of drawings collectively referred to by Mrs. Lionel Birch, p.80 as 'drawing and notes in colour of children's doings and their characteristic movements'. This one a 'merry boy'.
Exh. Fine Art Society, 1900, in 'Children and Child-Lore'.

6.10 *The Fortune Teller*
Charcoal Drawing on wove paper: 49.6x37.4cm.
NGC. Paris no. 24011068, Acc. No. 1295.

*6.11 *Girl (seated)* in Breton costume
Charcoal drawing: 40.6x50.8cm, monogrammed.
Sold, W. H. Lane, Penzance, March 15, 1984, for £340.

*6.12 *Girl with hands behind her back*
Charcoal: 43.2x26.7cm, unsigned.
NOB, 1981, Cat. No. 60, £90.
Sold, David Lay, Penzance June 17, 1999,(Lot 228, illus.), £1,600.
Private collection.

6.13 *Head of an Old Woman I*
Pen & ink: 15.9x14.6cm, unsigned.
NOB, 1981, Cat. No. 27, £80.

6.14 *Head of an Old Woman II*
Pen & ink: 15.9x14.6cm, unsigned.
NOB, 1981, Cat. No. 28, £80.

*6.15 *An Interior: Basses Pyrenees*
Drawing. Illus., *The Studio*, xviii. p.32.

6.16 *The little jewel, a young girl*
Chalk & black pencil: 38.1x25.4cm.
Sold, Christie's, Kensington, September 8, 1994 (Lot 182, illus.),£800.

6.17 *Mother & Child*
Wash drawing: 33x22.9cm, unsigned.
NOB, 1981, Cat. No. 61, £200.
Probably the same as *Mother & Daughter* Watercolour grisaille, sold at Sotheby Belgravia, London, April 27, 1982 for £350.

*6.18 *Mousehole from Raginnis Hill*
Charcoal: 43.1x20.3cm. Signed EA Forbes.
Private Collection.

6.19 *School* c.1900
Noted by Mrs. Lionel Birch as a sketch of 'the quaint, hooded little fellow off to school with his books under his cape', p.80
Exh. Fine Art Society, 1900, in 'Children and Child Lore'. Possibly a study for *Off to School*.

6.20 *A Shepherd of the Pyrenees* (1899 end date)
Drawing, illus. in *The Studio*, Vol 18, 1899, p.32, included in her submissions for the Fine Art Society Exhibition in 1900. Sold on July 10, 1902, to Miss H. R. de Lanon for 4 guineas, from the 18th Exh., NAG.

*6.21 *Elizabeth Stanhope Forbes, A.R.W.S.* (after 1899)
A charcoal drawing 'by herself'.
35x16cm. Private collection. Repr., p.43, in Mrs. Lionel Birch's biography.

6.22 *Stanhope A. Forbes, A.R.A., drawn by Elizabeth Forbes*
Charcoal
Repr., p.8 in Mrs. Lionel Birch's biography.

*6.23 *The Village*
Drawing. Illus., *The Studio*, Vol. 18, 1899, p.26.

*6.24 *Violet Girl*
Exh. Leon Suddaby Gallery, Chapel Street, Penzance, 1988.

6.25 *Study of a young woman in Elizabethan dress*
Pencil & charcoal on grey paper: 27.5x19.5cm. For sale as No. 365 at David Lay, ASVA, Sale of Paintings, August 28, 1986. Provenance: E. Lamorna Kerr with the following note: 'Sketch found by S. J. Lamorna Birch in the woods at Trevelloe by the studio of E. A. Forbes'.

6.26 *Study in White* 1895
No. 50, sold at the Sketch exhibition, December, 1895, Newlyn Art Gallery. Purchased by Mr F. Sargeant of St. Ives for 5 guineas.

6.27 *Woman in Profile*
Charcoal: 55.8x35cm, unsigned.
NOB, 1981, Cat. No. 48, £300.
For sale as No. 79 in David Lay, ASVA Sale of Paintings, Thursday, December 4, 1986. Provenance from previous sale. Label to reverse. Offered for sale as Cat. No. 47 (illus.) at W. H. Lane, Penzance, July 28, 1994.

Books and monographs

Bednar, George *Every Corner Was A Picture: 50 artists of the Newlyn Art Colony 1880-1900, A Checklist*, West Cornwall Art Archive & Patten Press, Cornwall, 1999.

Birch, Mrs. Lionel *Stanhope A. Forbes, ARA and Elizabeth Stanhope Forbes, ARWS*. Cassell & Company, Ltd. London, 1906.

Colenbrander, Joanna *Portrait of Fryn,* Andre Deutsch, London, 1984.

Cross, Tom *The Shining Sands, Artists in Newlyn and St. Ives, 1880-1930,* Westcountry Books in association with The Lutterworth Press, 1995.

Dunford, Penny, editor *A Biographical Dictionary of Women Artists*, London, 1990.

Fox, Caroline *Stanhope Forbes and the Newlyn School*, David & Charles, Newton Abbot, Devon, 1993.

Gaunt, William *The Pre-Raphaelite Tragedy,* Jonathan Cape, London, 1942.

Gill, Linda, editor *Letters of Frances Hodgkins*, University of Auckland Press, 1993.

Graves, Algernon, FSA *A Dictionary of Artists, who have exhibited works in the Principal London Exhibitions from 1760 to 1893*, first published 1883, third edition, with additions & corrections, Kingsmead Press, 1984.

Hardie, Melissa, editor *100 Years in Newlyn, Diary of a Gallery,* Patten Press, Newmill, Penzance, Cornwall, 1995.

Nunn, Pamela Gerrish, *Victorian Women Artists,* London, 1987.

Peacock, Ralph 'Modern British Women Painters' in *Women Painters of the World,* Art & Life Library, London, 1905.

Rezelman, Betsy Cogger, *The Newlyn Artists and Their Place in Late-Victorian Art* (Ph.D., 1984, Indiana University), University Microfilms International, Ann Arbor, MI.

Sabin, Arthur K., 'The Dry-Points of Elizabeth Adela Forbes, formerly E. A. Armstrong (1859-1912)', *Print Collectors Quarterly*, Feb., 1922, Vol 9, Pt. 1, pp.75-100, 1922.

Wallace, Catherine, compiler *Women Artists in Cornwall, 1880-1940,* Falmouth Art Gallery, 1996.

Whybrow, Marion *St. Ives, 1883-1993, Portrait of an Art Colony,* Antique Collectors Club, 1994.

Wormleighton, Austin *A Painter Laureate, Lamorna Birch and his circle*, Sansom & Co., Bristol, 1995.

Newspapers, Catalogues, Magazines & Journals, including original source materials

The Cornishman, 21.3.1912 and 18.3.1912, obituary and tribute.

Cornish Telegraph, 24.10.1895.

Cornwall County Council, as compiled by Newlyn Orion Galleries, *A Century of Art in Cornwall, 1889-1989.* Exhibition catalogue, 1989.

Crozier, Gladys Beattie 'The Newlyn School of Painting' *Girls' Realm,* Nov, 1904.

Dixon, Marion H. 'The Art of Mrs. Stanhope Forbes', *Lady's Realm,* 1904-5.

Fox, Caroline & Francis Greenacre *Artists of the Newlyn School (1880-1900)*, Newlyn Orion Galleries, Ltd., Penzance, Cornwall, 1979.

Garstin, Norman 'The Art of Stanhope Forbes, ARA' in *The Studio,* Vol XXIII, July, 1901.

Hind, C. Lewis 'Stanhope A. Forbes, R.A.' in *The Art Journal,* Christmas Number, 1911.

Holmes, Jonathan *An Artistic Tradition, Two Centuries of Painting and Craft in West Cornwall 1750 - 1950.* Exhibition catalogue, 1993.

Messum, David *A Breath of Fresh Air,* a collection of paintings by artists of the Newlyn School & other related works. Exhibition catalogue, spring 1990.

Meynell, Alice Two articles on the group of painters working at Newlyn, in *The Art Journal,* 1889.

Newlyn Art Gallery (1895 - 1912) Sales book, of paintings exhibited and sold on public exhibition, from the institution of the Passmore Edwards Art Gallery at Newlyn, Penzance, Cornwall.

Newlyn Archives: 1. Scrapbook (Cuttings from newspapers) 1895-1943 intermittent, kept by Forbes. 2. Photographic record album of Stanhope & Elizabeth Forbes. 3. The Elizabeth Forbes Scrapbook (Cuttings, source materials accumulated, kept by M. Hardie).

The Pall Mall Gazette, obituary 28.3.1912.

The Paper Chase: Issue 1, March 1908, and Issue 2, June 1909. Magazine published by Elizabeth Forbes and edited by F. Tennyson Jesse.

The Studio (established mid-April, 1893) About Elizabeth Armstrong Forbes (Mrs. Stanhope):
Charcoal study by: iv. 193
Drawings by: xviii. 32, 26 (illus)
Dry-Point Etchings by: iv. 188,195 (illus)
Etchings of: iv. 59
Indoor Studio & Outdoor Hut of: iv. 187

Paintings & Etchings of: iv. 186
'On the Slope of a Southern Hill':
xviii. 25 (article about)
Paintings by: iv. 192; xviii. 28, 29, 33;
xx. 183 (illus)
Watercolour Sketch by: (printed in
colours) xviii. 29

Wortley, Laura for David Messum,
(1987,1988) (Publication VIII) *British
Impressions, 1880-1940*, Exhibition
catalogues.

Wortley, Laura for David Messum
(Publication XII) *British
Impressionism, 'A Garden of Bright
Images'*.

**Repositories consulted by the co-
authors:**

Jamieson Library Art Archive
(Newmill, Penzance, Cornwall):
A collection of books, articles,
reprints, personal files, related to
women artists in general, and west
Cornwall artists in particular.

Newlyn Art Gallery Archive:
Minute books, exhibition catalogues,
personal scrapbooks, relating to 105
years' history of the Newlyn Art
Gallery, and its exhibiting artists.
Lodged in the West Cornwall Art
Archive, temporarily lodged at the
Jamieson Library as above.

The Tate Archive:
The papers and letters of Stanhope
Forbes, Archive No: TGA9015.
Included under the same catalogue
number is a small amount of material
relating to Elizabeth and Alec.

The V&A:
Newlyn Collection of drypoint
etchings by Elizabeth Armstrong
Forbes.

Judith Cook was born in Manchester but has many affiliations with
Cornwall. After spending a number of years as a national newspaper
journalist, she now concentrates on writing books and for the theatre.
She has published biographies of Daphne du Maurier, J.B. Priestley and
of a remarkable eighteenth-century Cornish woman, Mary Bryant, as
well as books on social issues and, recently, a series of crime novels set
in the sixteenth century. She has also had a number of plays given
professional productions including, most recently, an adaptation of
Trollope's *Barchester Towers* for Chichester Festival Theatre. Judith
Cook lives in Newlyn with her partner, Martin Green.

Melissa Hardie is the American-born collector and curator of the
Jamieson Library, Penzance, and the Publisher of the Patten Press. She
writes and lectures in the fields of art history, social and cultural
anthropology as well as health care organisation. An English Literature
graduate of Boston University, she completed her Ph.D. studies at
University of Edinburgh. She has lived in west Cornwall for 15 years
with her husband and six cats.

Christiana Payne is a Senior Lecturer in History of Art at Oxford
Brookes University. She has curated two exhibitions, the catalogues for
which have been published as *Toil and Plenty: Images of the
Agricultural Landscape in England 1780-1890* (Yale Center for British
Art/Yale University Press, 1993) and *Rustic Simplicity: Scenes of
Cottage Life in Nineteenth-Century British Art* (Djanogly Art
Gallery/Lund Humphries, 1998). The latter exhibition was shown at
Penlee House Gallery and Museum, Penzance. She is currently working
on a study of coastal imagery in nineteenth-century Britain.

Books on the artists of Cornwall
For details of Sansom & Company biographies of the artists of
Cornwall, please write to the Sales Department, Sansom & Company
Ltd., 81g Pembroke Road, Bristol BS8 3EA, or fax us on 0117 923 8991.